From The Women's Press Ltd
124 Shoreditch High Street, London E1

Photo by MaKo

Gisela Ecker

Gisela Ecker was born in 1946. She studied English, German and Philosophy at Munich University, and completed her Ph.D. in 1978. She has lectured at the universities of Munich, Cologne and Sussex. Among her publications are a book on sixteenth-century broadsheets, and articles on twentieth-century English literature and feminist literary criticism. She is active in the women's movement in Germany.

Harriet Anderson was born in 1957 in London. After studying German and Philosophy at Cambridge University, she took up teaching posts at the universities of Cologne and Graz. She is at present writing a doctorate thesis on women's writing in Austria at the turn of the century.

GISELA ECKER, editor

Feminist Aesthetics

Translated from the German by
Harriet Anderson

The Women's Press

First published by The Women's Press Limited 1985
A member of the Namara Group
124 Shoreditch High Street, London E1 6JE

British Library Cataloguing in Publication Data

Feminist aesthetics.
 1. Aesthetics
 I. Ecker, Gisela
 700'. 1 BH39

 ISBN 0-7043-2864-X
 ISBN 0-7043-3964-1 Pbk

Phototypeset by AKM Associates (UK) Ltd, Southall, Greater London
Printed and bound in Great Britain
by Nene Litho and Woolnough Bookbinding
both of Wellingborough, Northants

Contents

Acknowledgments

The following essays have been previously published. We are grateful to the publishers for permissions to reprint.

Silvia Bovenschen, 'Über die Frage: Gibt es eine weibliche Ästhetik?', © Ästhetik und Kommunikation, 7 (1976). Copyright in the translation by Beth Weckmueller, © New German Critique 12 (1977).

Elisabeth Lenk, 'Die sich selbst verdoppelnde Frau', © Ästhetik und Kommunikation, 7 (1976).

Sigrid Weigel, 'Der schielende Blick: Thesen zur Geschichte weiblicher Schreibpraxis', in Die verborgene Frau (Berlin, © Argument Verlag, 1983).

Heide Göttner-Abendroth, 'Thesen zu einer matriarchalen Ästhetik', in Die tanzende Göttin (München, © Verlag Frauenoffensive, 1982).

Christa Wolf, from Kassandra. Voraussetzungen einer Erzählung (Darmstadt, © Verlag Luchterhand, 1983); trans. Jan Van Heurck (London, Virago, 1984), © copyright in the translation by Farrar, Straus and Giroux, 1984.

Gertrud Koch, 'Warum Frauen ins Männerkino gehen', in Gislind Nabakowski et al., Frauen in der Kunst (Frankfurt, © Suhrkamp Verlag, 1980).

Jutta Brückner, 'Nachbemerkungen', in Renate Möhrmann, Die Frau mit der Kamera (München, © Hanser Verlag, 1980).

Christiane Erlemann, 'Was ist feministische Architektur?' in Luise Pusch (ed.), Feminismus. Inspektion der Herrenkultur (Frankfurt, Suhrkamp Verlag, 1983).

Eva Rieger, 'Einleitung', in Frau und Musik (Frankfurt, © Fischer Verlag, 1980).

Translator's Foreword

My priority in translating these texts was to produce a readable English rendering which conveys the sense and style of the original as closely as possible. However, some of the finer shades of meaning have necessarily been lost, as English, both in its vocabulary and structure, often cannot convey the metaphors, associations and word games of the German. An added difficulty is that some of the authors draw on intellectual traditions which may be largely unfamiliar to British readers. Where it was impossible to do so in the text itself I have tried to clarify the more important obscurities in translator's footnotes.

As the contributions by Silvia Bovenschen and Christa Wolf were already available in English when we started to prepare this anthology, we have reprinted these earlier translations.

Harriet Anderson
London, 1984

Preface

When I had the opportunity to exchange posts with a colleague at the University of Sussex for a year I was able to include a course on women's writing in my teaching. During the course I found myself increasingly regretting that we could not discuss the German feminist criticism I was familiar with alongside the English texts. My reading list at a German university had always included feminist writings in both languages, and the collective enterprise of translating and transplanting from one cultural context to the other had always proved stimulating, even if only for the purpose of displacing the 'naturalness' of our own concepts. Because the use of English is so widespread and English translations are so readily available, whilst German texts are less often found in English, the exchange has been rather one-sided. For this reason, some of the articles in this collection may prompt a re-reading, as British, American and French theories have been assimilated into German hermeneutics and the Frankfurt school of critical theory, and the reader-response theory. Despite feminism's declared autonomy, we are undoubtedly influenced by this critical and cross-cultural heritage.

Since Silvia Bovenschen's article on feminine aesthetics (see Chapter 1) was published in 1976, there has been a never-ending stream of contributions to this topic in Germany. A distinguishing feature of this writing is the concern with *all* forms of artistic expression, in contrast, for example, to the French feminists' emphasis on literature. A principal aim in my selection here has been to illustrate the scope of the debate and so I have included articles on the specific problems which arise within different art forms – literature, film, architecture, music, theatre and the visual arts.

The more general articles may seem rather abstract to an English-

speaking audience. This is because the German academic tradition has tended to abstraction and an emphasis on philosophical speculation – a tendency aggravated here, as I had to abridge most of the articles, and chose to highlight the ideas rather than the concrete examples, which in many cases were drawn from German texts unavailable in translation.

It might have been interesting for readers to have been given information on the wider framework of the women's movement in West Germany (and in the GDR, represented by Christa Wolf), and about how it contrasts with the movements in Britain and the USA. But in order to go beyond sweeping statements and stereotypes it would be necessary to describe in detail the political activities, journals, organisations and dominant topics. This has already been done in other essays[1] which are easy to get, so I have omitted such a survey.

This selection includes writings by both academics and women who practise the art they discuss: Christa Wolf is a writer, Christiane Erlemann an architect, Jutta Brückner a film-maker, Gisela Breitling a painter. I was also guided in my selection by the different styles of discourse which they employ (although this may have been lost in translation) – Christa Wolf's letter style, Elisabeth Lenk's language of dream (which she has since explored theoretically as a non-patriarchal discourse), Renate Möhrmann's colloquial approach, reflecting the fact that originally this was given to a wider audience, and Heide Göttner-Abendroth's language of communication theory (a theory she has since abandoned). The traditional distinction between the creative artist and critic who sticks to her meta-language has been powerfully challenged by feminists everywhere.

My thanks to Alison Light, Marcia Pointon, Cora Kaplan, Sybil Oldfield and Natascha Würzbach for their encouragement, Christiane Dinges, Barbara Gross, Marianne Kordsmeyer and Ruth Baumert for their help and, of course, Harriet Anderson, the translator, for many aspects of our cooperation between Brighton, Cologne, London, Graz and Vienna. Special thanks too to the students of my seminars at the Universities of Sussex and Cologne with whom I discussed many points raised in this book.

<div style="text-align: right">

Gisela Ecker
November 1984

</div>

1 Monica Jacobs, 'Civil Rights and Women's Rights in the Federal Republic of Germany

Today'; Hilke Schläger, 'The West German Women's Movement'; Miriam Frank, 'Feminist Publications in West Germany Today' (all in *New German Critique*, 13, 1978); Edith Hoshino Altbach, 'The New German Women's Movement', *Signs*, 9, 1984, 454–67; Sara Lennox, 'Trends in Literary Theory: The Female Aesthetic and German Women's Writing', *The German Quarterly*, 54, 1981, 63–75; Harry G. Shaffer, *Women in the Two Germanies* (1981); Sandra Frieden, 'Shadowing/Surfacing/Shedding: Contemporary German Writers in Search of a Female *Bildungsroman*, in *The Voyage In*, ed. E. Abel, M. Hirsch and E. Langland (Hanover, 1983).

Introduction

In this introduction I want to talk about traces of essentialism which can be found everywhere in the feminist debate on the artistic expression of women. First of all it is the term 'female' or 'feminine aesthetic' ('weibliche Ästhetik') generally used as a heading for the discussion in Germany, and which seems to contain ideas of an ontological essence, 'woman'. Yet from the way it is used we can see that the term serves as a mere catchword under which many points against essentialism are normally brought forward.

Except for a few groupings within the women's movement, who see no problems in holding ahistorical views about femininity, there seems to be a general consensus that condemns essentialist thinking. In spite of this explicit consensus there are, I would argue, quite a few fixed ideas about the 'nature of women' still implicitly contained in the discussion of women's art. If it is true that no utopian programme can do without myth-making it should at least be accompanied by an examination of how these myths are produced and what they are like.

I

It is easy to say that we cannot ever know what is truly male or truly female. There is much that we can know. (Adrienne Rich)[1]

Even if we managed to compile a complete inventory of features of works of art produced by women and if we then tried to find out, by comparison with the artistic production of men, what is typically feminine, would we encounter anything essentially feminine? What we would find would consist of a very mixed bag of distinctive

features and in any case be strongly influenced by the current state of things, such as women's position in society and the general values this society attaches to sexual difference. It is historically-defined *difference* which we'd come across in such empirical research; its significance would lie in heightening our awareness of what is going on, but it certainly wouldn't lie in its usefulness for arriving at a coherent definition of femininity. This may sound self-evident if not banal when stated explicitly, but it is far less self-evident when we look at the practice of much feminist criticism of art. There it often happens that what starts off as a description of historical phenomena ends up in essentialist statements and thus forgets that what appears as genuinely feminine in art is transitory, and that part of it is defined in relation to what is evaluated as male. From Virginia Woolf's attempts to define a feminine sentence to the contemporary discourse about the 'off-centre spatiality' or the specific rounded forms in women's art, there is this mixture of empirical data plus presuppositions about what is truly feminine.

What has been imposed on women through oppressive social conditions or prejudice should not be made part of our definition of women's art and thus be further perpetuated. It is true that women took to painting flowers and still lifes (whilst excluded from nude classes); to handling 'useless' household materials in object arrangements (whilst being confined to this environment); that they took to writing drawing-room novels rather than adventure novels and to using 'wool rather than marble',[2] yet this still cannot sustain any essentialist argument. Morever, the derogatory tone which seems inevitably to creep in when talking about 'wool rather than marble' points back to the patriarchal bias of the general aesthetic norms, which have been deeply internalised by men and women. The feminist 'arts and crafts debate' has increased our awareness of the problems that arise when the hierarchies in values at work are put into question and reveals that it is not sufficient just to reverse them. For example, I personally find it extremely hard to celebrate needlework having gone through convent school education during which it became painfully clear that what we were taught wasn't elaborate hemstitch embroidery but what was thought was essential femininity. What I would want to suggest is that it is necessary to bring out the full ambivalence of these questions rather than aim at a harmonising but obscuring solution. I shall follow this argument later when I deal with the problem of subjectivity.

It has been argued, and indeed it can be shown, that many features in women's art which originated in the commonly-known dis- advantages were turned upside down and transformed into creative instruments when in the hands of women who deliberately installed themselves as the subject and object of artistic expression. The integration of what I call 'kitchen table discourse' into writing (even academic), the various forms of abstaining from competition, the gesture of undoing hierarchies in all art forms do introduce considerable change which should not be underestimated. Let me quote Rachel Blau du Plessis' list of the features of women's writing:

> inwardness, illumination in the here and now (Levertow); use of the continuous present (Stein); the foregrounding of material (Woolf); the muted, multiple or absent telos; a fascination with process; a horizontal world; a decentred universe where 'man' is no longer privileged.[3]

It is perfectly true that many of these features can be found in women's writing, but when they are generalised they lead to new exclusions of those forms of writing which do not yet fit into a catalogue like this, or no longer do so. The women's sections of established publishers who are not really concerned with feminist ideas help to consolidate such provisional definitions by their selection and essentialist advertisements. What I also find worrying is the idealisations which often underlie such essentialist views of women. (It is rather dangerous to construct women as superior beings, as is done, for example, in some groupings of the peace movement, because this might lead to partial blindness towards our own aggression which cannot be properly dealt with when it is suppressed.)

It is tempting to mistake features of women's art as representations of 'women's nature'. The opinions which revolve around the body in contemporary art by women may serve to illustrate this. Menstrual blood, clitoral images, feminine body language and pregnancy are used to bring into play aspects of female sexuality which are absent or even repressed in male art, yet this iconography of the body is not displayed in the sense of 'how women are' but employed by women artists who have a political consciousness of sexual difference in art. Thus very often the body is used in performances in order to highlight and combat the ideological assumptions behind the

contemporary male/female dichotomy. Because art is open to multiple interpretation, the old critical categories (i.e. the ideologies which created them) are extremely persistent. Critics still manage to offer explanations in which they continue to see woman as a spectacle and essence rather than recognising the function of these performances as a process and an artificial construct.

In French theory the body is introduced into art from a different angle. According to Kristeva's view the body appears as 'jouissance' and semiotic force in writing which is able to disrupt the restrictive symbolic order. (Regardless of the differences in the theoretical writing between Kristeva and Derrida, I would like to stress here their common grounds in post-structuralist thinking.) For Derrida as well as for Kristeva, woman is the privileged site from which western phallocentric thinking can be de-constructed. The feminine (which does not necessarily coincide with real women) is seen as a negation of the phallic and thus the privileged carrier of utopian visions. What might be problematic here is the fact that again femininity is defined in relation to masculinity. Derrida's ambiguous play on the term 'hymen' sometimes appears as an appropriation of 'woman' for his own de-constructive activity. Although the idea of 'essence' is frowned upon in post-structuralist theory, the programme of *écriture féminine* which is based on the same grounds of thinking does occasionally move towards essentialist positions. For Hélène Cixous feminine writing means 'writing the body', which has been widely criticised for what was seen as a biologistic reduction. Such a reduction of femininity to biological functions can indeed be found in isolated passages of Cixous' writing, especially when she uses body metaphors of fluidity. Yet in Cixous' texts it still remains obvious that the female body stands for instinctual drives and desire emerging from the unconscious, both of which are inserted into writing.

Within French feminist theory there is a very subtle dividing line between approaches which provide an active critique of current ideologies and those which propagate a narcissistic return to symbiotic wholeness. The originators of the discourse about *écriture féminine* perform a brilliant tightrope act which keeps them from falling into blunt essentialism. In the hands of their successors these ideas about 'woman's voice' sometimes approach prescriptive views of what women's writing should be like. Taking body metaphors literally, and claiming that the appeal to the body is necessary

because it appears as the non-colonised space which women can return to, is highly questionable. Many performances by women artists have made it obvious enough that the female body is culturally coded. The stress on writing in French theory and its conceptual grounding in language will make it an interesting task to transfer *écriture féminine* to other art forms and to see whether this results in fixing women in a framework of biological determination.

II

So far my reflections have circled round the essentialist slant in the term 'female/feminine aesthetic'. If it is impossible, as I have argued, that gender difference can ever be sorted out in terms of distinguishing between what is 'genuine' and what is 'imposed' difference, should we not abandon the question altogether? If we could be content with stating that there is a different sensibility at work in women's art which is impossible to define, why do we go on attempting to define it?

The simplest answer is that a myth of non-alienated expression of gender and sexual identity must necessarily lie behind a utopian programme like feminist politics and it is hardly possible not to attach concrete fantasies to it. Such a myth is expressed even in historical investigations of women's oppression and can be found to be simply a 'vanishing point' within the very arguments which are used against essentialist positions. Although we know that 'authentic' femininity cannot ever find full social expression we have to be sure of a vague utopia in the background, an idea of not only what we want to be liberated *from* but also liberated *to* (this is very much comparable to Marxist utopian concepts[4]). The common desire underlying all feminist commitment is certainly nourished by the unconscious, in which the contradictions and complexities I have mentioned need not always be present. It must be realised, of course, that the myth of woman emerging from all adverse conditions has itself been developed under precisely these conditions which have lasted for centuries; it is irrational but pleasurable. Many contemporary women's novels, for example, contain such mythic qualities which sometimes are at odds with other levels of the text.

There is another more complex and adequate reason why it is not easy to discard altogether the search for femininity. It lies in the concept of subjectivity. For subjectivity — as it has come to be

understood, at least since Lacan – is a compound of what is expressed through the symbolic order and of what reaches back into pre-Oedipal and pre-verbal experience, with the unconscious emerging through gaps and fissures of what is expressed in language. Art is the privileged area where the subject in progress has been studied and art has, moreover, been seen as the dominant field in which those gaps in the symbolic order are most likely to occur. Through the opportunities for play and the socially-attributed space the artist is less bound to the social order (but at the same time endowed with less social power). The imaginary is the internal realm where all these contradictions – and they are contradictions because these levels are frequently in conflict with each other – can find their expression more fully than in any other social context. Very generally, the problems of subjectivity apply to both male and female artists and their work. And indeed, they have been applied most thoroughly to the work of male artists, especially modernist writers. The difference, however, lies in the fact that, as we know, the symbolic order has very different and unequal values to offer to each sex; values which present additional difficulties to the woman artist. Social definitions of femininity and feminine sexual pleasure, for example, are not the same thing, and any alternative idea of 'femininity' which does not comply with the socially-accepted one is bound to bring about major sanctions. Thus female subjectivity creates basic contradictions and causes necessary frictions between desire and social codes.

Altogether there has been far more research invested in analysing sexist structures in the symbolic order than pointing out sexual difference in the fields of the pre-verbal and pre-Oedipal which are supposed to be less subject to historical change. Still, the theories of Nancy Chodorow, as well as the various attempts to reformulate Freudian thinking in feminist terms, offer valuable contributions. Unconscious desire, the semiotic and bodily pleasure, have been conceptualised in different ways. But in most theories they appear as a force which evokes essential sexual difference. This, however, can never be defined because it can only be expressed by means of symbolic forms and is thus inseparably bound to them. Juliet Mitchell stresses this aspect in her critique of Kristeva. She aims at further historicising the subject, and questions the existence of a disruptive force which has a totally different status from the symbolic, although she starts from similar ideas of subjectivity.

What Kristeva calls 'the hysteric's voice' is, according to Mitchell, 'women's masculine language talking of feminine experience'.[5] Thus women are seen to speak from within patriarchal discourse rather than from a source exterior to phallocentric symbolic forms. Both positions take into account the subject in process as the site of struggle. What I want to emphasise in this line of argument is the fundamental 'undecidability?' surrounding the essential and the historically variable components of subjectivity.

It will be a stimulating critical activity to go on re-reading texts by women writers in the light of this perspective. Sigrid Weigel has translated aspects of female subjectivity into an optic image: the gaze of the woman writer in two directions, a cross-eyed glance, a defect, but at the same time a chance because otherwise woman would not see at all what she can at least glimpse with one eye.

III

For all the reasons given above, I am convinced that it is important to pursue not a 'feminine' but a 'feminist' aesthetics. The second demands reflecting on the first. It takes the complications of subjectivity into account, and feminist investigations of aesthetic theory necessarily aim at a critique of traditional assumptions. We have to be aware of the paradox that there cannot be any certainty about what is feminine in art but that we have to go on looking out for it. 'Feminist' would indicate a commitment which is relative to the historical moment with its specific necessities. The articles in this book demonstrate that each field of art has to confront its own problems. For example, in music, more than in writing, it is still very important to continue analysing the various reasons for exclusion from composing or from directing. In architecture there are so many pragmatic problems to solve and topics to discuss – like violence in the streets or the ideology of the nuclear family – that the question of aesthetic forms is put into a secondary (but still important) position. The institutions by which each art form is organised, and the artistic language which is used, lead to a range of different questions from those which are normally discussed in relation to writing. In any case, this diversity emphasises that externally there is still a lot to be done in addition to the necessary reflections on the internal site of struggle within the female subject-in-process.

As long as this myth of a *general* art, literature, etc. persists in the

way it has done up to now, feminist aesthetic theory must insist that all investigations into art have to be *thoroughly genderised*. When I think of the women artists I have met, I know that this will be a highly unpopular suggestion, for one of the most urgent demands expressed by many of them is that they wish gender to be treated as irrelevant or at least marginal: for centuries women artists have been confronted with apparently gender-neutral, but what is in fact male, 'Art', and their work has been set aside as 'women's art', a status which contained massive stereotypes about women. Why should they now, they ask, when institutions seem to have become more 'tolerant' and open to them, deliberately show that they are painting, writing, composing, constructing and filming *as women*? Although I can see that this has to be taken seriously as an effect of the ideologies which go along with the notion 'women's art', something must be profoundly wrong if any artist (or critic) feels she has to suppress her gender.

A truly genderised perspective would mean that the sex – male or female – of both the artist and the critic is taken into account. This also implies their relation to gender-values in the institutions and within the theories they apply. It cannot be stressed enough that it is impossible to deconstruct this myth of gender-neutrality in art if, at the same time, male artists and critics do not develop a consciousness of their own gender. If they do not, we'll have to make it transparent to them that what they term 'natural' or 'general' norms are questionable. Otherwise women artists will still be forced either to bang on the doors of 'Art' for admittance or establish secluded spheres of women-only art, if they are not to be silenced altogether. The same applies to women critics, of course. As soon as we analyse *as women*, with our specific concerns and our skills (developed in our historical position), the apparently gender-neutral and disinterested institution university reacts as if frightfully offended. It employs its own intricate web of trivialisations and nice little sanctioning gestures which nevertheless often end in exclusion. Gisela Breitling's appeal for a radically changed concept of universality in art points, I believe, to a future stage which cannot be achieved without going through the equally radical introduction of gender into hitherto 'unaffected' fields.

1
Silvia Bovenschen
Is There a Feminine Aesthetic?
Translated by Beth Weckmueller

> It is a matter of great concern to the queen to call upon every woman who can speak and write to put an end to this scandalous women's rights nonsense and all the related abominations which the regrettably weak sex, forgetting all sense of propriety, has fallen victim to. (Queen Victoria, 1860)

> I am as unique as the greatest figures on this earth. The greatest artist, philosopher or poet is not above me. (Rahel Varnhagen)

1. Old and New Appraisals of Women's Artistic Production

The time has come for a campaign against all the weeping and wailing. Even the media have got the hang of it – with their usual inconsequence. Women are oppressed, exploited, degraded . . . Although this state of affairs has hardly changed since it was first articulated, to continue to proclaim it now in the artistic realm seems almost pointless. But this need not necessarily be the case. As can be seen upon closer examination, it is the tone and the platitudinous character of the lament that make it seem inadequate. The form the lament takes still acknowledges its addressee. Traditionally it was women – professional mourners – who rendered grief public, be it in regard to death, to suffering, or to the victims of massacres; this was one of their rare opportunities to assume a public function. But precisely for this reason it was not at all startling. Indeed, no one particularly noticed, when women began publicising and decrying their own lot, that of their sisters, their female ancestors and, should women's fate not improve, the lot of future women. Clearly, Cassandra was not a false prophet. She was simply not heard. No one paid attention to her.

Lately though, the pitch has become more shrill, and lamentation has turned into accusation. Since there is no reliable authority guaranteeing justice, women are leaving the wailing wall.

For this reason I thought it would be tedious to enumerate once again the entire battery of obstacles constructed to frighten off and exclude women from the artistic realm. Yet the handicaps and the absences are also part of women's history, and perhaps even the greater part, since women did not clomp through history in combat boots, and their traces are fleeting and obscured. To be sure, we do not complain as much today because we have a movement making demands that will change the future. Nevertheless, in respect to the question of a 'feminine aesthetic', we need to re-examine its traditional assessments once again, if only for the reason that we lack a viable conceptual basis to work from.

Are you the poetess?

– Yes, Your Majesty. I am called thus!

You come from Silesia, do you not?

– Yes, Your Majesty.

Who was your father?

– He was a brewer from Schweidnitz, near the Grünberg vineyards.

But where were you born?

– On a dairy farm, like the one Horace had.

It is said that you never had instruction.

– Never, Your Majesty! My upbringing was of the worst sort!

But who helped you to become a poetess?

– Nature, and Your Majesty's victories.

But who taught you the rules?

– I know of no rules!

No rules? That is impossible! You must know the metre!

– Yes, Your Majesty! But I follow the metre from sound, and I know of no name for it.

But then how do you manage with language, if you never learned it?

– I have rather good control over my mother tongue!

I believe that, in terms of nuance, but what about the grammar?

– With regard to that, I can assure Your Majesty that I make only small mistakes!

But one should make no mistakes at all! (He smiles.) What do you read, then?

– Plutarch's *Lives*!

Surely poetry as well?

– Yes, Your Majesty! Sometimes poetry as well. Gellert, Haller, Kleist, Uz and all of our German authors!

But do you not read the ancient poets as well?

– Unfortunately, I do not know the language of the ancients!

But there are translations!

– I have read a few songs of Homer, translated by Bodmer, and Lange's Horace.

So, Horace! Do you have a husband as well?

– Yes, Your Majesty! But he deserted your ranks, he is wandering around Poland, he wants to marry again and is asking for a divorce, which I will grant him, since he does not support me!

Do you have children from him?

– A daughter!

Is she beautiful?

– So-so, Your Majesty! She did not have a beautiful mother!

But this mother was once beautiful!

– I most humbly beg your pardon! She was never beautiful! Nature forgot about her exterior!

Then how do you live?

– Oh, Your Majesty! Very badly! I cannot get a house in Berlin, and to give Your Majesty an idea of my apartment, I must ask you to imagine a chamber in the Paris Bastille! . . .

How do you live?

– Gifts from my friends! . . .

When you put poems in print, what do you receive for a page?

– Not much. Your Majesty! I had eight poems printed in honour of your triumphs.

And what did you receive?

– Only 20 Taler!

Twenty Taler? In truth! One cannot live on that . . .

(From a conversation between Anna Louise Karsch ('Die Karschin'), called Sappho of Züllichau, and Frederick the Great, recorded in her own letter to Wilhelm Ludwig Gleim, 15 August 1763[1])

Repeatedly and rightfully women have bemoaned the 'deformations of even their own cultural taste'. 'I would . . . far sooner have been caught dead with Hemingway than with Virginia Woolf in my

hands,'[2] says Shulamith Firestone about her development. The pursuit of art, often based on the search for a realm of sensitivity in hope of thereby escaping the confines of the home, may become a trap for women just as easily as other pursuits. When discussing that which we associate with patriarchal structures in the cultural realm, we immediately come up against a scandalous situation which, along with many others, was uncovered long ago but still prevails. Just to refresh our memory, Simone de Beauvoir established long ago that men mistake their descriptive perspective for absolute truth. The scandalous situation, then, is: the equation of truth with the masculine perspective, that is, with everything observed, examined and portrayed from a male point of view, which we were made to adopt very early in life. This false equation did not only predominate in the production and reception of art. It also guaranteed that, despite our fervent endeavour, this sphere remained external, foreign and remote. This was but one reason for our exclusion among the many overt and lucid strategies employed by men to repress us when they found that our perceptive powers had not been sufficiently blunted.

> Mr de Keraty followed me into the anteroom in order to debate with me, at yet greater length, his theory concerning the intellectual inferiority of women. It would be impossible for even the most intelligent woman to write a good work. And as I wanted to leave then, he ended his speech with a Napoleonic stroke, which was to shatter me. 'Believe me,' he said in a weighty tone, as I was about to open the last door of his sanctuary, 'bring children into the world instead of books!' 'My dear,' I answered, thinking I would choke on my laughter and slamming the door shut in his face, 'follow your advice yourself, as well as you can!'
>
> (George Sand, *Histoire de ma Vie*[3])

The classic notions about women's artistic competence are all too familiar. Though she is the great theme of art, woman as empirical being is acceptable only by virtue of her supposed inspirational powers. 'In an Amazon society there could be neither culture nor history nor art, since art is not essential to woman.'[4] We know today, though only because we bothered to look into the matter ourselves, that it would not be difficult for us to prove that such statements are historically incorrect. But that is only a minor point here. The quotation is from Karl Scheffler (*Die Frau und die Kunst*, 1908), a

sexologist who, by means of such value judgements and sexist categorisations, assured himself of the unqualified approval of male professionals and, alas, occasionally even of female professionals. Franziska zu Reventlow, recently honoured as heroine of the *Frauenkalender* and author of dubiously worthwhile novels, comes to the same conclusions in an enraged pamphlet attacking feminism (*Viragines oder Hetären?*). She, too, finds female genius a contradiction in terms; she, too, does not credit women with any real creative accomplishments – they can excel only as performers on stage. But 'play-acting is not actually productive art, it is only a matter of adaptation, of putting oneself into the role, of receptivity. We have great actresses and great dancers, but no notable female composers or dramatists.'[5] And yet, *this* woman wrote literature. She was even published. What are the processes at work here? How great must the alienation be, either from one's own *metier* or, as it were, from one's own sexual identity, to cause a female artist to make statements containing such questionable arguments against her own case? But this bizarre contradiction did not exist merely in her mind, pity though it was that she could not recognise it. It was, rather, an objective moment in all of women's art. All women artists faced the brutal choice of living either for their art (an insecure, joyful and sorrowful perspective) or reduced to their sex alone (a secure, sorrowful perspective). Only a very few possessed the sovereignty necessary to avoid that choice and the expectations associated with it.

The anti-feminist aspect of statements such as those by Reventlow and Scheffler is apparent. Women should stop getting upset about that. But more importantly, even if such statements constantly confuse cause and effect, they *do* contain kernels of truth. Read against the grain, contrary to their intended meaning, such explications can also give us an unobscured picture. They show (and help justify) that the masculine realm of artistic production, and often the artistic products themselves, are not only inaccessible to women, but are also fundamentally foreign to us. The number of art theoreticians who have worked this ground over is legion, and their line of argument, reduced to its banal foundation, reads: women are different, and one manifestation of this natural (*nota bene!*) difference is that they are incapable of art. The reference to a natural inadequacy was later replaced by the term 'deficit', borrowed from banking jargon. Critics have always regarded the female producers of

literature, art and music, few and far between as they are, as exotic aberrations. From a purely quantitative point of view, this indeed was and still is the case, although we have yet to rediscover the many women artists who were consciously forgotten. (Valie Export, in a highly informative report, once began a very abbreviated compilation of women's place in the history of art. I liked it particularly because she took the stance of 'well, this is just for starters, just what comes to mind immediately, but if we were to really start searching . . .'[6])

To be sure, women's representation in the arts is a rarity. And even this rarity is always measured in terms of production norms within the established framework defining the division of artistic labour, a framework which does not encompass forms of social creativity. And when a few works do manage to find their way to the public despite all obstacles placed in their path, they tend to be viewed in the following manner. Though women may have accomplished some rather nice and enjoyable things now and then, all the major innovative achievements have nonetheless remained the exclusive territory of the great *masters* of the pen, the brush or the keyboard. (Thus any mounting anxiety can be quickly and easily quelled.)

The pitiful little chapter that the cultural historian devotes to the handful of women writers and painters, not to mention women composers, alongside his exaggerated obeisances to the reigning men in art, serves as argument enough for conservatives. This ratio is all the evidence they need, for art cannot be women's *metier* if they are hardly ever represented. An argument based on such evidence is sheer infamy; it points an accusing finger at the just barely kindled spark of feminine artistic effort by means of a tautological reasoning process: Women's absence from the hallowed chambers to which they were denied entry is now presented as evidence of their extraordinary lack of ability. The recourse to nature for the substantiation of uniquely 'sexual' characteristics postulated *a priori* certitude and guaranteed agreement.

These stale misogynous jokes do not work any longer. The new women's movement has seen to that. But now there is a threat from the other front: the theoretician of equality. He came into the picture early on. In Germany, he made his first appearance during the Enlightenment, in the person of von Hippel,[7] who in the eighteenth century already pointed out the unequal access to sectors of the bourgeois public sphere afforded to men and women. We should laud him posthumously for his courage and insight.

In the meantime the picture has changed. Today the line of argument emphasising equality belongs to the repertoire of men in 'progressive' circles. Cultural historians readily sacrifice the statistical aspect of frequency or rarity in favour of a well-intentioned reappraisal. Scientific thinking suddenly springs into action. The limitations of and impediments to women's opportunities can now be explained sociologically. Such cultural and historical investigations are indeed essential, there is no doubt of that. But the sudden change of course is suspicious. To return to the threat mentioned above: cooptation, the desire to ignore and obscure differences – these are inherent in the claim that there are no longer men and women, but just thousands of human beings. Every woman has had countless experiences which render such contentions absurd. This kind of different-ness is not something which can simply be conjured up or made to disappear depending on one's momentary mood or situation. The new motto – 'Women are not really different from men' – overlooks the thousands of years of patriarchal history and the disparate socialisation processes. And coming at a time when women have begun to discover their own capabilities and needs, to set their own goals, and to reappropriate their uniqueness, it comes as a strategy to undermine these efforts. But it is too late for all that. OK, as far as I am concerned you are just as good as I am, says the husband to his wife when she comes home carrying the *Woman's Handbook*. I prefer the reactionary type who uses the differences (to him, they are the shortcomings of women) to further his chauvinistic ends. Because he is more honest, I would rather have him than the pseudo-progressive conformist who pats you on the shoulder and reassures you that, were they only given a bit of support and encouragement, women could really do the same things as men. This he says in the hope that, since they can no longer be kept completely ignorant, women will at least turn out to be what men already are. One need only open the floodgates, and women will stream into the spheres dominated by men. But what if we no longer view the difference as deficiency, loss, self-effacement and deprivation, but rather as opportunity? We shall come back to that later.

Around the turn of the century, the statement 'We women can do just as much as men' served as a beckoning light. Today it is no longer so terribly impressive. Of course we could do just as much. The question is, do we want to do just as much as men, or the same thing as men? Here we have come full circle. So it would seem.

If women imitate men's battles they will become weaker and weaker. They must find new forms of struggle. This became evident in Hendave where women demonstrated against the death sentence in Spain. Some women shouted and clenched their fists, while others just hummed. They went 'mmmmmm' with their lips pressed together, and moved forward in a row. That is a new way of demonstrating which can be a hundred times stronger than fists. We have had a virtual inflation of shouting with raised fists, and I, for one, simply walk by when I hear it. In film and in the arts we must also find a language which is appropriate to us, one which is neither black nor white.

(Chantal Akerman, interview in *Frauen und Film*
(Women and Film))[8]

Art has been primarily produced by men. Men have neatly separated and dominated the public sector that controls it, and men have defined the normative standards for evaluation. Moreover, in so far as they came into contact with this sector at all, women have for the most part acquiesced to its value-system. These realisations led Shulamith Firestone to the conclusion that 'It would take a denial of all cultural tradition for women to produce even a true "female" art.'[9] Such a statement is easily made. Indeed, aesthetic norms and cultural standards have meaning only in their sublation. But those standards and those norms were not even our own. What is the ground that we are working? From where does a 'feminine' art get its identity? Or does it not need to do that? Is art, then, still art in the traditional sense, no matter how far it has gone to the dogs? Is 'feminine' a criterion of substance, an ontological entity?

Let us then radically negate all the masculine cultural achievements and begin anew at the point where we once left off, tilling the soil as our female ancestors did before the great male *putsch*. That is not very funny, even as a powderroom joke. Perhaps we would enjoy that – linking ourselves directly to bygone power – but we should be wary of construing a direct connection where none exists. Making such a connection can raise false hopes of finding help.

Call as often as we might to the old mother goddesses – Aphrodite, Demeter, Diana and all the rest of those Amazons of long lost female empires – their power cannot reach this far, for their empires have been extinguished. Only the important consciousness that things were once different eases our burden a bit. To be sure, it is very

important that we reappropriate moments of female potential from past cultures which have been silenced in organised fashion by male history. And the work to be done in this area is immense. (I emphasise this to avoid any misunderstanding.) But any attempt to link them directly to our experiences in the twentieth century will be unsuccessful. And if we none the less force a direct connection, the results will be downright pitiful. We shall be left with parsley as a method of inducing abortion, and here and there a herbal home remedy.

The desire to tailor a positive (female) counterpart to the world that was constructed and interpreted by men is not satisfied in this manner. And are we even concerned with chronology? Let us rather quote the women of the past as we wish, without being pressured into retroactively fabricating continuity. On the other hand though, a historical archaeology in search of women past and forgotten, their obscured activities, living conditions and forms of resistance, is not just nostalgia. The hidden story of women, which reveals itself to us as primarily one of suffering and subjugation (now *here* is continuity!) is the dark side of cultural history – or better, the dark side of its idealised version. Illuminating this side initially implies no more than reiterating the aforementioned state of affairs; namely, that women put their souls, their bodies and last but not least their heads on the block for men, thus enabling them to take off on their cultural aerobatics and to sink to their barbaric lows. Women artists waft through history as mere shadows, separated from each other. Since their deeds remained for the most part without effect and their creations were, with rare exception, absorbed into the masculine tradition, it is not possible retrospectively to construct an independent counter-tradition. Only the female martyrs are not in short supply. All of this would certainly seem to be grounds enough for avoiding even the most trifling involvement with the problems of art and cultural history.

But the great refusal is not the solution either. To believe that feminine spontaneity need be creative in every case is to fail to recognise the powerful effect that cultural and historical deformation also had on the subjectivity of women, as mentioned by Firestone. Can women just 'be women', reduced to some elemental Being? We are in a terrible bind. How do we speak? In what categories do we think? Is even logic a bit of virile trickery? Or to put it even more heretically, how do we feel? Are our desires and notions of happiness

so far removed from cultural traditions and models? Feminism cannot ultimately imply that we are to stop thinking, feeling, longing. No one ever claimed that. On the contrary, we are consciously just beginning to do these things. No doubt we have always done these things differently from men (we are dealing with a sort of double exposure here). But the means of expression most readily available to us for communicating our perceptions, our thought processes – language, forms, images – are for the most part not originally our own, not of our own choosing. Here we are still at the beginning. Sensitivity to the patriarchal structures common to language usage, such as we find in Verena Stefan's book *Häutungen (Shedding)*, is certainly a step in this direction.

> What seems to be most important in this whole matter is that we focus our eyes and our feelings upon the flashes of insight which our feminine sensitivity affords us.
>
> (Lucy Lippard, *Why a separate women's art?*)[10]

> Language, the medium of my work, is for me already so generalised and mute that I cannot strive for even further generalities. Instead, I direct all my energies towards making the wall of generalities so thin that something will be able to break through the barrier, something can come from within my body and enter the over-articulated linguistic sphere. I want to show the generative base of language before it atrophies in communicable form.
>
> (Frieda Grafe, in *Filmkritik*)[11]

We ought to rid ourselves of the notion of a historically ever-present female counter-culture. And yet, on the other hand, the very different way in which women experience things, their very different experiences themselves, enable us to anticipate different imaginations and means of expression.

No matter which tack I take, I am left with the frustrations and difficulties inherent in positive definitions.

2. A Digression on 'Feminine Nature'

The 'nature' of woman is a favourite topic in discussions like this, coming this time not from the male chauvinist front (they have become more cautious here), but rather from within women's own

ranks. According to this line of thought, the mere existence of a particular type of biological organisation, irrespective of its historical development, constitutes a mythical power containing the sublation of inhuman relationships. (I, too, believe in women's mythical powers, but they have nothing to do with their wombs.)

Here the 'masculine' argument is volleyed back, simply reversed and interpreted positively. 'Deficits' can become opportunities, defeats can turn into victories. However, all this is not dependent upon the 'posture' – the symbols – we assume, but rather upon the political-feminist process in which we find ourselves.

Neither inferiority nor superiority can be deduced from the biological make-up of a human being. Nevertheless, all kinds of things are constantly being 'deduced'. As we know, biology has its societal side; we are made aware of this from the very first day of our lives. To this, then, we can no longer respond by mobilising the innocence of our respective bodies *per se*. It has always been easy to degrade women as the weaker sex by postulating psychophysical parallelism, i.e. the supposed physical weakness implies intellectual weakness. This argument still works today and is only *one* example of the idiotic assertion that the battle of the sexes will automatically resolve itself once economic equality in the realm of production and in the public sphere is achieved. Demands for equality no longer assure us of the inevitability of emancipation. On the other hand though, insight is equally impeded if one neglects the question of social constellations in which dissimilar biological make-up plays a part. It must be emphasised that both factors are inseparably interwoven. A particular type of biological organisation will necessarily have a certain value attached to it – in the case of women, one of exploitation – and the interrelatedness of these two elements cannot be dissolved in favour of either one or the other.

None the less, conscious identification with one's sex paves the way for everything else. Even if we want to deny it and take the opposite course, it determines our actions and thoughts. We stand and walk differently, we do nearly everything differently. Perhaps this is the reason why most transvestites become mere caricatures of women. There is too much that remains stifled in us at an early age and becomes an immutable part of our biography.

Ideology and the apportioning of roles subsumed women under the category 'primary nature'. This is what Simone de Beauvoir means when she says, 'Woman has ovaries, a uterus; these peculi-

arities imprison her in her subjectivity, circumscribe her within the limits of her own nature. It is often said that she thinks with her glands. Man superbly ignores the fact that his anatomy also includes glands, such as the testicles, and that they secrete hormones.'[12] The biological make-up of women plays a different role, or more precisely, *only* the biological make-up of *women* plays a societal role. That of men disappears in a cloud of activity, technology and ritual. But a simple retreat into biology cannot be women's aim. Aside from the fact that even the individual woman herself can no longer distinguish between her 'primary' and her 'secondary' nature, such a one-sided definition of female competence would bring us alarmingly close to reactionary ideologies of motherhood. We would be returning voluntarily to the cell.

> On the one hand, it is good that women are no longer ashamed of their bodies . . . But we must not attach intrinsic importance to that, or think that the female body will give us a new vision of the world. That idea is silly and absurd. That would be tantamount to creating a counter-penis. Women who think that way fall back into the irrational, the mystical and the cosmic. They are playing men's games.
>
> (Simone de Beauvoir, in an interview in *Der Spiegel*)[13]

Besides the one fact that women today have less difficulty accepting their bodies, what, then, are the positive elements that we can derive from this context?

Just recently another man, the philosopher Herbert Marcuse, gave us an answer. In this case we even become the carriers of revolution. Women's specificity is 'subversive potential', according to Marcuse. This 'subversive potential' consists of 'realising qualities which, all through the long history of patriarchal society, have been ascribed to women rather than men. Formulated as an antithesis to the dominant male characteristics, such feminine qualities would be receptivity, sensitivity, non-violence, tenderness, etc. . . . Feminine sensitivity could undermine the repressive rationality and work ethic of capitalism.'[14] One question arises here, apparent to anyone with even a bit of linguistic sensitivity. How do the sexual attributes listed, such as 'non-violence', stand in relation to the process of 'undermining'? That just as an aside.

Although women have been able to distance themselves at least

partially from the prevailing criteria of efficiency and achievement, this cannot mean that they therefore would neither possess, nor want to possess, any modes of productivity, rationality or – with regard to the extraordinary and ordinary violence they contend with daily – destructivity.

Of course, you still hear, 'Oh, a woman did that', and 'women are soft and sweet as honey.' But when women concretise their modes of seeing, the result is very vehement, very violent. It is just that this violence manifests itself differently than it does with men. Women's violence is not commercial, it is beyond description.
(Chantal Akerman)[15]

Receptivity versus productivity, sensitivity versus rationality, etc. Such dualities traditionally associated with the polarity between the sexes cannot be obliterated by mere juxtaposition. If we insist upon differentiation it cannot be in the sense of mere inversion.

'Intellectual achievements among women seem so embarrassing.' For that reason, people repress and forget them as soon as possible. Ideas? Every really new idea is in fact an act of aggression. And aggression is a characteristic that is absolutely contradictory to the image of femininity which men carry around within themselves and which they project onto women.
(Meret Oppenheim, upon awarding a prize for art)[16]

The dialectic that Marcuse relinquishes for his categorisations persists none the less within the individual qualities themselves. One such quality, supposedly always dominant in women's behavioural repertoire, is *Sanft-Mut* (gentleness).* This is an inherently ambivalent quality. On the one hand, it is emblematic of female subjugation and bears the traces of longstanding submissiveness and passivity. On the other hand, it contains utopian moments and lends us an idea of human behaviour beyond oppression, competition and compulsory achievement. At first glance, this appears as the promise of the future. However, since women were raised in and must live in a patriarchal world, since they must ensure their survival in it, their

* The compound word *Sanftmut* generally means 'gentleness'. When taken literally it means 'gentle courage' or 'the courage to be gentle' (*sanft* = gentle; *mut* = courage).

real existence must necessarily run counter to these possibilities. If indeed it is a positive manifestation of women's socialisation to find that it results in a lesser degree of aggression (and this is something I am coming to doubt more and more), then women must learn to mobilise more aggression each and every day in order to be able to combat the constraints of patriarchal organisations, whether in the family, the career or, as in this context, the artistic realm. The issue here is one of developing new forms of productivity, rationality and, if necessary (which it is), aggression. It is not a question of abandoning one aspect of the duality in favour of the other. The programmed thought-patterns inherent in such dualities seem to me to be highly suspect even if they are directed at a new goal, and even if in reality they may quite closely correspond to societal types. The academic sciences soon find a slot in revolutionary theories for this new 'potential' and new 'quality' everyone is talking about. They formally absorb these concepts, integrate them into an archaic frame of reference and deal with them in abstractions and language that are already on the way to becoming traditional.

Even when debating the prevalent theories, as I notice now in writing this, certain linguistic structures prove difficult to avoid and continue to manifest themselves. I am disturbed by the formal problems that show up while I am writing, when I am, so to speak, in dialogue with myself. What about academic language? We have to wade through it, it seems. We can expect many accusations, most of which we can ignore, but the charge of ignorance is not one to which we should expose ourselves. The rejection of every theory and every academic legacy expresses abstract hostility and puritanical celibacy; it is nothing more than irrationality and politically questionable anti-intellectualism. But we must keep a close eye on ourselves at all times, we must be careful at all times. There is only a very fine line between committed criticism and academic conformism. The battle must be waged on every front. The analysis of linguistic structures, imagery, the forms and symbols of behaviour and communication, is tough work which has hardly begun. If women are to succeed in freeing themselves from old patterns, in conquering new terrain and – finally to return to the subject at hand – in developing different aesthetic forms, they can do this only on the basis of their autonomy. Women's specific and unique experiences (so that knowledge can be experienced, not learned), rooted in their collective endeavours, are the preconditions for their success in any practical sense.

Schematically apportioning or redistributing 'qualities' by merely inverting or redefining them does not seem to provide a particularly fruitful answer to the question of women's creative potential. Nonetheless, I felt that discussion of theoretical proposals such as these would be useful, for two reasons. First, as it occurred to me while reading the Marcuse article, we are dealing with examples of how language and abstraction serve to widen *the gap between the concept and the object* in a manner which engulfs every instance of experience. The object rebels against this. This relates to the question, *How can the specifically feminine modes of perception be communicated?* The answer here may actually be in the examples of female creativity which already exist (i.e. in women's manner of looking at things, whereby I do not mean merely the aspect of visual perception suggested by the term), rather than in a premature programme of 'feminist aesthetics'.

And the second reason: in attempting to conceptualise female creativity, the old dualistic notion of the 'natural' and the 'artificial' is often evoked. If these concepts are taken in their trivial sense, then the principle of femininity is represented solely by the first. I have already alluded to the supposed naturalness of women. So here only a word in clarification. There is more behind the cosmetic industry than simply the idea of 'natural beauty'.

Such formulations suggest evasiveness on our part, suggest renunciation of all that is artistic, refusal of any attempt to use the media for our own purposes, denial of any aesthetic transformation. The verbal debate about this topic suffers greatly from linguistic inadequacy, with the result that in fighting with words one often loses sight of the tangible referent. However, perhaps precisely because of these obvious difficulties, it would be an act of sheer ignorance for women to neglect the aesthetic activities constituting an interesting aspect of our reality.

Difficulties arise when the notion of beauty is attached to an empirical woman. Marilyn Monroe was at one and the same time artistic product, myth of femininity and victim of an inhuman culture industry. We cannot posthumously dissect her into one natural and one artificial woman, leaving one part of her to Norman Mailer and turning the other part, clothed in jeans, into the figurehead of women's lib. The entire woman belongs to our side.

3. Digression II: On Feminine Beauty

Amazingly, it seems that even those images of femininity constructed by men or by the male art industry are turning against their creators in ever-increasing numbers. Having become mere commonplace myths, they are stepping out of their moulds, out of their literary or film contexts. I believe that their metamorphosis is not only the result of the new interpretation and effect they now have, due to the influence of the women's movement, it is much more dependent upon the fact that an element of female resistance, if only a passive one, has always contributed to artistic production. Mario Praz, for one, set out to learn about the uncanny from the *Belles Dames sans Merci*.[17] Olympia, Lulu, Nana, the Salome and Judith figures of the *fin de siècle*, Marlene Dietrich. . . . One need not engage in interpretational acrobatics to recognize the subversive disturbances instigated by these dangerous, wild women of history. In his lecture on 'Femininity', Sigmund Freud said to his audience, 'People have always pondered the riddle of femininity . . . [There follows here an insignificant passage from a Heine poem, S.B.] Those of you who are men will not have been spared this pondering either. It is not expected of the women among you, for you yourselves are the riddle.'[18] The possibility that women might experience and perceive femininity differently from men was often seen as a way of questioning, of posing an indirect threat to masculine art. Men's failure to comprehend this riddle was not, however, seen as their shortcoming. Instead, it was projected back onto women, seen as the eternal feminine mystique. But Oedipus did not solve the riddle of the Sphinx (that is only men's wishful thinking), though any woman could have. If women had been the ones to stand and stare in like amazement at the riddles of art – especially the one in which the feminine image is supposed to convey the idea of beauty, the one in which the riddle has been shoved off onto women – they could only have marvelled at the extent to which they had become a secret about which they themselves knew nothing. Treatises like those by Walter Pater and d'Annuncio on the smile of the Mona Lisa yield information about the riddle, abysses and revelations which they find crystallised in the image of woman. Of course, this pursuit was not concerned with empirical women but rather, for the most part, with images of women as created by male artists. It is possible that

the more sensitive artists, those who passed the riddle along to their contemporaries and followers, were already operating on the assumption that they would never be able to comprehend fully the truth about femininity. Instead, they limited themselves to dealing with only *that* part of 'universal' woman that was accessible to their individual dispositions, their sex and their sensory faculties. Through the centuries, culturally diverse standards of beauty have repeatedly re-established the status of the female body as object. On the other hand, adoration of masculine beauty, or of beauty as manifested in the male body, as we see with Michelangelo, was more rare and often clouded by the aura of homosexual desire. And an aesthetic theory measured in terms of the masculine model, such as Winckelmann's, only purports to glorify an ideal purged of such longings, even if generations of educators tried to make us believe otherwise.

> She looked at Amabel through his eyes. And saw everything in her escape them. Her poses and mannerisms, that were second nature, he would amusedly accept as so many biological contrivances. And if he thought her 'pretty' – sacrilege, even in thought, to apply to Amabel this belittling expression that at this moment I see as part of his deliberate refusal to take any kind of womanhood seriously and is not condoned by his protesting that neither does he take himself seriously – would play up to her as he does, as I have seen him do, with women who 'exploit' themselves; subtly conveying at the same time, to the simple female he saw behind the manoeuvres, that he knew what she was about and that she was doing it rather well. But perhaps he would not even think her pretty. (Dorothy Richardson, in *Dawn's Left Hand*)[19]

Women's identification with the aesthetic objectification of femininity has traditionally been misplaced. Only when the artistic figures embodying the principle of femininity broke away from the traditional patterns of representation and managed to avoid the usual clichés, could there be any real identification. Barring this, identification on the part of women could take place only via a complicated process of transference. The woman could either betray her sex and identify with the masculine point of view, or, in a state of accepted passivity, she could be masochistic/narcissistic and identify with the object of the masculine representation.

Causing women to conform mindlessly to the masculine image of

them is not, however, the only way in which men have helped determine women's image of themselves. This is because aspects of true femininity, instances of female resistance and uniqueness – though often in disguised form – have always been contained in the artistic product. These instances then appeared as indicators of the mysterious and puzzling nature of women.

Women no longer model their behaviour and appearance after such stereotypes. Those times are past. B.B.'s pout is no longer imitated. Nevertheless, the abstract negation of such standards of beauty (whether in the fine arts, in literature, film or even advertising) is still bound up with these very standards, just as Rosenkranz's 'Aesthetic of Ugliness' needed the idealistic conception of beauty as its counterpart. It is too overt and contrived to find beautiful *precisely* what is abhorred by conventional standards of beauty. Yet, if I am not mistaken, this very attitude reflects the feeling of many women today. Much is lost by thinking this way. The problem is further complicated when we find that artistic representations of femininity still serve as vehicles for a general debate about definitions of beauty. This means that we have to contend with continual crossovers from the artistic sphere to that of everyday life. Here again, merely reversing the values would be too superficial and contrived as to render a 'feminist conception of beauty'. This kind of show of power requires a lot of effort, but does not bring many results.

Rather than limiting ourselves in this way, we could expand our horizons towards genuinely feminist interpretations of female figures, like the attempts of some painters and action artists today. Female beauty can be won back from the celebration of consumerism by exploding the framework of masculine objectification and fetishisation of specific parts of the body, or the shape of noses. (We can then decide whether still to call this beauty, or whether to find a new word for it.) Here, we would not be merely inverting values, since body fetishism was never women's doing. Or has it ever been reported that sexologists discussed the collecting of men's shoes or underwear? In America (!) they have multicoloured, edible women's underpants, in assorted flavours.

For a long time – and I'm speaking now of our everyday life once again – women regarded their bodies in anticipation of masculine fetishisation, and allowed this to become the criterion for their own acceptability. The danger is that this criterion still exists, but now it

has become the standard for rejecting anything about the female figure that was once the object of male esteem. Sacrifice at the male altar continues.

Every century, within the framework of its particular standards of beauty, had its own favourite bosom and rear, so it is nearly impossible not to conform to one cliché or another. Especially in this regard, one finds little difference between the depictions by 'great artists', which have become frozen as norms, and the trivial dictates of taste handed down by the culture industry. But we should not underestimate the power of these beauty requirements, whether they are derived from art or from the petty fashion of the day. 'Would he still love me if I weren't beautiful?' asks the heroine in every eighth Hollywood movie, a question which has never been heard coming from a male actor pondering his relationship with a woman. This question is one well suited in making women even more insecure, in that it sets them wondering – usually unhappily – about whether or not they even possess the prerequisite for asking the question, namely beauty. Women's rage is absolutely justified. Those are the norms which have made our growing old intolerable and have caused the rift between us. It is time to disregard them completely, time to abstain from even their negative acknowledgement. This requires that women refrain from constructing their own set of trivial aesthetic norms, such as 'jeans are allowed but skirts are suspicious', 'red hair is fine but red fingernails don't make it', 'do I look too masculine or too feminine?' Setting up standards such as these, in negative reaction to masculine beauty fantasies, would merely limit our freedom once again.

4. The Myth Reflecting upon Itself.
Marlene Dietrich's Recent Appearances

A discussion I recently had in a women's group left an impression on me. Not long before, Marlene Dietrich, who is not exactly young any longer, was the solo performer in a gala television special in London. An artistic product came on stage, every movement perfected, every gesture precisely rehearsed, premeditated, every facial expression calculated for aesthetic effect. Every step, every movement of her head or hands – all these were spare, artificial. Added up, the details gave the impression that decades of experience lead to precision. Although she cannot really sing, the audience went wild over the

familiar old songs. In performance she was totally cool, faintly ironic, and even when she was portraying emotion everything was staged; she made no attempt to make the emotion appear genuine. When she sings – actually, it is more like talking than singing – she slurs, softens the refrains, but even this is not fortuitous. The pose is intentional. It says, you know this one already, I know you will be pleased if I sing it . . . And in the dialogue in between songs, familiar *kitsch*, reminiscences, the performer's stage biography blends with the biographies of the older members of the audience. For the younger ones it is already a legend. Behind her is an early picture of herself, only the head. Her face is older now, but even this change seems not so much the result of the biological ageing process, it seems much more something artificially arranged, a sort of dis-placement intended to signify historical distance. And her body is just as artificial, absolutely smooth as though encased in some unfamiliar fabric – we are watching a woman demonstrate the representation of a woman's body.

But back to the discussion. I was told it was all terribly sad, this woman dared not grow old, surely she had had her face lifted, a fine example of all the things women have let people do to them. The same old game, I agree, it is the same old game, but the rules have changed. The myth appears on stage and consciously demonstrates itself as myth. Just like in the zoo; the monkey is suddenly the observer, and the people are the ones standing and staring out from behind bars. All this has little to do with the actual woman whose real name most people have forgotten. Who knows how she looks in the dressing-room afterwards; who knows how we shall look at her age? That is another world. But the artistic figure, Marlene Dietrich, is interesting if for no other reason than because she is one of the few female performers who act by way of intellectual understatement and who managed to become a myth despite her subtle disdain for men. Now she comes on stage once again and demonstrates the process that turned her into a myth, a process she now rises above. Even reactionary theories of art always credited women with ability in the performing arts. This is to a certain extent true in that women, excluded from other opportunities, often used their bodies as vehicles for expressing their artistic impulses; they turned their bodies into artistic products. Many of them were destroyed in the process. But Marlene Dietrich, the cool one, triumphs. She alone controls the image to be projected. Whereas before an actress had to

satisfy the expectations of the audience, now the audience must conform to hers. The myth is on the receiving end and consumes the audience. She gazes down from the stage not once but twice, once as an image and once as an artist, as if to say 'OK, if this is how you want it . . .'

5. The Aesthetic and the Feminist Public Spheres

'The women who wished to be taken for men in what they wrote were certainly common enough; and if they have given place to the women who wish to be taken for women the change is hardly for the better . . .'[20] Virginia Woolf wrote this rather malevolent sentence in 1918, a time at which people in England were conducting heated arguments about the demands being made by the women's movement. The author did not entirely evade these feminist issues, even if her comments on this subject are pleasantly unorthodox. The quote contains an attack on the ignorance of formal problems in aesthetics – mistaking pamphleteering for literature – and raises the question of competence. Virginia Woolf's own works exemplify care and precision in dealing with linguistic material. She was an author who did not think that by simply recalling her female sex, her experience or nature or whatever else would dictate instant art onto the page. Of course women possess the potential and the right to do anything. It is indeed idiotic that we must emphasise even these old concepts of natural rights with regard to women. But a stick figure is a far cry from a Sarah Schumann painting. The combination of artistic ability with 'feminine' innovativeness is still a rare stroke of luck. Only the progress of feminism can make this happen more often and seem less exceptional, in all areas.

A feminine approach to art must include both aspects mentioned above. It cannot ignore the problems of what is aesthetically possible, the difficulties involved in working with artistic material, the matter of technique and of the intrinsic dynamics of various media, but neither can it ignore the question of the relationship between art and feminism.

Once before, it seemed as though a new age were dawning:

But here, too, women are coming to be more independent of opinion. They are beginning to respect their own sense of values. And for this reason the subject matter of their novels begins to

show certain changes. They are less interested, it would seem, in themselves; on the other hand, they are more interested in other women ... Women are beginning to explore their own sex, to write of women as women have never been written of before; for, of course, until very lately, women in literature were the creation of men.' (Virginia Woolf)[21]

And once before, these literary expectations were dashed, bound up as they were with the development of a new feminine self-consciousness and the hopes engendered by the women's movement. Once before, female artists were thrown back upon themselves and forced to rely upon a male-dominated public in order to get their works published or shown, in order to obtain even the slightest degree of recognition.

Thus far, I have found tangible instances of what might be termed female sensitivity towards writing (or towards painting, etc.) only in certain moments of female subversion, female imagination or formal constructs within various works. And I find these only when the specifics of feminine experience and perception determine the form that the work takes, not when some 'feminine concern' has merely been tacked on to a traditional form. The question directed at a painter of why she did not portray women's demonstrations or activities in her paintings is an objectively cynical and insulting one. Such a question reduces her work to the level of photo-journalism in weekly news magazines, something any man could do. The feminine quality of a work ought not be determined solely by its subject-matter.

The bridge linking the demands of the movement on the one hand with artistic activity and its concrete work with materials and media on the other is still very narrow. Thus, those women who are committed to both sets of demands face a terribly difficult situation. They are risking their fate to demonstrate that the gap *can* be bridged. Overcoming this opposition between feminist demands and artistic production is, even today, the special task faced by those women who dared to venture into artistic work and yet managed to avoid betraying their sex in the process, despite all the obstacles and resistance they met with. For them, the alternative of either 'real artist' or 'recorder of the movement's activities' can only seem a bad joke. It is risky to rely solely upon a public that is still in the formative stages of development – namely women – and that has not

always proven itself capable of making aesthetic judgements. Yet one can expect perhaps even less from the established art public, for they demand even greater willingness to compromise. For a long time the reigning men in this sphere, the big shots, critics and producers, willingly believed that art was an exclusively male province. (In fact, they still believe that today – they simply no longer advertise the fact!) Recently though, out of sheer necessity, they have conceded that art is androgynous in nature. (But even this in no way means that they consider women's works to be on a par with men's; their concession to androgyny is only a smokescreen.) But they will declare war on any feminist art that sees itself as something other than merely one odd variation among others cropping up on the currently bleak artistic scene. If women view their art as something produced by women for women men will fight it, if for no other reason than because their aesthetic yardstick is unable to measure a phenomenon such as this. Patriarchal blinkers cannot be taken off at whim.

6. The Pre-aesthetic Realms

Even in the past, I contend, the exclusion of women from the artistic realm could not extinguish all their aesthetic needs. These creative impulses, however, were shunted off into the 'pre-aesthetic realms', where they evaporated under the strain of women's daily routine. Women furnished the living quarters, set the tables, arranged, decorated and adorned their clothing, and above all themselves. That was allowed, as long as it was being done to please the man. These activities quickly corrupted women. They set the table for the man, they dressed and adorned themselves for the man – not for themselves or for each other, but rather in competition with each other. They busied themselves weaving and knitting, but such functional artworks, handicrafts and decorations have always been considered inferior, commonplace. This verdict is of course not entirely unfair, especially in those cases where even these most timid efforts were channelled into subservient obsequiousness and excessive affection-seeking.

> Once when I visited Buddy I found Mrs Willard braiding a rug out of strips of wool from Mr Willard's old suits. She'd spent a week on that rug, and I had admired the tweedy browns and greens and

blues patterning the braid, but after Mrs Willard was through, instead of hanging the rug on the wall the way I would have done, she put it down in place of her kitchen mat, and in a few days it was soiled and dull and indistinguishable from any mat you could buy for under a dollar in the Five and Ten.

(Sylvia Plath, *The Bell Jar*)[22]

Here the ambivalence once again – on the one hand we see aesthetic activity deformed, atrophied, but on the other we find, even within this restricted scope, socially creative impulses which, however, have no outlet for aesthetic development, no opportunities for growth. These impulses could not be concretely realised, nor could they lead to an artificial desire to experiment.

It is true that these activities never had to become static, unchanging artistic norms. They never became obsolete products, they remained bound to every-day life, feeble attempts to make this sphere more aesthetically pleasing. But the price for this was narrowmindedness. The object could never leave the realm in which it came into being, it remained tied to the household, it could never break loose and initiate communication . . .

But what would happen if someday we cleared out this realm and opened it only to ourselves and other women? What if we alternated painting our faces with painting on canvas? What if we turned recipes into poetry? What if all these activities were to shed their utilitarian rationale of male approval?

The old one was the first self-made
Grown too large.
The wound up time of urgent experience
Still fills it out.
Weeks of work and sensuality
Not divided into days and nights
Alone or entwined with many others.
The increase and decrease of tension
Attests to density in memory.
Fetched forth again the largeness appears, tucks bear witness:
 from the beginning.
Grown thinner, experience more fragmented
The smooth stitches turn into difficult cable,
Growing upward, lending strength.

Though I knitted narrow strips of blue into the grey,
There was hardly enough wool.

> *(On unravelling and reknitting a sweater,*
> (Ann Anders, 3 September 1976)

Perhaps that is all too simple, too superficial. Attempting to knit the gap between the artistic realm and social reality is problematic in that this gap is not simply the result of foolish blunder but is rather the result of particular preconditions.

However, it can be proved that women succeeded in entering the artistic realm when they gained access to it via the adjoining 'pre-aesthetic' realms. In the eighteenth century women were able to enter the realm of literature by means of letters (the epistolary novel), since this was an age in which letters and novels were gaining dignity and the dissolution of rigid formal rules allowed greater flexibility. Experience could be gained in writing private letters. Since letters and diaries have no clearly defined literary niche, it was all right for women to practise on them. Only the Romantics considered conversation – another feminine domain in literature – to be aesthetic activity. The letters of Caroline Schlegel are true master-pieces of mixed aesthetic form: wardrobe descriptions alternate with philosophical discourses, gossip with literary quotations, allusions and criticism. Men were amazed by the new tenor, the new tone, the irreverence and more sensual descriptions unique to women's letters, and on occasion they even showed open admiration. It did not take long for this medium to be included in the literary canon.

However, it is difficult simply to go back, optimistically to take up again those 'feminine' media – letters, weaving. It is, in fact, almost more difficult to do this than to work with the 'unfeminine' technical media such as film, since these need not contend with being traditionally relegated to the domain of the housewife. We should not foster the false assumption that our sewing teachers indeed pointed us in the right direction. There is no direct path from the decorative potholder to the tapestries of Abakanovicz. Besides, I am still horrified by the whole ruffles-and-sewing-basket business we were subjected to as young girls.

I believe that feminine artistic production takes place by means of a complicated process involving conquering and reclaiming, appro-priating and formulating, as well as forgetting and subverting. In the works of those female artists who are concerned with the women's

movement, one finds artistic tradition as well as the break with it. It is good – in two respects – that no formal criteria for 'feminist art' can be definitively laid down. It enables us to reject categorically the notion of artistic norms, and it prevents renewal of the calcified aesthetics debate, this time under the guise of the feminist 'approach'.

If, however, women have different assumptions with regard to their sensory approach, their relationship to matter and material, their perception, their experience, their means of processing tactile, visual and acoustic stimuli, their spatial orientation and temporal rhythm – and all these things are what aesthetics meant at one time, according to its original definition as a theory of sensory perception – then one could logically expect to find these things expressed in special forms of mimetic transformation. Put emphatically, this would mean that within the framework of a female cosmology there would be a changed relationship between the subjective artistic appropriation of reality on the one hand, and formal suggestiveness and receptive perception on the other. But it will be nearly impossible to find categorical evidence for this changed relationship: reality is not that logical, and there is no female cosmology either.

And yet, there can be no doubt that the realm of female experience is sociologically and biologically different from that of the male ... Is feminine sensitivity best expressed by a particular fragmented form or through strict unity? In circles, oval blocks or through a striped, filagreed pattern? Through sensual surfaces or through a subtle sense of colour? The images, the choice of theme, even the intentions behind the application of these forms or similar ones in video, film, dance – all these are merely superficial indicators of a more fundamental difference. I count myself among those who are convinced that this differentiation exists, and yet for every case that I can specify there are innumerable others that defy such specifications. (Lucy Lippard)[23]

There is no proof of a different (female) relationship to detail and generality, to motionlessness and movement, to rhythm and demeanour. At present, this is all still conjecture. I find the only sensible approach to be the search for evidence within individual, concrete texts (pictures, films, etc.) as Virginia Woolf once attempted with Dorothy Richardson's writing:

She has invented, or, if she has not invented, developed and applied to her own uses, a sentence which we might call the psychological sentence of the feminine gender. It is of a more elastic fibre than the old, capable of stretching to the extreme, of suspending the frailest particles, of enveloping the vaguest shapes. Other writers of the opposite sex have used sentences of this description and stretched them to the extreme. But there is a difference. Miss Richardson has fashioned her sentence consciously, in order that it may descend to the depths and investigate the crannies of Miriam Henderson's consciousness. It is a woman's sentence, but only in the sense that it is used to describe a woman's mind by a writer who is neither proud nor afraid of anything that she may discover in the psychology of her sex.[24]

Dorothy Richardson on the masculine manner of writing[25]:

The self-satisfied, complacent, know-all condescendingness of their handling of their material . . . The torment of *all* novels is what is left out. The moment you are aware of it there is torment in them. Bang, bang, bang, on they go, these men's books, like an L.L.C. tram, yet unable to make you forget them, the authors, for a moment.

The exclusion of women from vast areas of production and the public sphere has directed women's imagination along other lines, not to speak of women's responsibility for the biological and social reproduction of the species, as well as the economic, if they are working. Moreover, the much touted ahistoricity of women kept the polarity between intellectual labour and manual labour from becoming too traumatic. The disparate development of the sexes, though origin of so much of women's suffering, fortunately has not yet allowed women's behaviour and needs to become reified to the degree found in advanced capitalism. But generations of women paid for this with their banishment into the marital ghetto.

Is there a feminine aesthetic? Certainly there is, if one is talking about *aesthetic awareness* and *modes of sensory perception.* Certainly not, if one is talking about an unusual variant of artistic production or about a painstakingly constructed theory of art. Women's break with the formal, intrinsic laws of a given medium, the release of their imagination – these are unpredictable for an art

with feminist intentions. There is, thank heavens, no premeditated strategy which can predict what happens when female sensuality is freed. Because it is a process and historically tentative, we cannot verbally anticipate this freeing of feminine sensuality either at its traditional erotic centre (even though there's a lot going on there every month) or in the context of individual choice. We can do it only on the basis of a movement by women for women. Art should become feminised, and women's participation (limited by men to their sensuality alone) would do it a lot of good. Perhaps, then, our male colleagues would not need to proclaim the death of art one year and recant the next. But that is only peripheral here.

It is also premature to revel in women's spontaneous activities, such as their parties, as if they represented a new, 'vital' aesthetic, totally different from the aesthetic of objectified art products. (This would be analogous to the slogan of the student movement that art would henceforth take place in the streets.) Women will know how to resist the imprisonment of their imagination in the artistic ghetto, not because this fits into their 'aesthetic programme', but rather because, whereas terminology may fail, this imagination constitutes the movement itself.

The predisposition to feminine/sensual cognition and perception becomes most apparent in women's collective actions which in their appearance rise above the ordinary. Let us be wary of methods, however. These actions would be quickly coopted as manifestations of living or body art, or body language. Feminist art is not a stylistic trend. Women's actions or demonstrations are not artistic events. The relationship between political actions and art – as well as the reflecting upon this relationship – cannot operate on the level of traditional leftist animosity to art. Nor can it exist on the level of apolitical esoteric views of the type which allowed a demonstration for legalised abortion to be interpreted as a rebirth of the 'happening' scene. The point here is neither to rescue the notion of the 'beautiful illusion' nor to over-extend the concept of aesthetics, a term which by definition already encompasses all activity and hence has become totally meaningless. The important thing is that women artists will not let themselves be kept back anymore. They work on canvas, they make films and videotapes, they write and sculpt, they work with metal and with fabric, they are on stage . . . So let us take a look at what they are doing.

2
Elisabeth Lenk
The Self-reflecting Woman
for Karin Kersten

Is there a feminine aesthetic? I've been keeping an ear open but haven't come up with much so far – just a slightly ironic remark about Berthe Morisot's babies, and a joke about the 'Moaning Lisa'. I've also had the strange experience of finding that there are art buffs who become positively furious at the mere mention of Sarah Schumann's name. There seems to be something there which can't be understood in terms of taste, standards of painting, etc. And so I've decided to defend this something, although I don't really know what it is.

The 'feminine' is on the move. It can no longer be reduced to a set of attributes, let alone to an unchanging character structure. And so a feminine aesthetic cannot simply be the return of typically 'feminine' elements of art. In the eyes of men, a feminine aesthetic doesn't exist. At the moment, it is only a subversive process, a dynamic which is at once productive and threatening – productive because women are beginning to take command of their fantasies; threatening (to the establishment) because the seemingly immutable woman, the pillar of patriarchal society, the foundation on which men have stood for so long is on the move. This underground movement accompanies feminism, but it is not simply identical to it, just as aesthetic action is not the same as social action.

The new woman has two quite different faces – the one turned towards the world of men cannot be neutral or detached enough, because women still have to fight every day for the most elementary justice, and for that they need the strength to dispute as well as cool determination. The other face, turned towards women, is not a face at all, but the movement I spoke of. And I'm not forgetting the social misery of women when I now try, very subjectively, to describe

how she surfaces into the aesthetic sphere.

In man-made art so far, and in similarly man-made aesthetics (from Classical times to Breton and Adorno, to name only two writers whom I like and know), the so-called enigma of beauty has been inextricably linked to the enigma of woman, and perhaps I feel so close to these two writers because they come very near to solving the enigma which is no enigma – but they only come near to it, they do not succeed. Breton quotes Nadja: 'I am the thought over the bath in a room without a mirror.' The woman, Nadja, is certainly no longer a lifeless object, but she still does not relate to herself. She is body, and thought hovering over body. Dreaming, she lingers in the mirrorless room so that the Other, the man – that is, the artist – can take possession of her fantasies.

And now here's Adorno:

Even if the enigmatic quality of art seems to be secondary to the representation of experience, that enigmatic character will still erupt. It is this which gives works of art their significance. It is this which stares out at us from archaic images but is hidden from view in traditional art because of the conventions of artistic language. (*Theory of Aesthetics*)

Artists and art buffs gazed in delight at surface appearances, at natural phenomena, at the body, and tried to decode them as if they were hieroglyphics, an unspoken language, because they thought the image could not be sufficient in itself.

When women start to conquer the aesthetic space, when the pretty, silent picture disintegrates of its own accord, then the enigma which is no enigma must necessarily be solved, dissolved and demystified. But the enigma is not where men have for so long suspected it to be – in the fetishist gaze at the image, in contemplation. (See Gisela Dischner's essay, 'Socialisation theory and materialist aesthetics' in *The Powerlessness of Reality*, Berlin, 1975. She approaches child-socialisation and art production from the point of view of the *process* at work rather than the final product, that is, the 'ego' or the work of art, respectively.)

Modernist art reached this limit of contemplation of its own accord. And, since then, all art can do is to make it clear that it has come to a full stop and to accuse itself of not being able to progress. The actions of action art have long since petrified into museum

objects. It is as if the horizon – or is it the consciousness? – of artists had been nailed down – something the, a member of the Dusseldorf 'zero' group of modern German artists, artist Günter Uecker very clearly demonstrates by the compulsive and zombie-like gesture of hammering nails. (Hammering nails is, by the way, an archetype of masculinity. Is this ballet to go on forever, this *pas de deux* between the nail and the needle?)

The dehumanising character of art can perhaps disappear only when woman stops being that strange, alienated being who can be circumscribed by the gaze. In woman's new relationship with herself she is Many, or rather she occasionally melts for moments into pure movement. In these moments femininity is as distanced from her as masculinity and the world of stereotyped sex characteristics. It is this movement, which for so long was a dream-like movement, which expands wherever it wakes into consciousness; an external action which becomes internal and thus a mirror-image action, an action which reverses sides as a mirror does. It is aesthetic action.

The woman's body is, so to speak, no longer a blank page but a written one – one which can even read. (See *Speculum de l'autre femme*, (Paris, 1975), by the feminist psychoanalyst, Luce Irigaray.)

We've already glimpsed the new woman a number of times. But wasn't it only men who have caught sight of her so far? Today five women are standing at the edge of a desert, holding a telescope and camera, but also paintbrush and pencil. They are looking at the fata morgana with scepticism but also with optimism. For the time being – but confidently – they call what they see (and each one sees something different) the 'new woman'. Before they have even considered whether there can be such a monster, such a crossbreed, such a deviant creature, they have started to film, paint, write and dream her. And now, on the dune opposite, five more women can be seen. The field of vision expands and simultaneously contracts. And soon the desert, the blindingly bright desert, is black with groups of women standing on the dunes. They are all looking at the fata morgana. And looking at each other too, trying to find out how the woman opposite has imagined the fata morgana. This is a shimmering image because in the desert, in the white infinity of the desert, every tree, every copse of trees and so every group of women seems to shimmer.

Now the five women are tired. They sit down at the edge of the desert. They do not talk, they do not think, perhaps they doze off for a while – yes, they doze happily in the sun. There aren't any chairs in

this part of the world so it can't really be serious when one of the five quietly chants: 'Is there then no chair, chair, chair/ For my Clare, Clare, Clare.' The five reclining women (for, as I said, they have got used to not sitting in these far-off parts) wake up with a start. Something has moved on the horizon. Immediately they grab their telescopes, cameras, pencils, anything that is telescopic. What they see is a group of five women, each one heavily laden with olive wood like a pack-ass, approaching slowly. The five women see their past in these other five women: oppression, slavery, resignation, everything they hate. They suddenly have a bad taste in their mouths, feel like tourists; they are tourists. They return as quickly as possible to their home country but cannot forget the fata morgana.

I'm tired, although I was fresh just a while go and the day is only just beginning. Is it writing that tires me so much? Perhaps it is all the false gods in me which I'm accusing as I write. I am also accusing myself because I have educated myself and gained strength from living up to them. I have believed in culture, education, art. I have felt a great sense of achievement when I've managed to live up to my idols, and devalued when I did not. At times I have sensed that I stand outside society, that as a woman I am excluded; that all women are excluded. I tried to avoid this uneasiness, I tried to enter society, to be inside it, but when I succeeded, it was only as a sexless object, not as a woman. Perhaps because I am touching on this unpleasant state of affairs, touching on something in myself, I grew tired so quickly, although I was wide awake when I got up. 'I cannot shake the fatigue of nations from my lids.' One of my idols wrote something or other like that. All this forgetting exhausts me. Karin, to whom this is dedicated, understands me. The men of culture *are* culture, even if they revolutionise it. It remains an object for us, a pile of things we can play with, or a strange head we can balance on our own head.

The aesthetic cannot be separated from the erotic. And yet I want to keep them separate. The erotic is fickle, just like luck. Often, when ecstasy is at its highest, we crash back down to earth. We are totally dependent on transitory moods. The erotic peaks and falls at tremendous speed just like on the helter-skelter, and eventually I arrive back at the starting-point completely drained, exhausted. Perhaps it's also because feeling moves so terribly slowly . . . But I want to keep the aesthetic and the erotic separate precisely because there are these peaks and falls, these endlessly long, dull, desolate days. The aesthetic encompasses all experience, even the insipid,

dull and boring; the erotic on the other hand focuses on events. The aesthetic can even flourish in boredom. It does not drive boredom away for that would be merely distraction; rather, it extends it. It is the power to heighten boredom so that it becomes unbearable.

Gertrude Stein's style, for example, was never aroused, never enthusiastic in the usual sense of the word. 'Never without one/This might be sometime/Just as if they *knew/This might* be sometime/ Some time' (Gertrude Stein, *How to Write*).

Women are experimenting with the erotic. This gives them the temerity to believe that a new aesthetic and even a new human being is in sight. Until now women have participated only passively in the aesthetic, and in two ways. They were passive members of the audience and also its most despised ones: the addressees of boulevard pieces, of an inflated family literature. But they were passive in another sense, too, because they had to bear the brunt of being the ideal of beauty. Women had to be beautiful, or at least fascinating. The woman who knew how to 'catch a man', whether in the salon, at a ball or even in the street, could call herself lucky, and all the others tried to imitate her even though they were not so 'richly endowed'. Even the first attempts at education were devoted to this goal. The intellect was a kind of ornament, and woman was supposed to let it sparkle like her opals and diamonds in order to be fascinating. As a beautiful, fascinating woman she obeyed the aesthetic of the strong. Every woman identified herself with the inscribed imperative of out-doing every other woman. She had to be the centre of attention, the most beautiful, the most entertaining woman. Even in the new world of love of Charles Fourier, who certainly wrote some of the most radical critiques of the traditional love relationship, there are still echoes of this concept.

By this I mean a conventional concept of the aesthetic (although this is still to be found in the papers' arts pages) which works with superlatives, with ideas which are supposed to express the great, the exceptional, the special, the significant. Here people still talk of styles establishing themselves, of masterly works of art, etc. I believe the concept of greatness has been a misunderstanding in aesthetics right from the beginning. The prosaic critics thought that the authors and their works were great, while in reality the object represented did not have any human dimension at all and so gave the impression of being larger than life, of being great. You can see what I mean in any carnival procession. You'll see all the beer-bellies in

fancy-dress of course, but there are also the giants.

One such is the housewife in Chantal Akerman's film *Jeanne Dielmann*. Psyche, who is adored by twenty men, falls in love with Narcissus, who is adored by twenty women, and he falls in love with her. Their first move to escape the old egoistic love relationship is that they must both satisfy their admirers before they themselves can get together. Yet Psyche and Narcissus are no less the traditional couple for all that. They are the old fairy-tale figures, the prince and the princess, and will only disappear when the hierarchy within has disappeared.

The king has survived the downfall of kings in the shape of the internal king. The hero of daydreams and novels, said Freud, is 'His Majesty, the ego'; and Flaubert: 'In the heart of every one of us there is a Hall of the Kings. I have walled it up but it is still not destroyed.' The whole internal architecture is based on this perhaps only fictitious presence. 'And finally, freed from its bonds/The sea will engulf the empty tower.' (Novalis, in his utopian poem, 'I know where a castle stands . . .').

I'm going to tell you a story now; it's the scenario of a film the Canadian Sylvia Spring made many years ago. A woman (let's call her Madeleine) is living with a revolutionary. She would like to paint but does not because the revolutionary says the most important thing at the moment is the revolution. The woman is quite lonely. In her loneliness, she fantasises. She always fantasises about the same things – a landscape, and in this landscape a fool, a rather mad, beautiful, cheerful boy with whom she can play (the revolutionary is too serious for that). One day she sees a young man who is identical to her fantasy of the fool. She goes up to him and says: 'I know you.' The salesman (for he is a salesman) is rather surprised but takes the opportunity. . . . So far so good. I don't want to go into too much detail. She leaves the revolutionary and paints. What I really wanted to tell is the ending. On an LSD trip – the film was made in the 1960s – she has the old fantasies again. She sees one of the vast landscapes and the fool. She runs after the fool, taps him on the shoulder, he turns round and she discovers that she herself is the fool.

Woman is beginning to relate to herself. The woman who attracted everyone's gaze was only apparently narcissistic. In reality she did not exist for herself but only for others. And what was even sadder and left this fairest of all women so empty was that others did not exist for her. This woman was purely passive, an object

only. She was loved, but she herself did not love; she was seen, but she herself did not see.

The relationship of woman to herself can be explained by the mirror – that is, the gaze of others, the anticipated gaze of others. Ever since ancient times woman has asked the anxious question of her fairy-tale stepmother: 'Mirror, mirror on the wall, who is the fairest of us all?' And even then, when the gaze of others is replaced by the gaze of one other, of the husband or the lover, the anxious question is still asked. There are still the terrible moments when woman searches for herself in the mirror and cannot find herself. The mirror-image has got lost somewhere, the gaze of men does not reflect it back to woman.

Woman can only develop her new relationship to herself through relationships with other women. Woman will become the living mirror of woman in which she loses herself in order to find herself again. The relationship of woman to herself which will emerge from this is so new that it cannot be defined yet. It is a relationship that repeats hundreds of old relationships but is not equivalent to any one of them. Now it resembles childhood friendship, now lesbian love, now the relationship of the troubadour to the lady and the lady to the troubadour, not to mention all the family relationships which pass by. You can get a feel for this in the letters that Virginia Woolf (aged twenty) wrote to her friend Violet Dickinson, who was fifteen years her elder. She calls her successively 'wife', 'my wife', 'aunt', 'my child'. Woman expands, she becomes manifold; she is in turn the whore, the pimp and the corruptible judge of both, she is the circling bird of prey and the victim; yes, she is even the sky which is reflected in the sea.

Woman often believes when she enters into this relationship to herself for the first time, when she first reflects herself, that she has gone mad. But this apparent madness is no madness; it is the first step towards sanity.

It is only sad that the lot of men who are temporarily deserted and superfluous now appears to be so dismal. Sometime in the future men will be divided into the foolish and the wise, as the virgins are in the Bible. The foolish will despair, they will gnash their teeth and mock, and hope that the old relations will be reinstated. The wise will polish their lamps and wait.

The turmoil of roles does not end in madness because woman now has a living mirror instead of a cold, inanimate one. A fluid

relationship now replaces romantic-imperialist love. Neither in the erotic nor in the aesthetic are there any sharply defined alternatives any more. We slide unnoticeably from one form into the next, from friendship into love, from love to quarrelsome childishness and back again, from the letter through a compulsion to rhyme in ballads and doggerel, and from there sometimes to the endlessly psalmic song of languor.

The sexes are going their own ways. They are no longer living past each other, but are moving away from each other at last! For women need space for what is only to be found in their imagination.

3
Sigrid Weigel
*Double Focus:**
On the History of Women's Writing

1. The History of the 'Second Sex'† in the Male World Order

Feminist literary criticism investigates the consequences of the patriarchal order for the aesthetic representation of women in literature written by men (that is, *images of women*) as well as for the possible existence and actual examples of literature written by women (that is, *women's literature*). This division into images of women and women's literature is merely a conceptual aid; it should not lead to a schematic confrontation between 'masculine' and 'feminine' culture. Instead, it should allow a detailed investigation into the relations between the two and prompt the questions: How far do the images of women in male discourse and male poetics take women's social and individual reality into account? And, Does women's literature reproduce these images of women or does it liberate itself from them, and if so, how?

The attempts (which have become much more vigorous over the last few years) to reconstruct the *cultural history* of women should no longer be content with just filling in the blanks on the map of literary texts wherever a woman's name was 'forgotten'. They should not build a *museum* of earlier model women and heroines (or victims) with the aim of proving the falsehood of women's supposed lack of culture and history, a museum in which all the 'sisters of

* The chapter title is full of ambiguities. 'Der schielende Blick' can mean 'the cross-eyed gaze', 'the surreptitious gaze out of the corner of the eye' or 'the gaze directed in two divergent directions'.

† In the German this is 'das andere Geschlecht' which means literally both 'the other sex' and 'the different sex'. It is clear that Weigel is referring to de Beauvoir's book *La Deuxième Sexe* (*The Second Sex*).

yesterday' are exhibited, who – in spite of all that men say – *did* manage to write, think, work, celebrate, or even be politically active.

Because the impoverished tradition of women's culture is not only a consequence of the meagre cultural production of women but also the result of male norms and attitudes as to what constitutes tradition, any consideration of women's history must necessarily be linked to a critique of existing literary theory and history. We should, however, be wary of separating the laborious search for the remnants of sources from the formation of theories and concepts. A 'certain positivist thrust', instead of promoting a sensitive search for the traces, seems to me to be harmful. All too many heroines whose biographies are more characterised by the wishful thinking of their creators than by the life of the woman in question are put before us nowadays. On top of this there is now a mass of theoretical contributions on the themes of feminine aesthetics, productivity, writing and cultural history which for the most part ignore the actual texts and tend instead to be programmatic. The anticipation of a liberated female culture in feminist theory runs the risk of becoming normative if it does not follow the way shown by criticism of women's existing aesthetic expressions. To take just one example: the image of Ida Hahn-Hahn as a scurrilous aristocratic writer created by male literary criticism can be found side by side with theories which talk about the search for a 'female space' without considering Ida Hahn-Hahn's strategies, which had precisely that aim. Her image, drawn according to male bias, does not meet with feminist theory. This separation of theory and positivist research into the sources is particularly characteristic of German feminism.

The *partisanship* of feminist literary criticism must not be allowed to take the form of voluntarily sorting the sheep from the goats, that is, taking care of the goodies and leaving the baddies to the mercies of male criticism. This partisanship is far more productive if the texts and biographies of real women – their contradictions, problems, their mistakes and even their failures – are read and examined as material women can learn from. A text which we discover in some dusty archive is not good and interesting just because a woman wrote it. It is good and interesting because it enables us to come to new conclusions about women's literary tradition; to come to new insights about how a woman copes in a literary form with her social position, the expectations attached to her role as woman, her fears, desires and fantasies, and which strategies she developed in order to

express herself publicly in spite of the confinement in the personal and the private.

Women are not without a history, they do not stand outside history. 'They are within history in a special position of exclusion in which they have developed their own mode of experiencing, their way of seeing things, their culture.'[1] A new (feminist) analytical and interpretational effort is needed if these are to be reconstructed. The theoretical and methodological steps towards this must start with the historical phenomenon that women are seen as the 'second sex'[2] and that they see themselves to be such. Here, second is not meant in the sense of comparison or otherness but in the sense of inferiority: men are the first, the authentic sex. Women are always defined according to male criteria as regards their characteristics, behaviour, etc. Woman in the male order has learnt to see herself as inferior, inauthentic and incomplete. As the cultural order is ruled by men but women still belong to it, women also use the norms of which they themselves are the object. That is, woman in the male order is at once *involved and excluded*. This means for woman's self-awareness that she sees herself by seeing *that* and *how* she is seen. She sees the world through male spectacles. (The metaphor 'spectacles' implies the utopia of a liberated, unhindered gaze.) She is fixated on self-observation refracted in the critical gaze of man, having left observation of the external world to his wide-ranging gaze. Thus her self-portrait originates in the distorting patriarchal mirror. In order to find her own image she must liberate the mirror from the *images of woman* painted on it by a male hand.

The metaphor of the 'mirror' – its reverse side and edges, its splintering and 'doubling' effect – is now commonly used to describe female self-awareness controlled by the male gaze. However, the 'search for evidence within individual concrete texts (pictures, films, etc.)' which Silvia Bovenschen in her article 'Is There a Feminine Aesthetic?' postulated in 1976 has been undertaken only hesitatingly and sparingly. There are still very few precedents for an investigation of this mirror relationship in the *actual* writing by women – that 'complicated process involving conquering and reclaiming, appropriating and formulating, as well as forgetting and subverting.' In the following pages I would therefore like to consider a few actual examples of women's writing – necessarily rather disparate – looking at the writers' relation to the dominant image of woman, the strategies they developed within the context of the mirror-image and

how they related to their existence as the 'second sex' in the male order. But before that I shall look at the methodological basis of such an investigation.

2. *Women's Culture and Other 'Other Cultures'*

There are more 'other cultures' than women's culture and so it seems sensible to start by seeing if we can learn from their experiences, their concepts and analyses, the form they take, and to see whether their methodological assumptions can be adopted. For example, there is Lenin's 'two cultures' theory which defines proletarian culture as opposed to the bourgeois; the 'alien culture' theory used in investigations into national or ethnic difference, particularly with regard to the peoples of the 'Third World'; the category of 'sub-culture' used as a term for the excluded and oppressed groups within the spatial and temporal context of a ruling culture; and the concept of the 'outsider'. It cannot make sense to use the category of 'outsider' to describe women's culture because of the sheer numbers of those concerned. It is merely a logical distortion when Hans Meyer[3] considers *images* of women rather than the women themselves in his investigation in which he subsumes women, homosexuals and Jews under this category. In discussing mythical, art-historical and literary female figures, he unhesitatingly merges these with the biographies of actual women.

Many forms of women's expression have a shadowy existence similar to that of a 'sub-culture' against which the ruling culture constructs a defence just as it does against the phenomena typical of a 'sub-culture'. But women's culture cannot be subsumed in this concept either, because there is an elementary contradiction between women's importance in producing and reproducing material and social life on the one hand, and women's marginal cultural position on the other. This fact, and the dialectical relation between the gender roles (which corresponds to the similarly dialectical relation of the proletariat to the class opposed to it) highlights the theoretical relevance of a Marxist class analysis and also of the Marxist idea of the development of the proletariat as a class in itself. Yet man and woman's bond as *sexual* beings contradicts the social dichotomy of their existence. The complicity of women with a representative of the ruling culture in a sexual relationship is an important factor in the fateful enticement and bondage of woman into the patriarchal

order which undermines the assertion of a (second?) female culture.

There seem to be more similarities with the theory of an 'alien culture', or, more precisely, with the relationship between the coloniser and the colonised. This, too, is the product of an historical process which appears to be inevitable. Just as the 'colonisation of minds' (F. Fanon) changes and destroys the alien culture, so the inculcation of patriarchal values in woman represents to her the danger of assimilation as soon as she rises into (while still within) the male order. Feminist history's mistrust of the methodological impetus coming from recent ethno-anthropology and psychology cannot be too great. Their investigations are for the most part conducted by members of the colonising peoples and written out of a fascination with the 'natives', redolent of the fascination of the innumerable male theoreticians who participated in the discourse about the 'nature of woman' and who thought they could discover all the lost and alienated capacities and qualities in the other sex (or in the alien people), so making of woman a natural being whose only value for culture lay in her naturalness. But unlike the colonised, women cannot resist by drawing on memories of an autonomous, pre-patriarchal culture. They do not have any collective memory of a mode of existence independent of the patriarch/coloniser. And even if women could remember alternative existence, it would still be one based on the relation to the male sex. There are very few traces – but perhaps that means no more than that very few have been discovered – of the actual existence and utopia of man and woman living side by side in equality, without domination. Feminist investigations into the special *modus vivendi* of women who are both participants in the existing culture but also excluded from and oppressed in it must start with a healthy distrust of all conceptual and methodological tools which are of non-feminist origin.

3. About the Detours on the Route from Writing Women to Women's Writing

When reading women's literature the *modus vivendi* of the second sex should be seen as a problem of *perspective* (the perception and narrative mode of the writer). The image of woman presented in the text, or the woman's self-awareness, is the expression of an accepted artificial relationship to the male idea of 'femininity'. A reinterpretation of female experience when reading women's literature can

only succeed if the detour via the male idea is taken into account.

The content and narrative mode of women's writing cannot be called original expressions of female experience *tout court*. Rather, they are attempts to find some leeway within male culture and steps towards liberation from it. The beginnings of the female literary tradition are primarily inauthentic* self-expressions of women'; expressions of the second, not of the first sex, and so are not genuinely autonomous expressions. The goal of an undistorted women's literature will not be reached until women can say 'I' in public without having first to acknowledge the male definition of their gender role. The history of a female literary tradition can be described as the step-by-step liberation of writing from the male perspective to an authentic women's writing and language.

So many of the discussions about whether there is a specifically *female way of writing* have gone round in circles, getting nowhere, because women have not used the words 'woman' and 'feminine' unambiguously; they have spoken about women's cultural expressions in a completely ahistorical manner, confusing the *ideological, empirical* and *utopian* meanings of 'feminine'. That women write 'differently' from men can be proved and disproved by an equal number of examples. The question of whether the counter-examples are exceptions – in fact, the attempt to establish empirically a difference in writing at all – seems to me to be meaningless in itself. Of much more significance to me is the question of whether women have found their own cultural niche, whether, because they write differently from men, they have developed a way of talking which reflects their desires and experiences, or whether they submit to the pressures and temptations of the male image of women. The empirical observation that women write differently is therefore only a starting point for the question of whether this different writing is equivalent to following the prescriptive pattern defined in the discourse about the 'nature of woman', or whether it strives after a utopia of another but autonomous femininity. Of course, this alternative exists only in the abstract formulation of the question

* In the German this is *uneigentlich* which has two meanings: 'not being true to oneself' and 'not being primary'. I have chosen to translate this as 'inauthentic' (and therefore 'eigentlich' as 'authentic') following the English translation of Heidegger's *Being and Time*. Weigel implicitly draws on Heidegger. (See *Being and Time*, trans. by Macquarrie and Robinson, London, 1962.)

and not in the text itself. For a text, so long as the author lives in a patriarchal culture, will never present the dominant image of woman or the 'new woman' alone. A literature which gives voice to woman's predicament as the inauthentic sex cannot (yet) be sufficient.

Because individual women writers in the past have reacted to the dominant ideas of 'woman' affirmatively, critically, protestingly, or by offering a counter-model, this has led the literary history of women to be wrongly divided into *phases*. Elaine Showalter, for example, sees first, the phase of imitation and internalisation of male norms (the 'feminine' phase); secondly, the phase of protest ('feminist'); and thirdly, that of self-fulfilment ('female').[4] Even if you do not consider these phases to be an accurate historical chronology, they still prove inadequate when interpreting most texts because a large amount of the literature written by women is highly *ambivalent* about the image of woman it presents. The relation of woman's individual self-fulfilment and cultural self-assertion has evolved in a very contradictory way. The literature written by women since the eighteenth century offers ample instances of contradictions between, for example, the public sphere and liberation, between various genres of writing, between programmes of emancipation and fictional fantasies, between intellectual emancipation and romantic love, between external conformity and subversive escape.... None of the women from whose biographies we now (have to) try to piece together the mosaic of women's history succeeded in realising 'freedom and happiness' – they did not even succeed in claiming it. Partial conformity and submission – as strategy, as protection, or simply and quite unproblematically as an internalised behavioural norm – were usually the price they paid for escaping the role. Renunciation and remonstration, independence and subservience, courage and despair usually lie so close together that we have to decode the hidden structure of women's opportunities for expression in a patriarchal culture before we can evaluate their writing. These contradictions may explain why different biographies of the same woman often present such divergent pictures of her.

4. Breaking Away from the Private Sphere. On the Difference between Writing and Publishing

[...] As long as no move is made to establish a female counterpart to the public sphere, writing women will find themselves faced with the

choice between conforming to male aesthetic criteria and acquiring their own language in the shelter of the private sphere if they do not want to expose and sacrifice their whole *person* when they publish a *text*. Women's reluctance to flaunt themselves on the literary market is a result of their experience in the private sphere. Their exclusion from economics, politics and culture implies that authentic women's literature at first could only give voice to 'merely' personal and subjective feelings and concerns. The publication of woman's subjectivity is, however, not equivalent to her liberation, for it has consequences (often unpleasant ones) for her personal happiness. As far as women are concerned, no distinction is made between the *writer* and the *person*. Woman's desire for public involvement and equality in the cultural sphere is thus broken by the desire to protect her own self. The wish for acknowledgement independent of a relationship with *one* man makes a woman's private life public. Yet, in what scholarly monograph about a male author, for example, can one find the sort of sensational rubbish that one finds about Sophie Mereau in Ernst Behler's book on Schlegel;[5] 'Schlegel had answered: "But she is a charming little slut," to which Pölchau replied, "Oh, she is delightful in bed".'

It wasn't only Caroline Schlegel who decided to limit herself to letter writing. So did Rahel Levin (Varnhagen) who above all is concerned with the authenticity of women's writing when she reviles publication:

It seems to me to be in the nature of this reprehensible flattery when a woman writes for publication – that is, intends to write down something consciously thought out – that she always places herself in a position of subordination to one or several men and disfigures herself at the same time. (Diary entry of 1823)[6]

Yet she recommends her sister, in a letter written in 1819, to 'Go to places where there are new objects, words and people, where you can refreshen your blood, life, nerves and thoughts. We women are doubly in need of this.'[7]

In her salon and in her letters she created places where she could herself come alive. She directs her own verbal and written expressions at individuals or small groups. The letter as genre, because of its private character, most closely fits her visual, associative language in which spontaneity and reflection do not exclude each other. In this

genre the hierarchies of the male discourse and normative genre poetics are valueless, the male order of things, the order of rank, significance and importance cannot reach it. Here, 'time can follow the rhythm of its feet.' [. . .]

5. *Approaching the Feminine Utopia under the Protective Guise of Literature*

In the eighteenth and nineteenth centuries many published texts written by women appeared anonymously or under a (usually male) pseudonym. Such a path to publication represents the *formal* possibility of overcoming the contradiction between self-protection and self-expression. However, it is an illusory solution like the function of the veil in front of a woman's eyes which certainly protects her, but also obscures her vision. A real solution can only be reached on the basis of a different public and poetics, namely, if these correspond with female experience. On the long and weary road to this solution women have developed a multiplicity of strategies to enable them to speak and write *in spite of* this conflict. One of these is the unfolding of the fictional text. Women published literary texts before they aired any views about their sex in philosophy, journalism or politics. Before the 1848 Revolution there were (in Germany) only a few published non-poetic texts by women. In the revolutionary years, and then increasingly from the 1860s onwards, there were a growing number of essays, programmatic works and open letters by women about the situation and role of woman. Women's autobiographies, too, which as a genre stem from the publication of personal experiences, have only existed since the middle of the nineteenth century.

Disguise in the form of literature gives *protection* as well as the chance to overstep the boundaries of the real and to postulate *utopias*. Fiction is a space in which to learn to walk, to fantasise, and to experiment in order to open up a creative way out of the tension between the 'limitations of the strategies and the unsuitability of the desires'[8] in the real lives of women.

It is obvious why there was an increase in the number of women who took to the pen at the end of the eighteenth century, at the time when new possibilities in poetic expression were brought by the aesthetic of the Romantics. The principle of mimesis was abolished, the fragmentary was accepted, the closed text was dissolved. The

harmony between the structure of reality and the narrative was broken and this opened doors through which women could enter into the sphere of high literature. For the *rhythm of female experience* is largely excluded from the temporal and spatial organisations sanctioned by society, from the recognised hierarchy of themes and feelings. (This is why the concept of the male order is suitable for the description of the ruling patriarchal culture.)

Only an aesthetic which defines itself in opposition to the 'naturally beautiful' (which is in fact no longer beautiful, and for women usually ugly) allows the development of a female language of experience without demanding conformity to the dominant pattern of perception and discourse. The real limitations of the female life can be overcome, a female protest unleashed, only where the contradictory experiences of women can be fashioned and need not be transferred to a plausible, realistic solution within the framework of a text/plot. This is the reason why there are so many smooth transitions to the affirmatively *trivial* in the social novel when written by women. Consider, for example, the emergence of the 'woman's novel' in the nineteenth century.

Many of the novels written between 1815 and 1848 derive their critical edge from the resistance to the marriage of convenience; their epic tension comes from the motif of the opposition of love and marriage. However, in these texts too, the ideology of true love lurks behind the criticism of the marriage of convenience. In the second half of the nineteenth century there is a rise in the number of novels which give a positive treatment to the motif of the marriage of true love, in which the conflict is resolved, the tension has disappeared. But the role of women has not changed, except that the heroine now submits out of love. These novels are trivial not least because they once again depict gender roles within the given framework.

6. Maskings – Problems of Representation for Women Writers

Even within the narrative genre for women there is a double significance (aesthetic and gender-specific) when they decide on a particular form of representation and way of writing. The problem of their status as the second sex with a view to publication – which, however, is no longer merely a formal problem – is particularly closely linked to the point of view of the narrator. In narrative theory up until now this has been dealt with in terms of the time and place

of the narrative action. A gender-specific dimension cannot simply be tacked on to this but must contribute to a new critique of narrative technique. The relation which is established in the text between the narrator, the characters and the author should not be read as only the realisation of her [the author's] literary concept but also as a function of women's perception and experience as the second sex. It cannot be taken for granted, even in contemporary women's literature, that a woman author will choose to create a *female main protagonist* and/or *narrator;* these are not always best suited for the themes and plot. Women writers often choose a hero*ine* more readily than allow the narrative point of view to betray them to be writing women. Many who write from a feeling for and an awareness of their position as the second sex express this by experimenting with different combinations of narrator. This often causes discontinuities in the text, but this should not simply be put down to haste for it also shows how difficult it is for many women to maintain the mask of a seemingly objective but in fact male element of traditional narrative.

Narrative distance is very often introduced when a woman character with whom the writer obviously identifies is made the main protagonist. And even if Christa Wolf no longer seems to have problems about letting a female narrator ponder about Christa T.,[9] that does not mean that the problems of representation sketched out here are solved for women as a whole. Many contemporary texts by women illuminate – sometimes with an effort which comes through the text – their experience as women, and they thereby achieve their vantage point. This has been criticised as false introspection, female narrow-mindedness, etc. In my opinion this way of writing can only be properly understood in terms of its historical importance as liberation from a past of pretence, masks and conformity. [. . .]

7. *The Disenchantment and Destruction of the Image of Woman and the Birth of the New Heroine*

There are other concepts of writing which inscribe these contra-dictions into literature, and in doing so do not dismiss or destroy them but shape them in order to work with them. There are texts which conceive the *search* for a new identity and way of living by women as *liberation* from the life patterned according to the stereotypes of femininity. This liberation in its radical form seems to

be possible only if dependence is recognised. Woman as the second sex who knows that she perceives herself as the reflection of male desire can develop self-assurance by fashioning her self-observation as *de-reflection*. That this de-reflection also contains *disenchantment* has its roots in the fact that male images of women – in contrast to the social reality of women – not only present woman as an underprivileged sex but also set her on a pedestal, so that the images encompass humiliation and veneration, as well as fear of the supposed omnipotence of woman. The path of disenchantment often leads through the testing and traversing of these images to destruction or disillusionment. [. . .]

8. *Of Fantasies and of Renunciation*

The *imaginative production* of women writers cannot be considered independent of women's lives and the context of their lives. The unleashing of the female imagination has always seemed threatening to bourgeois pedagogues. In everyday life women's creativity is confined by the limited scope for action and experience within the ghetto of the needs and pettiness of family life (which potentially offers the scope for concrete and worthwhile work, but in fact, because of its structure, isolates the woman who works there and alienates her from any meaningful social contexts). Yet even this structural hierarchy was apparently not thought secure enough by the authors of innumerable education handbooks. In the nineteenth century these advisers on the upbringing of young ladies were full of theories, suggestions and schemes for the channelling of the female imagination. Grammar was seen as the instrument for ordering language and thought; all kinds of needlework which demand constant patience were advised as these exercised the norms of the bourgeois work ethic ('work first, play after') and directed the creative urge into the production of useless, safe and pleasing products which, moreover, if they were part of her trousseau, occupied the thoughts of the maker with her future destiny as wife and mother. [. . .]

The ambiguities in the emancipatory message of many women's novels are usually recorded only with helplessness or denigration by literary critics. In my opinion the contradiction between the female characters' protest and the affirmative stance presented in the text[10] rests on a specific epic tension which corresponds to an ambivalent

stance on the part of the author. Within the fictional space of the plot, escape is imagined, resistance is tested, indignation formulated. Without denying herself the pleasure of fantasising, the author can, because she is responsible for the thoughts and actions of her heroine, remain conformist either by punishing her heroine or by letting her (understandingly) renounce. And so, perhaps, the message will still get through to women readers, but in a subversive way. I suspect that contemporary readers read the novels of Luise Mühlbach, Fanny Lewald and others between the lines, for how else could such literature have gained the disreputable reputation of being in the tradition of George Sand whose name was synonymous with the emancipated woman?

9. The Feminist Resource:* Looking Out of the Corner of One's Eye

The argument so far may seem restricted in theme and concept. It revolves around *the Other*, the development of a female culture and utopia, and above all around the relation between images of women and female self-awareness. Women should allow themselves to look out of the corner of just one eye in this narrow concentrated way so that they can be free to roam over the length and breadth of the social dimension with the other. In order to be able to see through their specific role as women in all spheres and on all levels they need at least half their field of vision to concentrate this rigid gaze on the so-called 'woman problem'. They will only be able to correct this *sideways look* when the woman theme is redundant – when living and writing woman has overcome her *double life* of living by the pattern set by the dominant images *and* in the anticipation of the emancipated woman.

> And as emancipation presupposes or includes the abolition of economic inequality and social injustice, so the new feminism has, so to speak, a double, split gaze.[11]

The Italian woman, Lidia, who is speaking here means by this the irreconcilability of her feminist and her political biography. She expresses the experience of many women who come up against

* In the German this is *Vermögen* which means both 'ability' and 'wealth'.

obstacles whenever they want to put their opinions into practice, obstacles to which they must partially submit if they want to communicate anything at all. Conformity or refusal (or renunciation) is the bitter alternative for those women who want to break out of the ghetto of female duties. This occurs in all male-controlled areas – in institutions, established political parties, other political organisations, and pressure groups.

This then is the typical female opposition:
Conformism/exaggerated eccentricity.
Acceptance of male values/rejection of all values.
Whatever mode of behaviour woman chooses all that is left her is *silence* or *chatter* as long as she cannot formulate any new values.
How can we find a way out of this dead end?[12]

There have been many attempts to formulate theoretically the connection between the analysis of political issues and the relationship between the sexes. The primary/secondary contradiction is one of the most tenacious and also one of the most unprofitable variants of these efforts. The slogan which has recently become popular, that 'the personal is political', attempts to reconcile the opposition rhetorically. This is provocative because it offends the taboo surrounding what has been declared merely personal and publicizes the power relations within the home. It thus verbalises the refusal of many women to tolerate the existing divisions any longer.

However, 'the personal is political' is deceptive too if it promises a political solution to personal suffering. There can, thank goodness, be no political – that is, organised, formal – solution to the really personal, for that would mean the suspension of individual self-determination. Love, pain and happiness, the desire to overcome personal boundaries and self-assertion cannot be distributed according to rules; that would result in the collapse of human relationships. This is shown by the literary utopias which attempt to reconcile the conflict between a desire to submit and a striving for autonomy which in turn exterminates the roots of this conflict; that is, desire. Programmes like these rest on a fundamental misunderstanding. They confuse the painful coupling of love and submission, the submerging of relationships by the patriarchal relations of power in which individuals confront each other as the carriers of gender roles,

with the vibrant contradiction between freedom and identity which arises in every deep heterosexual relationship and which is also experienced in homosexual and lesbian ones. 'The power of the social replaces that of the sexual only too often.'[13] Women will have to come to terms with experiencing the 'personal' on their own for a long time to come. Wherever women are isolated they experience a hiatus, whether in connection with their jobs or in social, cultural or political life. The thread connecting what is otherwise experienced and lived in the company of and in conversation with women seems to be broken off. They become backsliders. Learning how to look out of the corner of one's eye as a feminist tactic includes seeing this not as a personal failure but instead as necessary, as a *double existence* which cannot be harmonised here and now, during this period of transition.

Let us return to the mirror image. If the projections, the images, are wiped off the mirror then at first it is blank. The mirror can be painted with new concepts but these are equally images; even the shattering of the mirror leads to nothing. What the liberated woman will look like cannot be imagined with any certainty or in any detail at the moment, let alone how she will be experienced. In order to live through this transitional space between the *no longer* and the *not yet* without going mad, it is necessary for woman to learn to look in two diverging directions simultaneously. She must learn to voice the contradictions, to see them, to comprehend them, to live in and with them, and also learn to gain strength from the rebellion against yesterday and from the anticipation of tomorrow.

Both the hysterical woman who abandons her role and the mad woman who assails the male order use their bodies to articulate the contradicton. 'Madness and hysteria are the two sides of female insanity as it has been defined (and incidentally also caused) by men.'[14] By reading between the lines of the male definition, the rebellious element of hysteria has recently moved into the (feminist) field of vision. Yet even in this reading the ambivalence remains because the hysterical and the mad, by using their bodies, also abuse them and so harm themselves.

It is certainly some achievement not to become *de-ranged** considering the present state of affairs. Elisabeth Lenk in her

* In the German this is *ver-rückt*. By hyphenating the word in this way, Weigel gives it another connotation to its usual meaning of 'mad'. It now also implies 'displaced'.

metaphor of the 'self-reflecting woman' who can 'develop the new relationship to herself only through relationships to other women'[15] has shown the healing element in this madness:

> Woman often believes when she enters into this relationship to herself for the first time, when she for the first time reflects herself, that she has turned mad. But this apparent madness is no madness; it is the first step towards sanity.[16]

This relation in which 'woman will become the living mirror of woman by losing herself and then finding herself again'[17] can, in my opinion, only become a healing process if the woman does not see the other woman as a model* to be copied, only if she is prepared to discover and to accept the 'no longer' and the 'not yet', that is, her present double life. Rahel had an inkling of this double life. '[I have] the tremendous strength of being able to double myself without confusing myself,'[18] by which she meant the irreconcilability of her inner and outer life. In her doubling of the self she retains what would have been destroyed if publicly exposed. It is this conscious renunciation of reconciling models and utopias which Julia Kristeva means when she says that 'a feminine praxis must be negative if it is to say that this is and this is not yet' that is, 'to say the not-being'.[19]

The language we have learnt is unsuitable for such a *negative praxis* as the speechlessness (the unwritten literature of women) and the volubility (the reams of trivial literature produced by women) show. Our language has been learnt from our fathers – and mothers. The institution of 'father' and the reproduction of 'mother' in the forms which have been discussed/conjured up in an endless discourse over the last two hundred years from the days of the early Enlightenment to the ideologists of a bourgeois family politics are, however, the foundations of patriarchy. What holds true for appearance also applies to language. Female language (which does not mean a new vocabulary as is often thought) 'no longer' and 'does not yet' exist; it is 'no longer' pleasing and virtuous and 'not yet' liberated and authentic. Therefore, we shall have to practise

* In the German this is *Vor-bild*. Again, by splitting the word, Weigel gives it another meaning. In common usage it means 'exemplary model'. But here it also implies an image which is placed in front of someone and also an image which chronologically precedes another.

carefully using the newly acquired language accurately, aware of both its visible and hidden constraints, paying attention above all to the meaning of language patterns, rhetorical devices and genres.

If writing/literature is to be a space where the double life can be expressed, opinions exchanged in order to break down the concept of life as the mirror-image of male projections, where freedom can be tried out in order to find a language for our own desires and wishes, then the existing concepts (above all those of the dominant genres) are not adequate, or only at a pinch if their patterns are used in a refracted, paradoxical way.

10. Femininity in Writing – Spot the Woman

The shift in emphasis in feminist theory from interest in the representation of man/woman to interest in elements of femininity in writing is a feature common to the writings of the French psychoanalytic feminists Luce Irigaray and Hélène Cixous.

> I am not concerned with making woman the *subject* and the *object* of a *theory*; it is impossible to subsume the feminine under any generic term. The feminine cannot be signified by any proper name, by any concept, not even that of Woman.[20]

The 'feminine' means more than 'woman'. Luce Irigaray's concern that it is not a question of 'making a theory of woman but of giving the feminine a place in the difference between the sexes'[21] follows from this. Her method for finding that 'place of the feminine' once again is the *traversing of the various discourses*, the philosophical and the psychoanalytical, in which the 'feminine' is in fact defined as lack, as deficit. (See her book *Speculum*, which is an example of the traversing of Freudian theory and criticism.) This traversing takes place however – contrary to the model of the onto-theo-logical – in the feminine style:

> This style or this 'writing' of woman sets fire to fetishised words, appropriate terms, well-constructed forms. This style does not give privileges to the gaze ... the simultaneous would be its 'essence' ... which never pauses in the possible self-identity of some form. It is always flowing . . . Its 'style' opposes every kind of rigidly constructed form, figure, idea, concept, and makes them explode.[22]

The traversing, questioning and uprooting of the discourse is necessary (writes Irigaray) because the exclusion of the feminine takes place inside the models and the laws, the systems of representation, which function only as self-representations of subjectivity. The final aim is to be the destruction of the discourse's mode of functioning.

These aspects of Irigaray's thoughts on the 'feminine' have much in common with Hélène Cixous': the proximity of the 'feminine' to what flows, to the body, to rhythm, the formlessness of a feminine text without beginning and end, the closeness to feeling and touching. For Cixous, these are features of a 'feminine economy' which she describes as antagonistic to the 'male economy', to the symbolic, the philosophic and to discourse. Woman is like the unconscious which has been repressed and excluded from the male order. It is therefore possible in her view for woman to let the repressed appear in her writing without making a detour by traversing the discourses as Irigaray suggests.[233] And thus women can harbour within themselves the potential for a *positive programme:*

> It would therefore be that women begin ... to display a desire ... which would break with the calculation of 'I mustn't lose unless it is to win even more' ... in order to save themselves from everything that is negative about work, and to instigate work which has a positive orientation which will be characterised as the living Other, as the saved Other, as the Other which would not be threatened by destruction. Women have something about them which could organise this survival and revival of the Other, of undamaged difference.[24]

The attempt to revitalise that 'Other' which was excluded from culture along with the female sex is contained in this programme. The text is an object of desire, 'femininity' is inscribed in it: as continuity, the unconscious, the rhythmic, the archaic. If this description of the 'feminine' is correct then the didactic programmes of philosophers such as Kant, Fichte and Rousseau seem to have succeeded in their intention of polarising the sexes: 'It is, so to speak, the duty of women to find morality *through experience.* It is our duty to bring it into a *system.*'[25] Rousseau, with his opposition of movement and abstraction, values the 'feminine' less highly, Irigaray and Cixous value it more highly, not merely out of a simple reversal

of the norms, but with the intention of suspending and dissolving the dichotomy altogether, of undermining the system. Femininity is, then, the real goal for *both* sexes. That means that man is no longer allotted the 'masculine' and woman the 'feminine' but that femininity can be rediscovered or manifested in both man *and* woman. This is no longer the old dream of androgyny – that is, the mixing of characteristics independent of biological sex – but the *feminisation of culture* – a point of view unique to this theory.

Although the principles of Cixous and Irigaray contain a wealth of insights into the male order and lead the way to important textual observations I see some potential dangers, above all in the reception and application of their principles. The lack of any historical differentiation between what woman should be according to male desire (for example, Rousseau), what she is, and what she could be – that is, the lack of a distinction between the *image of woman, woman* and *utopia* – risks confining the 'feminine' to the 'eternal feminine', while in a revision of the male order the masculine takes strength from the feminine – an old dream to be found in Schlegel, Kleist, Flaubert, Marcuse and many more. The merging of the object of desire (woman) with the object of desire (text) by man fantasising himself to be woman in the text – that is, the peaceful coexistence of misogyny and the glorification of woman – has its roots in the substantiated connection between sensuality, poetics and femininity. [. . .]

I don't believe that the discovery by men of 'feminine elements' in literature leads us very far, at the very least its theoretical presupposition – Freud's thesis of human *bisexuality* demonstrated by the presence of 'female' and 'male' traits in both sexes – is a problematic use of the conceptual polarity feminine/masculine. Although fired by the good intention of freeing the gender roles from their biological determination, this thesis in fact only prescribes a gender dichotomy in a much deeper and more significant way because it eternalises that dichotomy in terms of *social* gender roles. A whole bundle of specific characteristics is subsumed under one concept so that the opposition (deriving from the bourgeois gender dichotomy) of 'masculine' (active, rational, etc.) and 'feminine' (passive, emotional, etc.) is resurrected, the only difference being that now there can be 'masculine' women and 'feminine' men. That's not much of an improvement!

On the contrary, it seems more sensible to me to keep the words

'man' and 'woman' – for after all it is a question of the living individuals who are characterised by those terms – and to speak and think about the implied characteristics and modes of behaviour as if they actually existed. Only by speaking of living individuals is it possible to link two discrete phenomena, such as the active and the emotional (which are otherwise fixed in conceptually irreconcilable oppositions), without this being proscribed or labelled 'insane'. Only then would it be possible to question individual aspects of what in bourgeois discourse the male stands for and not to reject it wholesale. Thus I would like to rehabilitate considerations of *woman* in feminist theory and poetics, unlike Cixous and Irigaray whose mystification of *the feminine* makes me uneasy even though I share their criticism of those theories which constitute woman as the new object of old discourses.

In order to free themselves from the mode of existence as the 'second sex' women need all their senses, their reason, and their feelings. They must, above all, find new ways of perceiving and expressing, of coming to perceptions which are sense impressions, which grasp, judge and are active, as, for example, the gaze.[13]

Irigaray, who works within the structuralist tradition, allocates the gaze to the male system, to the conceptual, the naming and the individualising, to the metaphor, while woman is connected with the gestural, metonymical, associative:

> The predominance of the gaze and the special treatment of form, the individualising of form special to western logic, is alien to the feminine erotic. Woman finds satisfaction through touching more than through gazing.[26]

In my opinion what is important here is the warning that woman should beware of alienating herself from her associative perception which is linked to experience. But on the other hand, this awareness of daily life has also contributed to the fact that woman is trapped in her situation. Understanding and metaphorically seeing through it will be an important step towards change. Instead of renouncing the gaze, woman will have to sharpen her vision – not put on male spectacles but develop her *own* gaze, an active, non-voyeuristic gaze. The woman who reproduces herself, to whom woman becomes a living mirror in which she loses and finds herself again (Lenk), in my opinion needs a sharp eye in order to understand the language of the

other woman, the articulation of her body, her silences, her gestures.

I don't think Irigaray's path which traverses the discourses is the best one. There are other perhaps less thorny and zig-zag ones which have different starting points according to the individual woman but which perhaps lead to a common meeting place. To take literature as an example: there is the analytical approach which attempts to grasp the ways of producing the feminine in men's literature in order to recognise the patterns and images – those eternally recurring, self-perpetuating images of femininity. It is an approach which creeps up unawares on the *images of women* and *disenchants* them. And then there is women's literature which does not follow this (conceptual) detour. Because woman traditionally embodies the 'feminine' she learns and *lives* to see herself as lack (which in the discourse is merely defined), as the 'second sex'. The path which describes, comprehends and expresses *this* experience constitutes the search for the writing and life of woman as an authentic sex and is not the possibility/result of this search.

The utopia of woman as an 'authentic' sex does not mean – to reverse patriarchal relations – claiming to be the only or the superior sex, rather it demands that woman is no longer defined in relation to man. Instead, she sees and experiences herself as autonomous and considers her relations with herself and with others as her own and not as deviant. With the transition from 'second' to 'authentic' sex she will no longer have to identify herself as lack – although here too she is not imitating man but acting independently.

This difference between woman as 'second' and as 'authentic' sex does not come out clearly enough in the writing of Cixous and Irigaray. This is my main criticism of their theories. The contrast between criticising the existing state of affairs and positing the utopia of liberation lies in this difference. I agree with their analysis of the place of the feminine in the male order but their programmatic remarks about a feminine praxis seem to me to be highly problematic, above all the restriction of feminine praxis to writing (Cixous) and the assumption that this contains a latent positive programme. When writing down her unconscious, her fears and desires – even the totally regressive dreams of dependence – woman discovers a mass of images in herself, a terrible confusion of misleading images and rebellion caused by desire. By traversing *these images in writing* (and also by actually living them to get them out of her system) woman can free herself from them and come to an independent consideration

of herself, of her culture, and of her society [. . .]

11. Women's Reports of Insanity – The Destruction of the Beautiful Image

The destruction of the images of femininity often comes about by harming the women who are supposed to live up to these images. Evidence of this can be found in the reports women write about their own 'ill health'. Their dis-illusionment* can be seen on the body, the locus of representations of 'femininity'. Woman, who in the male order is condemned to silence, makes herself heard through the talkativeness of the hysterical, anorexic or depressive *body*. Her chatter is not aimless, even if it often (at first) leads nowhere. And it is noticeable that the cure or amelioration of the illness in the psychiatric sense – that is, the improvement of the acute symptoms of illness – often leave a feeling of emptiness in the woman concerned. [. . .] This feeling of an empty space, of a 'shapeless ego', remains when the 'normal' feminine ego is discarded. The contradiction formerly felt between the promises attached to 'femininity' and the actual bleakness of women's lives is *resolved in a negative way* if self-esteem is accommodated to what is actually experienced – the destruction of the image, disillusionment and the lowering of expectations to the level of reality. [. . .]

The *latent schizophrenia* of woman consists in the fact that those elements of the model of femininity which earn her *moral* respect (for example, motherliness, understanding, sociability) are also the basis for her social subordination. If she questions the supposed inferiority of the female sex and enters the professional or political rat race then she has to pay for it with her 'femininity' and status as a human being. The guilt working mothers feel is eloquent proof of this contradiction. My proposal of looking out of the corner of one's eye as a feminist resource is a response to the fact that this conflict cannot be solved here and now. [. . .]

* In the German this is *Ent-täuschung*. In common usage this means disappointment. The separation of the word makes the implicit meanings explicit. The word thus also implies demystification, disillusion. (*Ent* = taking away, subtraction of; *Täuschung* = deception, illusion).

4
Heide Göttner-Abendroth
Nine Principles of a Matriarchal Aesthetic

The principles of a matriarchal aesthetic can easily be derived from my description of matriarchal art of the past. But a matriarchal aesthetic is not a retreat into the distant past but a partly descriptive and partly prescriptive theory of a number of aspects of modern art. I shall apply this theory to art forms found in the work of contemporary female (and male) artists which already have matriarchal features. By means of a comparative analysis the meaning of these forms will become clear and from this clarity a programmatic structure may emerge. I shall also develop a matriarchal art utopia using these (already existing) forms as starting points.

But first I shall set out the nine principles of a matriarchal aesthetic, which I shall then go on to discuss in more detail.

First: Matriarchal art is located beyond the fictional, both in the past and in the present. Beyond the fictional art becomes magic. Magic intrudes into reality by means of symbols and has the effect of changing reality. Ancient matriarchal art tried to influence nature and to change it by using magic (ancient magic); modern matriarchal art attempts to change psychic and social reality using magic (modern magic).

Second: Matriarchal art has an enduring and predetermined framework: the structure of matriarchal mythology. This structure is universal as it is the basic pattern of all mythologies and all the later religions which developed from them. It is one of the fundamental objective categories of the human imagination.

But, like every structure, so the structure of matriarchal mythologies is not complete in itself. Each matriarchal society gave to the structure of its matriarchal mythology (religion, rituals, ways of living) a different reality. The result is that its concrete forms are as

varied as the regional, individual and social conditions of those who created them. Matriarchal art which derives from the structure of matriarchal mythology is therefore diversity in unity, in which the unity is not dogmatic, the diversity not subjective.

Third: Matriarchal art transcends the traditional mode of communication which consists of: author–text(art product)–reader. Matriarchal art is not 'text', it is not limited to manufacturing art products. On the contrary, it is a process which gives a pre-existing inner structure, found in the ritual of dance, external expression. It is a process in which all participate collectively to create this external expression; all are simultaneously authors and spectators.

The structure of matriarchal mythology is also not 'text' which a (woman) author produces and a (woman) reader fills with meaning – quite apart from the fact that female authors and readers do not feature in traditional communication theory at all. It exists as a fundamental category of the human imagination, the most ancient, the principal one from which all later religious and artistic artefacts of the imagination developed. This imagination is no undisciplined eclecticism, no arbitrary chain of associations – that is only its very late and degenerate aspect – rather, it follows its own inner rules, inscribed in the structure of matriarchal mythology. Its concrete forms continually give collective expression to this highly complex code of rules in many different ways. (In order to discover them, you don't need to delve into the unconscious for possible archetypes; you need only reveal the forgotten matriarchal traditions by analysing past societies.)

Fourth: Matriarchal art demands the total commitment of all participants. As it does not recognise any division between author and audience in which the author creates the symbolic action and the audience (at the most) either identifies with it emotionally or contemplates it on a theoretical level (a patriarchal role division): in matriarchal art there is no division between emotion and thought. All participants operate simultaneously on the levels of emotional identification, theoretical reflection and symbolic action. In this way, the universal, objective nature of the structure of matriarchal mythology, which is known to all, prevents the identification from becoming subjective sentimentality, the theorising from becoming abstract arbitrariness, and the action from becoming mere catharsis. Matriarchal art welds together feeling, thinking and doing in the form of the concrete mythological image and it is this totality which

releases true ecstasy in the participants.

Fifth: Matriarchal art does not correspond to an extended model of communication with the elements: author–text–dealer–agent–audience. The dealer (art market) and agent (critic, interpreter, translator from one medium into another, archivist, art historian, etc.) are redundant. As it is a process which takes place between the participants matriarchal art cannot be evaluated and interpreted by outsiders nor sold as a commodity on the art market and later stored away in a dusty archive or exhibited in a museum. For matriarchal art cannot be objectified; that is, turned into an object. It is a dynamic process characterised by ecstasy and with a positive impact on reality (magic).

Sixth: Matriarchal art cannot be subdivided into genres because it cannot be objectified. The ritual dance ceremony embraces music, song, poetry, movement, decoration, symbol, comedy and tragedy, all for the purpose of invoking, imploring, praising the goddess.

The division between art and non-art is also redundant. On the one hand, matriarchal art breaks down the barrier between art and theory. In its ancient form, matriarchal art merges with mythology and astronomy; in its modern form with philosophy, the humanities, and with the natural and social sciences. At the same time, it breaks down the barrier between art and life. As ancient matriarchal art it merges with practical skills too, and with lifestyles which are opposed to the *status quo*. That is another reason why it cannot be applied to traditional communication models. For matriarchal art is not a simple one-way communication process, but a complex process of social interaction of which communication is only a part.

Seventh: As matriarchal art derives from the structure of matriarchal mythology which has a completely different value system – and not merely a reversed or contradictory one – from that of patriarchy, it too shares this different system of values. The erotic is the dominant force and not work, discipline, renunciation. The continuation of life as a cycle of re-births is its primary principle, and not war or heroic death for abstract, inhuman ideals. A sense of community, motherliness and sisterly love are the basic rules of the matriarchal society and not paternal authority, dominance of the husband, private and group egoism.

Modern matriarchal art, which gives these values expression and brings about changes in the psychic and social sphere, is a complex subversive process in a patriarchal society. It represents a subversive

process which is not interested in power and control and therefore does not need a disguising ideology. In every patriarchy it constitutes a subversive force which proposes a revolutionary alternative.

Eighth: The social changes which matriarchal art brings about override the divisions in the aesthetic sphere. In patriarchal societies aesthetics is divided into a formalist, élitist, socially effective art on the one hand, and a popular, widespread but socially vilified and outcast art on the other. Overcoming this division would return to art its original public role, allowing it to emerge as the most important social activity and bringing about the aestheticisation of the whole of society. This was the reality of ancient matriarchal art; modern matriarchal art attempts to achieve it once again.

Ninth: Matriarchal art is not 'art'. For 'art' is necessarily defined in terms of the fictional; the principle of fictionality is the primary principle of every patriarchal theory of art (aesthetics). 'Art' is a concept and in its form as object has only existed since the aesthetic sphere was divided. 'Art' is therefore always artificial or denatured art.

Matriarchal art is independent of the fictional and is therefore not 'art' in the patriarchal sense of the word. Nor does it require any special technical know-how. It is rather the ability to shape life and so change it; it is itself energy, life, a drive towards the aestheticisation of society. It can never be divorced from complex social action because it is itself the centre of that action.

Further Remarks about the Nine Principles of a Matriarchal Aesthetic

These nine principles need a few further remarks so that the goddess can dance again.

About the first principle

It is the concept of 'modern magic' which may seem difficult to accept in this principle – it seems like a contradiction in terms. And what does an intrusion into reality by means of symbols with the effect of changing psychosocial reality mean?

It seems to us today that the problem with ancient magic was that it was believed it could interfere with natural forces by means of symbols; for example, that it could make the moon wax (moon dances) or bring rain (rain dances). However, this is to over-simplify

things. The peoples of ancient cultures knew very well that the moon would wax again. After all, they had developed a calendar based on lunar phases which was in many cases (the Babylonians, the Maya) more accurate than the modern calendar. As far as the weather was concerned, they were well-versed in weather lore which was derived from close observation of the sky, cloud formation, the behaviour of animals and plants, from which they could forecast the weather with great accuracy. Their use of magic, therefore, did not stem from their ignorance as today's arrogance would have it.

But they were convinced that this rational-technical knowledge was not enough in itself to influence the moon and the rain; emotion had to be involved as well. This belief was expressed in the moon dance which only took place at times carefully calculated using astronomy, or in the rain dance which was only performed when they could see from physical signs that rain really was on the way. They did not regard nature as merely quantifiable, but as a living being which could change its mind at the last moment. And so it was necessary to communicate with it via symbols in order to make themselves understood, to make it clear to nature that it should stand by its intentions. For it was, after all, still a goddess to them – a feeling which today we have completely lost.

Their belief in the role of magic in nature derives from the role magic played in people's everyday lives. They were familiar not only with natural magic but also with magic in psychosocial reality. They knew that an invalid would not recover with the aid of medicines alone – and they had plenty of these – but knew that there was also an important psychological element too – the belief in cure, the hope of recovery, the trust in the woman doctor, the witch doctor who fought the demon disease. It is well known that faith works wonders. This was the function of the complementary use of magic via symbols with medicinal cures (white magic, shamanism). It is a mistake and a distortion to believe that these peoples thought that symbolic treatment alone brought a cure. Their extensive knowledge of herbalism, a science which is almost totally lost to us today, proves otherwise.

Magic, which at that time was in effect psychology, could be found throughout the social matrix. Erotic and aggressive drives were not allowed simply to run wild. They were danced out and thus contained within a social context, that of the dance. The resulting change in social reality was a new, meaningful, communal living.

We encounter this involvement with psychosocial reality symbolically in all aspects of life today. It can be found in individual and social psychology, particularly in the psychology of the unconscious. However, this is now anything but healing, because the underlying ethos of magic has been lost. Instead, it merely serves the pressures of patriarchal society to conform, to disguise and to manipulate.

Magic, denounced as witchcraft, was a principal target for patriarchy when the latter was establishing itself. And for most people magic has still not lost its connotations with the primitive and evil, so it may sound strange when I talk of an 'ethos of magic'. But the difference between the practice of ancient magic in reality by means of symbols and modern manipulation by means of symbols is that the former was always based on the idea of harmony. Its goal was always unity with reference both to the individual and society. Symbolic practices were always directed towards the individual's total powers of recovery or towards all the possibilities for the peaceful continued existence of a society. Not only were the intellect, feelings and ability to take action involved, but also the natural environment. Modern symbolic practices, on the other hand, serve only the very limited purposes of analysing people like machines and are only concerned with parts of the individual, not with the whole person. This is particularly the case when psychology is used to promote social conformity, commerce or war. The underlying 'ethos' is the opposite of the ethos of magic which tries to cure the individual or society by a harmonious combination of all capacities. The effect today is a corresponding chaos.

'Modern magic' means nothing other than symbolic practices which influence psychosocial reality but are based on an ethos of totality which does not succumb to private or sectarian interests. It differs from ancient magic in that there has been a considerable increase in knowledge in specific fields. It is the task of modern matriarchal art to develop a system of symbolic activities based on an 'ethos of magic' which corresponds to our present state of knowledge. This could help the fragmented, specialised, stereotyped and supervised individual of today to regain her/his totality.

About the second principle
The system of this unifying way of thinking was the structure of matriarchal mythology. I called this structure the fundamental category of the human imagination because it is not only ancient but

also because it can be found amongst primitive peoples all over the world. It was the basis of the beliefs of all early complex cultures, and so had an impact even on the development of later patriarchal religions, philosophies and art and still exerts a covert influence today. I discussed this influence in my study of matriarchal mythology. [. . .]*

Matriarchal cults and mythologies continued to be of great importance in the patriarchal epoch, for they did not disappear with the decline of the matriarchal society but survived for thousands of years either openly or as secret cults, or as images and ideas appropriated by the patriarchal religions. Later, they continued to be handed down in the form of folklore, festivals, fairy-tales, legends and even in 'great literature', although knowledge of their origin and significance increasingly declined. In my book mentioned above, I have described this process in Europe using the examples of folklore and literature.

In view of these historical trends I am certainly not exaggerating when I claim that the structure of matriarchal mythology is (or should be) the basis of modern matriarchal art. I am only demanding that something which has always existed in poetry and art but is now relegated to the unconscious should be consciously realised. There is nothing new about this structure in the sense that the connection with matriarchal art could not be re-established for us until its discovery. This connection has in fact always existed. It is just a question of a new awareness which will make the connection a living one for us again. It must become an explicit continuity after centuries of being merely implicit. This obscurity is not that of some mysterious, collective, unprovable archetype of the soul (in the sense of Jungian archetypes); it is the obscurity of a very old and repressed cultural tradition which has been handed down divorced from its context, and whose patterns have petrified into mere ceremonies. There is no need for introspection in order to discover this cultural tradition; instead, we need a thorough ethnological and cultural-historical research. This will enable us to locate it precisely and follow it chronologically and geographically. In this way it will lose any aura of the mysterious and unprovable.

The analyses of art and literature in the next section show that such a structure of matriarchal mythology is appearing increasingly frequently and unambiguously. It is as though it were gradually

* *Die Göttin und ihr Heros* (The Goddess and her Demigod), Munich 1980.

re-emerging from a long oblivion to become part of our social con-
sciousness. We only have to help it through the final stage for it to
become an articulated body of knowledge and an example for artists.

About the third and fifth principles
In these principles I presented the external expression of the
structure of matriarchal mythology, that is, a matriarchal 'work of
art', in terms of a negative description. As the basis for this negative
description I used the general model of communication which has
been used for patriarchal art. In this way I could establish precisely
what matriarchal art is *not*.

It is not an object – a poetic, musical or optical 'text'; instead, it is a
process. It does not need a commercial dealer or an agent; it does not
acknowledge the distinction between author and spectator; it does
not make a distinction between genres or between art and not-art.
What is it then? Is it a kind of multi-media show? Certainly, but it is
not only the staging of the combined effect of many media. Is it a
performance? Perhaps, but it is not limited to the individual action of
an artist whom others are only allowed to look at. Is it a happening?
As the artistic expression of many people it is that too, but it is not a
pattern that a few people worked out arbitrarily, for it has its given,
enduring structure which contains the objective categories of the
human imagination. Is it environmental art? As the artistic modi-
fication of the environment it is that too, but it does not find its full
expression in the transformation of a flat, a house or the surrounding
countryside, for it does not create passive, observable objects. Is it art
at all? Yes, because it creates beauty, but not as the 'veil of
appearance' but as reality. Isn't it then a new cult? No, because it does
not stipulate any religious content, unlike religions which use
dogmatic propositions. And anyway, this question assumes the
patriarchal division of 'art' and 'cult' and is unanswerable. Can
matriarchal art establish itself then outside a matriarchal society?
No, because it was and is that society's direct expression. This form
of society used to be that of the whole tribe and it was this which
gave matriarchal art its accessibility. Today, it can at best be found in
small groups living in cultural isolation but even there it is not a
different form of society but a different way of living. Matriarchal art
practised there can only be anticipated through experimentation,
which still has to find a valid form and full public accessibility.

My descriptions of moon dances and the structure of matriarchal

mythology clearly show what matriarchal art is. It is exactly what the nine muses did: ritual dance festivals following the seasonal cycle representing initiation–marriage–death and return.

But today it seems impossible to revive ritual dance festivals of this sort. But didn't this appear to be the case with magic? Wouldn't these difficulties be overcome if we reminded ourselves that these ritual festivals merely symbolise fundamental categories of the human imagination? And these categories have not changed.

The question is only: how can these categories be symbolised today? The answer is completely open. Trial and error will show us and give us many different answers. The question of the possible shape and meaning of the matriarchal *Gesamtkunst** today does not have only one answer. Every individual woman or every group responds to this question differently when giving these categories a living form. For the experiences, insights, conduct, and symbolic forms each woman or group invests, the meanings each gives to these categories, cannot be foreseen. Not even the participants know exactly, for it is only in the *process* of matriarchal art that the content becomes crystallised as form. The appearance of new meanings and new forms are certainly sought after but actually enter quite unpredictably. It is precisely this which enables matriarchal art to change reality. It is magic which is performed and experienced, and its spontaneous expressions can be so gripping that they lead to ecstasy.

Perhaps it has now become clear how fundamentally different matriarchal art is from patriarchal art. Matriarchal art is neither ornament nor commodity nor mere pleasure. Neither has it got anything to do with that unpleasant alternative between dogmatism in art on the one hand which still prescribes the themes, meanings and tone (as Christian art does), and subjectivity in art on the other which finds expression in any old theme or form (as bourgeois art does). Matriarchal art is coherent without being dogmatic because it does not prescribe meanings, and diverse without being subjective because it follows the framework laid down by the categories. This explains its unexpected effects.

About the fourth principle
From this we can easily see why this type of art makes demands on all human faculties and why these do not diminish during the art

* This is art which appeals to many senses and transcends traditional aesthetics.

process but lead to the climax of ecstasy. This needs more discussion.

Our understanding of ecstasy today is just as vague and prejudiced as that of magic or ritual transformation. When these cultural forms declined at the beginning of the patriarchal era they were subsumed by a mass of polemic and intentional misunderstandings from which we still have not freed ourselves. Thus, for most people ecstasy is a kind of delirium leading to total incapacity, or at best a kind of gentle madness; to them, it is always something thoroughly irrational. This is wrong.

True ecstasy, however, is difficult to describe for it is the spontaneous meshing of all human forces, the emotional, intellectual and the active. We can evoke it but cannot direct it. Concepts like 'inspiration', 'illumination', 'intuitive seeing of connections' do, of course, indicate ecstasy at its intellectual level, but over-emphasise this at the expense of the active level. Similarly, the erotic will not do as an illustration either, although this implies action, because to do so is to neglect the spiritual-intellectual elements. The erotic is always involved, but if it is reduced to the emotional level – as is possible – it only generates delirium. This has nothing to do with the dynamic power of ecstasy.

True ecstasy unites the intellect, emotions and action in a climax where no one power is limited by another. They are not expressed consecutively but simultaneously, and each to its utmost capacity. Ecstasy is their transitory, inimitable collision at the moment of their fullest unfolding. For example, if we want to give expression to the elements of the imagination represented by the goddess-and-hero structure, then we need the intellect to recognise these elements, emotional strength to cope with experiencing them, and a large potential for action to bring them to completion. When these forces do succeed in this creative harmony – which does not happen very often – then there will be ecstatic moments: moments of rapture and liberty. They are like the chords of the harmony of the spheres played on the fragile instrument that is man and woman. No one can grasp and hold them – which is just as well as they could not be tolerated for any length of time.

Another decisive difference between matriarchal and patriarchal art emerges from this. For as an ecstatic process it is not a spectator art, not an art for voyeurs. Only by entering the process can one experience it.

About the sixth principle
I probably do not need to say anything more about the suspension of the division between the genres. But here are a few remarks concerning the division into art and non-art.

I think it has become clear that entry into the process of matriarchal art presumes a theory, a knowledge of matriarchal forms of society, of the structure of mythology, and considerable thought about the possibilities of applying it to the present. But the process of matriarchal art always includes the transformation of forms of living for it encompasses all the practical skills as well. This disregard for the boundaries between theory and everyday life does not have to take place independently of the art process itself in the sense that you do the theory first and then apply it. They occur simultaneously.

Let us imagine that this process lasts for several days or weeks. Then the functions of daily life are necessarily involved: resting, sleeping, eating, drinking. Equally important are the elements of theory which are involved: speech, discussion, meditation. Without theory the elements of daily life lack a symbolic dimension. When combined, actions of daily life are integrated into a symbolic context and thus are no longer surface actions but become symbolic. This is why they can both emerge from and lead back to dance forms – giving the interpretation of dance a wider sense than that of today. Dance not only includes musical movement, but also parades, processions and dramatic interludes, all of which flow into one another. The kind of movement is varied just as at festivals. At festivals, too, there are ritual meals which are prepared, and enjoyed within a ritualised set of gestures, just as there are celebrations in which inspiring dramatic speeches are followed by dramatic interludes, while sleeping and waking are symbolic states of being which can be the stimulus for new and arcane festive acts. It would be inappropriate to isolate any single element, for it is only within the whole context of the process of matriarchal art that the individual elements gain their meaning. The process always takes place on many levels. It is only possible to isolate a single element when it no longer contains the symbolic value given it by the structure of matriarchal mythology as festival ...

About the seventh, eighth and ninth principles
'Life' is not confined to everyday life. It is clear from the last three principles that it encompasses political action too, for the changes in the ways of living which the process of matriarchal art brings do not

only affect the lives of individuals, they also impinge on groups and whole societies. It is only when seen from this perspective that the full significance of symbolic actions of matriarchal art are understood.

After what has been said, this extension into politics may seem implausible; after all, isn't the process of matriarchal art in its assumptions and the course it takes essentially esoteric? Who knows what the structure of matriarchal mythology is? Who can reach true ecstasy? Who will allow their whole way of living to be transformed by an art process? And anyway, so far matriarchal art has only existed at an experimental stage and has been isolated in small cultural enclaves which do not appear to have any social impact.

This scenario is opposed to the nature of matriarchal art. For it is a ritual, public in character, taking place in the open, in the fields or in the city squares, accessible to all.

It should be public for another reason as well: nature is involved. In ancient matriarchal ceremonies the important elements were those natural phenomena such as the lunar cycle, sunrise, rain showers, and that is why the dates had to be calculated so accurately. If one can predict nature precisely then it does in fact cooperate and accomplish the most impressive 'symbolic feats'. These represented the climax of the ancient matriarchal ceremonies; the dancers had discoursed with nature and it had answered – and this, as a rule, inspired profound awe. That an astronomical calculation had determined the date of the event did not detract from the ecstasy, for the whole group had paid homage to nature by studying it so carefully, and it in turn had rewarded them with the right phenomenon at the right time.

The possibility of communicating with nature by means of symbolic acts is not out of the question today in spite of our denatured environment. It does, however, demand that we once again learn to adapt ourselves to nature instead of trying to force it to adapt to us. This starts with how we treat our own bodies, which also belong to nature, and goes on to how we treat our immediate, alterable environment. We cannot demand that the sun and the moon adapt to us, they demand that we adapt to them. If we do this then nature still favours us and cooperates with our symbols. The joy, the delight, which is thereby released can be traced back to the harmonious correlation of a change in nature with a spiritual change in ourselves. The one is expressed by the other so that the whole act

becomes symbolic. And it is precisely this obviously symbolic aspect which enables the uninitiated to understand completely what is taking place. It is unnecessary to explain at length not only because basic patterns such as initiation–marriage–death and return are known to everyone – for after all, these are the basic patterns of the human imagination which are expressed one way or another in all religions – but also because such fundamental processes occur simultaneously with visible natural phenomena. Nature itself explains the structure of matriarchal mythology by means of the seasons. It is not necessary for the uninitiated to be conscious of it. In this way the uninitiated are included in the ceremonies, and slowly become participants. Nature itself is the greatest ceremony. Anyone who has taken part in this process of matriarchal art in which every element in interaction becomes a symbol knows that they have not taken part in a new form of art, but in a new form of living.

That is exactly the reason why matriarchal art transcends the character of fiction, why as soon as it enters the public sphere it becomes provocative. It is an involuntary provocation. For matriarchal art encompasses a different set of values from patriarchy's and it lives according to this set of values without compounding it as the 'veil of appearance'. It demonstrates nature's unity with human beings as opposed to nature's exploitation and utilisation by men. It demonstrates the harmony of the individual's capacities as opposed to their fragmented specialisation which in most men leads to the most absurd excesses and in most women to equally absurd limitations. It shows the erotic to be the strongest creative force as opposed to devaluing and suppressing it as the ascetic patriarchal religions and moral systems have done. It demonstrates the finiteness of death and the infinity of life as opposed to the bleak scientific attitude to death and a cynical perfection of its machines. There is not a single aspect of the process which is not different from any corresponding patriarchal idea.

It is a tremendous challenge to live by the values which patriarchal societies have banished to the ghetto of the unreal. Patriarchal societies will fight matriarchal art because it does not allow itself to be domesticated either formally or socially. And thus this art finds itself involuntarily at the centre of political action. Its form will be the very unusual one of political confrontation, a totally unexpected tactic for the opponent who has not experienced this form of resistance before. The battle will not be an exchange of

hostilities but an incessant ebb and flow/advance and retreat, an ungraspable symbolisation, the creation of a completely new web of connections in the centre of this fragmented, atomised world. This symbolisation cannot be anticipated – its phases, extent, forms will continually change. What can the opponent latch on to in this game of tag? He is bewitched and paralysed.

This complex, socially subversive praxis cannot be fought with conventional weapons because the dominant social praxis is so totally irrelevant to it. It is a form of living which is self-contained, it is an effortless integration according to the rules of diversity and completion. It is beauty but not a commodity. It seeks to dissolve the divisions within the aesthetic and so aestheticise the whole of society. This means creating a meaningful social life together. Seen from this perspective, art is no longer a specialised technique, an exclusive know-how but the universal ability to shape a worthwhile life, both personally and socially.

In a patriarchal society this art, this beauty, is the prime opposition; but that is unimportant to beauty. And what weapons can be used against withdrawing and opposing, opposing and withdrawing beauty?

5

Christa Wolf

A Letter, about Unequivocal and Ambiguous Meaning, Definiteness and Indefiniteness; about Ancient Conditions and New View-scopes; about Objectivity

translated by Jan van Heurck

> For the facts that make up the world need the non-factual as a vantage point from which to be perceived.
>
> (Ingeborg Bachmann, *The Franza Case*)

Dear A.,

When I have moved from Berlin to Mecklenburg, as I always do at the end of the winter; when I have finally unpacked my suitcase and emptied out the sacks of books in the workroom I love best – a room that smells of wood; from one of whose round 'bull's-eye' windows I look out on our grassy yard, the home-planted willows by the pond bank, the pond, neighbour O.'s manure pile and stable wall, Edith's washing (today is her housekeeping day), my two oak trees, interwoven, bare and full of promise, and the village houses which later in the year will be hidden by the foliage of these oak trees; from whose other bull's-eye window, before which my desk is standing on a wooden platform, I have that view which I would like to see in the hour of my death: the big meadow, still dun-coloured, in the middle the mighty cherry tree, a sign of coming spring, diaphanous, surrounded by smaller apple trees, bramble bushes; P.'s red crofter's cottage right beside the pond, which is almost completely concealed behind a billow in the earth; and then far off, the low horizon with its shallow undulations, ploughed land, pasture, groups of trees; then I feel my expectations rise. I shall not even begin to talk about the colours, or the skies either – for now that I have reached the end of

the sentence which began with the spilled-out books, I still have the duty of listing a few of the titles which lie, perfectly legible, on top of the book-mountain, or half-hidden further down: *The First Sex. Mothers and Amazons. Goddesses. Patriarchy. Amazons, Warrior Women, and He-Women. Women–the Mad Sex! Women in Art. God-Symbols. Love-Magic, Satanic Cult. Male Fantasies. Female Utopias–Male Casualties. Women and Power. The Sex Which Is Not One. The Secret of the Oracle. Utopian Past. Outsiders. Cultural-Historical Traces of Repressed Womanhood. Mother Right. Origin of the Family, Private Property, and the State. Woman's Wild Harvest. The White Goddess. Woman as Image. A Room of One's Own. Womanhood in Letters.* And yet this list, even if I were to continue it, would not give you a proper idea of the remarkable blend which has made up my reading for the last year; for the archaeology, ancient history, and classical authors are still inside another suitcase.

It began harmlessly, with a question which I felt I had to ask: Who was Cassandra before anyone wrote about her? [. . .]

Dear A., It's witchcraft. Ever since I took up the name Cassandra and began to carry it around like a sort of credential and watchword; ever since I entered these realms where it now leads me, everything I encounter seems to be related to it. Things that in the past were separate have merged without my realizing it. A little light is falling into previously dark, unconscious rooms. Underneath them or previous to them (places and times flow together), further rooms can be sensed in the dim light. The time of which we are aware is only a paper-thin, bright strip on a vast bulk that is mostly shrouded in darkness. With the widening of my visual angle and the re-adjustment to my depth of focus, my viewing lens (through which I perceive our time, all of us, you, myself) has undergone a decisive change. It is comparable to that decisive change that occurred more than thirty years ago, when I first became acquainted with Marxist theory and attitudes; a liberating and illuminating experience which altered my thinking, my view, what I felt about and demanded of myself. When I try to realize what is happening, what *has* happened, I find that (to bring it down to the lowest common denominator) there has been an expansion of what for me is 'real'. Moreover, the nature, the inner structure, the movement of this reality has also changed and continues to change almost daily. It is indescribable; my professional interest is wide-awake and aims precisely at description, but it must hold back, withdraw, and it has had to learn to want and

to bring about its own defeat. (Now who was it who taught us to enjoy being disconcerted!) An intelligent and cultivated poet told me he does not understand me; why should I no longer wish to accept the authority of the literary genres? After all, they really are (he said) the objective expression of laws filtered out of centuries of labour, the laws of what is valid in art, and by which we can recognise and measure it. I was so stupefied that I could not answer him.

I set to work on Aristotle. 'The mimetic artist depicts human beings in action. These people are necessarily either good or bad.'* These are more or less the same criteria most of our newspaper reviewers still apply to books today, I thought in surprise. Swiftly – and I ask you to do the same – I reviewed my family, friends, acquaintances, and enemies as well as myself, subjecting us to the test 'good' or 'bad'. By Aristotle's standards there would be no suitable models for the imitator-artist to represent. But Aristotle knows how to defend his case: 'Homer, for instance, depicts people with higher qualities than average.' (Whereas comedy 'portrays people who are inferior.') Yes, I thought: Homer. I cannot resist the temptation to quote to you the passage I underlined in the fifteenth book of the *Iliad*. Homer, justly famed – *very* justly famed for his metaphors and similes – describes as follows the flight which Hera, Zeus's wife, undertakes to the other Olympian gods at Zeus's behest.

> Safe home the seasoned traveller names
> A foreign town – 'Ah,' he exclaims,
> 'That charming spot! I wish I were
> No longer here, but once more there.'
> Then other towns he calls to mind,
> His thoughts run swifter than the wind
> And, though his body does not move,
> Revisits every scene they love.†

In the same way, Hera needed merely to think of Olympus, and there she was: entering the banqueting hall of Zeus's palace.

* Passages from Aristotle are translated directly from Christa Wolf's German version, which differs slightly from the standard English translations.
† This simile about Hera as man's thought is quoted from the Robert Graves' translation, Book XV of *The Anger of Achilles: Homer's Illiad* (London, Cassell, 1959).

But the facts – that is, the myth – about Hera are these (and please bear with the following, perhaps longish digression from Aristotle). Like the other goddesses Artemis, Aphrodite, Athena, she had already been incorporated by the Greeks into their patriarchally-structured pantheon by Homer's time – that is, the eighth century BC, when they were (once again) taking over a written language from the Phoenicians. That is, Hera too, the wife of Zeus, has a long prehistory which can only be interpreted in matriarchal terms. This prehistory, I believe, still shines through the seemingly abstruse Witches' Multiplication Table in Goethe's *Faust*:

> See, thus it's done!
> Make ten of one,
> And let two be,
> Make even three,
> And rich thou'lt be.*

Goethe – like all his contemporaries – considered history to have begun at the point arbitrarily fixed by the Greeks, in the year of the first Olympiad, 776 BC. Yet Goethe knew the triformity of the ancient mother goddesses (the very first trinity, from which all the later trinities derived). In this trinity 'three' were 'even' (the same), in that one goddess appeared in three manifestations corresponding to the three tiers that composed the world. First she was a bright young maiden-huntress of the air (Artemis). Then she was the mature woman goddess at the centre, dispensing fertility, ruling land and sea, an erotic divinity (Demeter, Aphrodite, Hera, who earlier was called Era = *Erde*, or earth, whose other names are Gaea and Rhea: the Great Earth-Mother of Crete and the Near East). And finally she was an old woman who lives in the underworld, the goddess of death who at the same time effects rebirth (Io, the Cretan cow-goddess, one aspect of Hera, and of course Hecate-Hecuba). Their/her colours are red, white, black, corresponding to the phases of the moon which is their/her symbol and whose goddess they are (do you notice how we have to struggle with ourselves in order to speak of many as one? The convolutions of our brains, and our linear speech, resist the Witches' Multiplication Table).

And now read in *Faust*, Part II, that passage in the classical

* Quoted from the 'Witches' Kitchen' section of *Faust* (London, R. Warne, n.d.), p. 76.

Elvira Bach, *Schlangenhochzeit* (Snake Wedding), 1984, acrylic on canvas, 230 × 190.

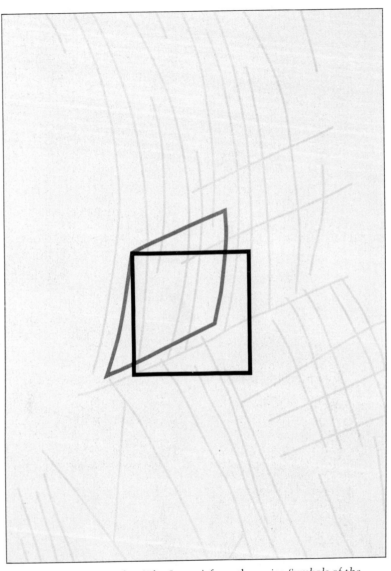

Rune Mields, *Das Quadrat* (The Square), from the series *Symbols of the Stone Age*, 1983, aquatec on canvas, 200 × 145.

Anna Blume, (no title), 1982, pencil, 73 × 103 each.

Angela Räderscheidt, *Die Seele der Nacht* (The Soul of the Night), 1984,
charcoal on transparent paper, 220 × 180.

Christa Näher, (no title), 1983, brush drawing, 30 × 21.

Ulrike Rosenbach, *Madonna mit der Kreissäge* (Madonna with Circular Saw), photocollage.

Eva-Maria Schön, *Umrandete Löcher und Risse* (Paint-bordered Holes and Cracks), 1983, floor painting (second stage).

Maria Vedder, *Das Geheimnis des künstlerischen Schaffens* (The Secret of Artistic Creation), 1982, series of photos.

Ilthes Holz, *Besetzung* (Squatting), 1983, dispersion on fabric, 180 × 150.

Annette Pfau von den Driesch, *Lebenslauf* (Curriculum Vitae/The Course of Life), 1983, acrylic on canvas, 155 × 100. Photo: Anne Gold, Aachen.

Gretel Haas-Gerber, *Küche II* (Kitchen II), from the series *Isolation*, 1978, oil and tempera, 110 × 150.

Painted by 'Malgruppe WeibsBilder' (The 'Bitches'): Lilith Lichtenberg, Lisa Endriss, Sara Rogenhofer, *Die drei Grazien* II (The Three Graces), vinyl on muslin, 200 × 150.

Carola Andries, *Toter Wald* (Dead Wood), 1984, Indian ink, 19 × 24.

Michaela Melián, *Himmel auf Erden* I (Heaven on Earth), 1982, acrylic and dispersion on duvet cover, 137 × 156.

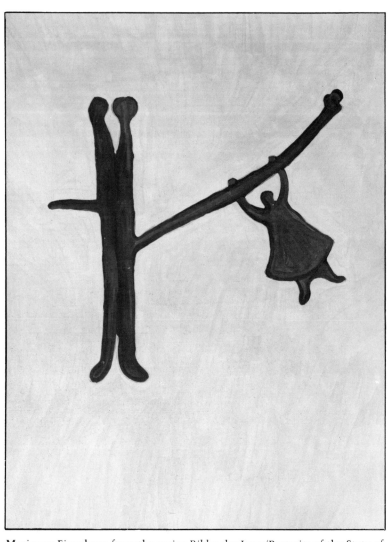

Marianne Eigenheer, from the series *Bilder der Lage* (Portraits of the State of Affairs), 1981/82, acrylic on paper, 200 × 157.

Ulla Horký-Heuel, *Ausbruch* (Breaking Out), from the series *Embryonale Mumifizierungen*, 1983, photos and paper cocoon, 100 × 70.

Marianne Kordsmeyer, *Portrait of the Painter Gabriele Donder-Langen tearing one of her own pictures,* 1984, photograph.

Barbara Hammann, *Conversation Pieces*, 1983, video.

Sarah Schumann, *hamayakalt*, 1982, collage, 50 × 73.

Gabriele Schnitzenbaumer
Aufgebrochenes Gehäuse
(Eruption from a container),
1984, ceramic, height 78 cm

Annalies Klophaus, *Mensch*, 1983, drawing.

Walpurgisnacht where Anaxagoras and Thales debate the world's underlying substance. Here Anaxagoras, an adherent of the catastrophe theory, causes a mountain to grow which is inhabited by pygmies. They immediately get into trouble through their own wickedness and vengefulness, so that the philosopher, 'after a pause, speaking with solemnity', feels compelled 'in this to raise his hands to heaven':

> Ageless on high, and evermore the same,
> Threefold in nature and threefold in name,
> Out of my people's woes I cry to thee,
> Diana, Luna, Hecate!
> Thou deep of heart, the soul's endower,
> Thou outward peaceful, yet of inmost power,
> Reveal thy fearful gulf, profound as night,
> And, without magic, show the ancient might.*

Diana (in the above verse) is the Roman form of the Greek Artemis, the maiden-huntress. Luna corresponds to the Greek Selene, goddess of the moon, whose other aspects were Artemis and Hecate. It is claimed that Luna bore a strangely scintillating relationship to the mythical Cassandra – not the literary Cassandra – and indeed was identical with her. For originally the twin brother and sister, Helenus-Cassandra, were one person, namely the Argive moon goddess Selene, who was fused into the Trojan Helen and the Greek Helen. So Cassandra remained as Paris's sister, a 'Hellenised version of the Trojan Helen': beautiful (like Helen), endowed with the gift of prophecy like the Greek Helen and the Trojan Helenus. By the way, prophetic power was once closely linked to the moon deity. It was not exercised in the service of Apollo, the god of light and the sun. *He* is much younger than Hecate, Selene, Helen, Helenus and Cassandra, and is a mythological reflex of the patriarchal revaluation of values, as is Aristotle's *Poetics* in the realm of art legislation. Goethe's predecessors and Goethe himself, as a young member of the middle class, rescinded the *Poetics* along with the rules and other lumber of the French aristocracy. But never, as far as I know, did they argue against the passage from Chapter 15 of the *Poetics* about 'Characters',

* All passages from *Faust*, Part II, on this and succeeding pages, are quoted from the Philip Wayne translation (New York, Penguin Books, 1959).

where Aristotle asks authors to take care that their characters possess 'goodness'. He goes on: 'Women, too, and even a slave can be good, although in general woman is perhaps an inferior, and the slave a worthless being.' For this reason it was logical that women never attended Greek tragedy, not even as actresses. Iphigenia, Antigone, Clytemnestra, Electra, Medea, Hecate, the Trojan women, were all men in women's dress, wearing buskins, slender-limbed no doubt, pretty, possibly homoerotic – but men. This whole earthy-fruitful hodge-podge, this undisciplined tendency to merge and change into each other, this thing which it was hard to put a name to, this throng of women, mothers and goddesses which it was hard to classify and to count, was brought under control, along with the right of male inheritance and private property, after what appear to have been long, difficult centuries, which now are described as 'dark' and have been forgotten. The prohibitions of that day still tell us what things made people feel threatened. Aristotle: 'For example, character is good when a man has courage; but in general it is not appropriate for a woman to be brave and manly or even alarming.' Alarming to whom – to the man, who has deprived her of all education, of all public activity, of course, of the right to vote? Yes, precisely *because* he has done so. We know from our own experience that the things we exclude and ban are the things we have to fear. This is what happens to Goethe's Anaxagoras, who, you will remember, has recklessly invoked the moon goddess and learns to his horror: She is coming!

> Lo, ever mightier, candescent, clear,
> With orbed throne the goddess, looming near,
> Brings terror to the eyes, a portent dire,
> And gulfs of gloom now redden with that fire.
> Thus far, no further, globe of threatening power,
> Lest we, earth, ocean perish in this hour.

A rock has fallen out of the moon and crushed the race of pygmies. So this was what Anaxagoras had intended as an example of the 'ancient might' 'without magic'! Surely his plight is an anticipation of the significant, painful insight voiced by the aged Faust in the ghostly presence of the 'four grey Hags' (Want, Guilt, Need, Care – if there were only three of them the analogy to the three Moirae, the Parcae, the Norns, the weavers of fate would be complete):

> Could I but break the spell, all magic spurning,
> And clear my path, all sorceries unlearning,
> Free then, in Nature's sight, from evil ban,
> I'd know at last the worth of being man.

Magic, though, was once exclusively the art of women (who, when driven to lovelessness, revert, not without reason, to magic spells). It was the art of the female tribal elders in the early agricultural societies; then, for a long time, of the priestesses, from whom the first priests could entice away the ritual only by pushing their way into the magical clothing of women. It would seem comical to me to point out these things in a tone of indignation, for humanity could not stay at the level of magic and sorcery. But what I ask myself and you is: Was it necessary that the man should come to stand 'alone' before Nature – opposite Nature, not in it?*

Recently I was discussing the problems of modern science with a company of younger scientists, and we also talked about the history of woman in the West. One of the young men – evidently determined to come clean at last – declared: 'People should stop complaining about the lot of woman in the past. The fact that she was subordinated to the man, took care of him, served him – that was the precondition for the man's ability to concentrate on science or on art, and to achieve peak results in both fields. Progress was and is possible in no other way, and all the rest is just sentimental twaddle.' A murmur arose in the room. I agreed with the man. The kind of progress in art and science to which we have grown accustomed – extraordinary peak achievements – *is* possible only in this way. It is possible only through depersonalisation. I suggested that a kind of Hippocratic oath should be introduced into the mathematical sciences which would forbid any scientist to collaborate in research that served military ends; and the debaters declared that this was unrealistic. If scientists here did not break the oaths (they retorted), they would in any case be broken somewhere else; there could be no taboos on research. 'For me,' I said, 'the price is now too high for the kind of research that science as an institution has been producing for some time.' Later, I heard that some of the participants had detected in me a trend of hostility toward science. A ridiculous misunder-

* Cf. the original line in Goethe, *Stünd ich, Natur! vor dir ein Mann allein* (lit. 'If, Nature, I stood before you a man alone'), in Act 5 p.f *Faust*, Part II ('Midnight' scene).

standing! I thought in the first moment. Then I paused. Could I be 'amicably' disposed towards a science which has moved so far from the thirst for knowledge it derives from, and with which I still secretly identify it? I believe we have to stop taking seriously the labels that people throw at us. [. . .]

I must ask you not to lose patience. Don't think I have lost sight of the question I am really trying to get at: Who was Cassandra before people wrote about her? (For she is a creation of the poets, she speaks only through them, we have only their view of her. . . . This, too, is one of the trails I must follow up, until another trail branches off that I must follow, until the third compels me to let go of the second.) What I would like is to communicate to you the feeling which has induced my restlessness – a restlessness which this letter no doubt reflects. It is the feeling that everything is fundamentally related; and that the strictly one-track-minded approach – the extraction of a single 'skein' for purposes of narration and study – damages the entire fabric, including the 'skein'. Yet to put it in simplified terms, this one-track-minded route is the one that has been followed by western thought: the route of segregation, of the renunciation of the manifoldness of phenomena, in favour of dualism and monism, in favour of closed systems and pictures of the world; of the renunciation of subjectivity in favour of a sealed 'objectivity'. [. . .]

Aeschylus is still conscious that, in the beginning, the world was ruled 'by the triform Moirae and the fidelity of the Erinyes'. Even Zeus – whose figure appears only with the existence of kingdoms governed by male succession – could not long override the dictates of the Moirae, the elder goddesses of fate. Two processes ran parallel: the formation of nation-states and the overcoming of ancient tribal goddesses by the new, state-recognized gods. It was in these same centuries that the god Apollo annexed the shrine at Delphi. Initially the mountain nymph Daphne ('laurel'), once installed by the earth-mother Ge as a soothsayer-priestess, used to perform her duties at Delphi in a simple hut of laurel branches. This was in the second millennium BC – the time of the 'historical' Cassandra! At Delphi, too, there was a purely matriarchal cult of priestesses who accompanied every important public occasion of their clan, their tribe, with choral chant, dance, ritual sacrifices, and the pronouncement of oracles. Later came a 'temple of wax and feathers', which had allegedly been built by bees (these creatures which belong to female clans). Finally, these cults gave way to the first great Bronze Age

temple, which arose in seventh-century Delphi and now was unequivocally dedicated to Apollo, and which is said to have borne the 'golden singers' only as figures adorning the pediment. These were the so-called keledones, shouting women, who used to go to the crossroads once a month and invoke the moon – a cult linked to Demeter and Artemis, the sister of Apollo . . .

The women were incorporated into the pediment frieze of the male god. But down below, in the temple of Delphi itself, was the soothsaying Pythia, the only woman left in the otherwise exclusively masculine cult of the oracle. Now she was nothing more than a medium in the control of the powerful priests, placed in a trance by narcotic vapors, by the chewing of laurel, perhaps by autosuggestion or hypnosis. Stammering, writhing, she uttered the incoherent words of her oracle, whose interpretation and, to some extent, poetic formulation once again devolved upon men – priests, the first poets. At first men had identified with women, mimed the birth process, castrated themselves so they could become priests (it is claimed that even Apollo did this); wormed their way into the office of priestess dressed in women's clothing (Apollo is said to have done this, too). At Delphi later this relationship is more than simply reversed – the woman becomes a tool in the hand of the men. Here, in the profession of poet, prophet, priest, which derives from a magical root, you can detect it most clearly: the woman, once the executant, has either been excluded or turned into an object.

Centuries have passed since then. At one seam of these conflict-ridden happenings stands Cassandra. Daughter of a royal house in which patrilinear succession seems secure; but in which the queen, Hecuba – who, many scholars believe, comes from the matriarchal culture of the Locrians – has not yet sunk into insignificance on that account. Moreover, here the transitional custom by which a suitor steals a princess because only the woman could confer the throne on the man is still a familiar phenomenon (witness Paris's abduction of Helen). In this house, the ancient matriarchal cults may well be practised alongside the young cults of the new gods; especially, no doubt, by the rural population, especially by the lower classes. In this house a young woman can become a priestess, but there is no chief priestess anymore. In this house she can be a 'seeress' overwhelmed by visions, and qualify as such, but she cannot be the official oracle. It is men who read the future out of the flight of birds, the entrails of sacrificed animals. Men like Calchas, Helenus, Laocoön. She lives in

a culture which perhaps was no match for the strictly patriarchal culture of the Mycenaean Achaeans, for their harsh determination to conquer. Perhaps Cassandra was not 'really' a priestess of Apollo at all? (Please don't protest, she actually did exist!) Or at least perhaps she was the priestess of a different Apollo from the 'radiant' god of the Classical Greek pantheon, he who 'strikes his mark from afar'? Was she priestess of an older Apollo who appropriately bore the designation 'Loxias', 'the dark one'; whose wolfish ancestry, whose dual identity with his twin sister Artemis, were still present in the people's minds? In the same way the Athena who is honoured in another of Troy's temples cannot have been the classical Pallas Athena but a cult symbol. Her qualities lie somewhere between those of the chthonic female ancestor-idols, and of that later virginal, dominating goddess who sprang from no mother's womb but from the head of her father Zeus. This latter Athena sprang forth like thought, which Greek men – intellectuals, of course – are taking charge of during this period, in order to drive it to astonishing heights, to an admirable level of abstraction. Thought too, indeed, has no mother but only fathers. Does it seem misguided to you to believe that if woman had helped to think 'thought' over the last two thousand years, the life of thought would be different today? (We forget too easily: woman as an intellectual has existed in appreciable numbers only for the last sixty or seventy years. We know stories of her and about her, but *her* history – a history of incredible exertion and courage, but also of incredible self-denial and renunciation of the claims of her nature – has still to be written. It would be, at the same time, the history of one of the undersides of our culture.) [. . .]

Now, dear A., this is a wide field, but I think we had to come to the edge of it if we were to follow the lead of the watchword 'Cassandra'. Do people suspect, do *we* suspect, how difficult and in fact dangerous it can be when life is restored to an 'object'? When the idol begins to feel again? When 'it' finds speech again? When it has to say 'I', as a woman? We see a landscape generations wide where the writing woman still tends to get lost: lost in the man, the male institutions, federations, churches, parties, states. We have eyewitness and earwitness documents of how men and women talk to each other. Let's take the things the man Elnis says to the woman Ebba in Fleisser's *Tiefseefisch*: 'A woman who loves a man can do anything.' 'I am so tender inside.' 'My sufferings are your sufferings. We are one body and one flesh.' 'You shall have no will. You shall no longer be

there. I want to absorb you.' 'You must become completely my slave, and I must become completely your slave.' 'I have seized on you the way a male animal corners his mate. I defend my prey. I will think about you so rigorously that it will keep you at my side, spellbound.' 'You will forget that you are being sacrificed.' 'I am a magician.' 'You must trust in me blindly. Naturally I cannot have someone near me who doubts.' 'Put an end to yourself if you feel sorry for yourself. Hang yourself, walk into the water! Then there'll be one less woman.' 'I will make a human being out of you yet.'

And what does the woman say in this forlorn landscape? What can she reply to this man who is diseased in himself? She says things like this: 'I cannot see my way in my life anymore. Am I not a human being who feels things?' 'You will not be a slave, not you.' 'It is terrible.' 'You would not ill-treat people if you were not handsome.' 'Mine is a nature that sees ahead. I can renounce things.' 'I am always forced to see the abyss. I could scratch the eyes out of my head.' 'I want to become different.' 'His eyes accuse me. I could wipe myself off the face of the earth.'

Dear A., you know as well as I do that you cannot argue against such sentences, using other sentences that begin, shall we say, with 'But'. I claim that every woman in this century and in our cultural sphere who has ventured into male-dominated institutions – 'literature' and 'aesthetics' are such institutions – must have experienced the desire for self-destruction. In her novel *Malina*, Ingeborg Bachmann has the woman disappear inside the wall at the end, and the man Malina, who is a part of her, serenely states the case: 'There is no woman here.'

The last sentence reads: 'It was murder.'

It was also suicide.

Dear A., I have notified you that it is hard to define the limits of the theme around which my thoughts are orbiting. Nevertheless, I will not yield to the urge to talk about 'the position of women', to cite observations, to quote from letters. One day, no doubt, I must do so, if only to give legitimacy to what women write about women, which critics do not want to acknowledge. Of course, I see that this desire to legitimate still reflects the compulsive notion that we women have to adapt or disappear. I also see that it reflects indoctrination by that prevailing system of aesthetics that I have called up for discussion here. For women there have been three thousand years of muteness or, at best, sporadic speech. Then along comes a woman who says: 'I

will collect only the stories which do not come to public notice, and only stories with a lethal outcome' – *Todesarten* – 'Types of Death'.*
Dear A., I cannot prove my assertion – or can prove it only in isolated cases, which prove nothing in favour of the kind of summary declaration I am about to put forward so coolly – *but*, aesthetics, to the extent that it is a system of categorisation and control, and especially where it advocates certain views about the subject-matter of the various genres, namely 'reality' (I notice this word appearing between quotation marks more and more often in my writing, but I can't help it) – aesthetics, I say, like philosophy and science, is invented not so much to enable us to get closer to reality as for the purpose of warding it off, of protecting against it.

Do you think that Bachmann did not know how Goethe wrote novels, as well as Stendhal, Tolstoy, Fontane, Proust and Joyce? Or do you think she was unable to foresee that a creation like the one she presented in the guise of a 'novel' would dumbfound all duly qualified rules and categories of aesthetics – even if they were interpreted with great latitude!? And that encountering no net, however thin, to break its fall, it would catapult straight to the ground? 'I am Madame Bovary.' Flaubert said that, as we know, and we have admired this remark for more than a hundred years. We also admire the tears Flaubert shed when he had to let Madame Bovary die, and the crystal-clear calculation of his wonderful novel, which he was able to write despite his tears; and we should not and will not stop admiring him. But Flaubert was *not* Madame Bovary; we cannot completely ignore that fact in the end, despite all our goodwill and what we know of the secret relationship between an author and a figure created by art. But Ingeborg Bachmann *is* that nameless woman in *Malina*, she *is* the woman Franza in the novel fragment *The Franza Case* who simply cannot get a grip on her life, cannot give it a form; who simply cannot manage to make her experience into a presentable story, cannot produce it out of herself as an artistic product. Lack of talent? This objection does not apply, at least not in this case. To be sure, it is hard to understand that one sign of her quality as an artist is the very fact that she cannot kill the experience of the woman she is, in 'art'. A paradox, yes indeed. An ability to be

* The 'woman' is Ingeborg Bachmann. 'Types of Death' is the title of Bachmann's projected novel trilogy, left uncompleted at her death. The quotation about 'stories with a lethal outcome' is also taken from Bachmann, Vol. III of *Werke* I–IV.

'authentic' – to use another literary term – that comes only by renouncing the detachment afforded by definite forms. A frenzy driven to find words, that cannot adhere to the subduing ritual, that cannot adhere to anything, that is untamed, wild. A wild woman, you can only raise your arms in perplexity. It is a different kind of logic that comes from her, who perhaps better than any woman knows the male thinking process: the if this/then that; because/therefore; not only/but also. A different way of asking questions (no longer the murderous who did what to whom). A different kind of strength, a different kind of weakness. A different friendship, a different enmity. Whichever direction you look, whichever page you open the book at, you see the cave-in of the alternatives which until now have held together and torn apart our world, as well as the theory of the beautiful and of art. A new kind of tension seems to be struggling for expression, in horror and fear and tottering consternation. There is not even the consolation that this is still capable of being given form; not in the traditional sense. [. . .]

see page 301 ff. of
my full copy.

6
Gertrud Koch
Why Women Go to Men's Films

Going to the cinema is still not a particularly respectable way of spending your free time. This is particularly – although, of course, not exclusively – true of women film-goers. Women who regularly – or even occasionally – go to the cinema admit that they do so feeling that it is something forbidden, something that women just do not do. Strangely, this censure applies most strongly to those women who go alone; if they go with a male companion then it is acceptable to go the cinema. Nevertheless, there seems to be more to this censure than the traditional sanction against unaccompanied women in public meeting-places like pubs, streets, stations, etc., that is, the protection of a woman as a man's private property from the gaze of other men or from contact with them which could break his exclusive access to her. The aim of the sanction against going alone to pubs, etc. is to remove women from the voyeuristic gaze of men, whereas the implicit cinema prohibition denies the voyeuristic gaze to woman herself. Thus, what patriarchal society allows itself as an undisguised and conscious perversion is deemed indecent when applied to women going to the cinema. It is quite obvious that the voyeuristic gaze, like most other facets of the female erotic associated with the more aggressive sense of touch, has become taboo for women even though voyeurism is by no means limited to male childhood sexuality, and has in fact left its traces in female socialisation. Social history[1] shows quite clearly that even though women were the desired objects of male voyeurism, they themselves had to hide their own desires behind their veils, the bars on their boudoir windows, their expensive and time-consuming make-up rituals. In the male gaze they saw only a reflection of themselves. It is this which must have confined women in their past socialisation to

narcissism, to a voyeurism which is rejected by the more aggressive male gaze and confines itself to the exhibitionism of the narcissistic woman. Woman is subjugated by the dominant gaze before she can even begin to measure herself against man, to measure her gaze against his. All that she can do is look demurely at the ground, to strip her expression of all meaning in order to deny and avoid the aggression of his gaze, or to take refuge behind the mask which conceals the gaze.

One of the most unnerving camera angles in the history of film gets its ambivalence from the breaking of the taboo on women's gaze. In *Sommaren med Monika* (Sweden, 1952, directed by Ingmar Bergman; English title, *Summer with Monika* or *Monika*) there is a long, static scene in which Harriet Andersson looks directly into the camera, that is, she looks directly out of the screen at the spectator. Because she is not looking at some imaginary distant point as is usually the case, the spectator gets the impression that she is looking straight at her/him. This use of the camera was felt to be extremely unsettling when it was first used and it is still very suggestive. Harriet Andersson's deeply sad and slightly contemptuous expression has itself something of the female gaze which is denied insight into the world. At the same time, it radiates an unequivocally erotic allure which corresponds with Andersson's role as a kind of proletarian vamp. The 'lost' gaze accompanies the breaking of the taboo on the gaze: if woman dares to gaze then there is nobody who can freely reply to her. The inherent unhappiness of love has been anticipated in this camera angle. The autonomous, freely gazing woman will never find anyone who can stand up to her gaze, who will not try to deflect and subjugate her gaze.

The vamp is one of the few female stereotypes who is allowed to gaze uninhibitedly at men. Mae West is an example, who directly links the denigrating 'sizing up of a hunk of meat' look with her sexual ambitions: for instance, after having looked men up and down, she gives them a discriminating pinch on the bottom. Her opposite is Marilyn Monroe's surreptitious gaze. In *How to Marry a Millionaire* (USA, 1953, directed by J. Negulesco) she is short-sighted, almost incapable of seeing anything. Because of this she can be narcissistically enticing without being affected by the male gaze all that much. This is a phenomenon for which Schneider and Laermann have found historical precedents and labelled the 'deadly nightshade gaze':

The poisonous alkaloid (atropine) found in it [the eye-wash made from deadly nightshade – G.K.] caused the pupils to dilate and thereby imitated erotic arousal in which the eyes dilate of their own accord. But an eye aroused by using this concoction was blind as well as burning with passion ... Women could only see through blurred eyes. Their refracted gaze could itself no longer catch the brightness that it emitted.[2]

But why do women go to films in which women offer themselves as objects to the male voyeuristic gaze? For me it is not enough merely to see this as a kind of identification with the male aggressor by which the supremacy of his gaze is validated and to which woman is subject. It is important to recognise in addition that there is a certain congruence in men's and women's view of woman, for male and female socialisations do correspond up to a certain point – that is, for as long as the love-object for both is the mother. The common childhood joy in gazing is the basis for activating that joy in women as well as in men, and for turning women's gaze on women and not only on members of the opposite sex. At this early childhood stage gender identities have not yet been established in the child's consciousness, who still believes that she can change sex at will as she has not yet grasped that sex is biologically determined. Man's fear of permitting female voyeurism stems not only from a fear of women looking at other men and drawing (to him perhaps unfavourable) comparisons but is also connected to a fear that women's bisexuality could make them competitors for the male preserve. And there's certainly a genuine basis for men's undisguised jealousy of the female pleasures of women dressing each other, combing each other's hair, oiling each other, which come from a joy in looking at each other. The relevance of this becomes clear when we try to understand the preferences of women film-goers for certain women stars. The success and popularity of Marlene Dietrich and Greta Garbo, for example, very probably has a lot to do with their fleeting bisexuality. This also explains why not all men like the female stereotypes embodied by these two stars.

Many female stars from Asta Nielsen to Lieselotte Pulver have at some time dressed up as men and played 'male' roles. Yet very few have incorporated androgynous or transvestite images of woman. Dressing up as a man has more often been merely part of the plot and the role was always a very consciously assumed one. Many of

Marlene Dietrich's roles are impressive examples of the aesthetic mystification of sexual identity. This is very obvious in *Blonde Venus* (USA, 1931, directed by Josef von Sternberg). What is interesting about this film is the combination of the androgynous disguise with the role of mother. The result is that the spectator is placed in the role of child. Marlene Dietrich is transformed from a star appearing in a dinner-jacket to the crooning mother at the cradle by the emotional investment in and identification with the child on the part of the spectator. This transformation takes place in a context which directly draws on emotional elements in childhood which are determined by the child's lack of knowledge about the division of gender roles and the resulting joy in gazing, as well as by the continuous uncertainty about sex characteristics. It's safe to assume that not only the male mode of socialisation crystallises out of this diffusion of sexual perception but that the female mode does too. We know that, for the first three or four years of life, children are unaware of sexual difference in spite of their parents' efforts to tell them the facts of life, and the force of social norms. This infantile ambivalence, then, might explain the fascination exerted over many woman by many female stars who play androgynous roles. However, it is undoubtedly the case that these roles are submerged by other connotations which obviously relate to the interests and needs of male socialisation. (We shall come back to this point and its significance for the female spectator later.)

In the darkness of the cinema women can indulge their voyeurism which is otherwise denied them or of which they are themselves the object. This does not mean that they can see there what they actually (if only unconsciously) want to see. They are, after all, dependent on what the market has to offer. It is only very recently that there have been alternatives on show in the ever-increasing number of women's cinemas. And it remains true that the vast majority of films feature female stereotypes which do have an empirical correlative in women's social reality, and that many films, even those made by men, have as their primary intended audience women. Women's preference for melodrama, comedy and the so-called 'problem film', as well as their rejection of the thriller, horror and war film, westerns and pornography clearly shows that women draw firm boundaries within male film production between what is acceptable and what is not. Of course, many women go to films not fitting into the 'woman preferred' category because these are their male escorts' choice, or

perhaps because they are curious to find out what attracts men to certain stars.[3]

Apart from a few psychoanalytical studies on how films are received, it is conspicuous that most studies are based on a concept of roles which only recognises established social roles and the norms associated with them. The historical context which determined these roles, and the idea of an unfolding inner nature which is more than merely the sum of the roles and functions ascribed to an individual in a social system, is almost totally ignored. However, because in a patriarchal society the social role of man is exclusively defined in terms of being the superior provider and worker, woman's role is necessarily defined as merely complementary and not as one which has its own history. It is this recognition of woman as having her own history which is the precondition above all others for perceiving woman as subject. In so far as these studies of the film consider this theme at all they will always be marred by a fundamental lack of theoretical foundation even though many have highlighted interesting gender-specific differences.

In most of the available studies, however, gender-specific differences are only very superficially dealt with. For market research, gender is certainly significant in that it has been independently recognised by statisticians as one of the two variables (along with age) which is applicable to all quantitative operations. In practice, however, this means quantifying the unknown, because whatever is regarded as biological, and thus unchangeable and autonomous, is not given any precise meaning or any theoretical foundation. So it comes as no surprise when the female is usually described as deviating from the male, expressed in the form: men like x, women prefer y. Flicking through these studies is like looking at a nineteenth-century atlas. They are spotted with blank patches, unexplored areas, which nevertheless already bear the names of the colonisers: the routes are known; who owns what has already been agreed. The mystification of woman (in so far as woman becomes the centre of attention at all) corresponds to the tacit primacy of research interest in the male half of the population. The more patriarchal society made woman into the enemy within its own gates (Hegel),[4] that is, the expression of a world living according to other principles, the more it was logical that the delving into the inner nature of woman, into her femininity, was either dismissed or confined by mystifying natural categories. And where norms are no longer derived from biology, the question of

the social and ethical legitimation of the whole value-system and its gender-specific division comes into play. Such a questioning has always aroused the hatred of those members of a social system who have a vested interest in an unquestioned exercise of power. Freud, for one, stated quite clearly what the reasons for this tendency to mystify women were: 'Some portion of what we men call the "enigma of women" may perhaps be derived from this expression of bisexuality in women's lives.[5]

The psychoanalytical approach has in many cases provided an excellent framework for understanding the complexities in the perception of films; the myriad effects which films have cannot be explained by a theory of learning involving reinforcement or change of attitude. The psychoanalytic approach is concerned with the inner psychological processing and assimilation of what is seen and its impact on the psychology of the subjects themselves. At the same time this approach assumes that films build on psychic mechanisms which they then activate in the spectator. According to this theory, films are more the reflections and the products of the inner nature of the subjects, of their desires, needs, erotic ideals, instincts, etc., and less the representations of an external or social world. It is here that a few short-circuits have occurred in the feminist discussion. It is not enough, for example, to say that films made by men portray women through men's eyes, and give a more or less pathologically distorted view of woman and thus say more about the inner nature of the representatives of patriarchal culture than about the women pre-sented and the women audience. The overt behaviour of women, who only in the last fifteen years have kept away from the cinema, since the films on offer have become primarily those which women traditionally don't like, has still not been explained. The question of why women went to the cinema in the past in spite of patriarchal dominance and why they still occasionally go now has still not been answered.

The assumption contained in this question is that the film's message can be smoothly transferred to the audience: a notion which is itself probably a leftover of the behaviourist consciousness of the here and now. Many theoretical arguments about the film as genre which oppose this idea can be cited, arguments which consider the product as well as the audience. And even if the aesthetic of a film is primarily defined by the intention of a single man and an authori-tarian patriarchal apparatus – for example, when Sternberg boastingly

declared that the Marlene Dietrich myth was exclusively his own invention – the film's connotations are always independent of and transcend the director's intention. It is this discrepancy which makes every form of visual art individual and specific. Images never have the clarity and unambiguity of verbal language which can rise to conceptual meta-levels and from there posit meanings. The concept 'table' can always subsume all the actual tables. The film-image of table, on the other hand, is always the image of the particular table in front of the camera. Sternberg may indeed have intended to create the myth of woman in the images of Marlene Dietrich, but this myth still has a living referent. This actuality of film images is not without consequences for their reception. Films can most certainly create myths, stereotypes and clichés, that is, ideal psychic images, but these are in no way comparable to conceptual abstractions. They are themselves merely images of inner images, pre-verbal signs of a non-verbal world which can only become linguistically accessible by a long and laborious process of interpretation. Of course, the effect of these images is independent of whether I am able to give them verbal form. I can, after all, appreciate a film without any command of language. 'To see is to recognise,' Jean Mitry[6] once wrote. The psychoanalytic micro-analysis of seeing and recognising shows, however, that it is not only the case that films reflect subjective needs. It is rather that the subject will recognise her/his needs in the film. Thus it is that the process of appreciating a film is rather like producing the film for a second time; that is, the film is created in the mind of the audience and exists in as many variations as there are spectators. This is not to say that perception is arbitrary. It does, however, seem to be sensible to work on the assumption that the variation in the subjective perception and assimilation of visual objects is very much greater than is often assumed in discrete investigations. Besides, these investigations themselves depend on the process of translation into verbal language and represent past experience in their very treatment of the films they discuss.

It is possible that, contrary to the intentions of their creators, many film-images leave the way open for a multiplicity of inter-pretations. From this it may be suggested that these images are like the *trompe l'oeil* pictures of the mannerists – those pictures which seem to change their motifs, forms and meanings according to the position of the spectator; only in the case of film images, these change according to sex. An example of this would be the reinter-

pretation of the female stereotype which Marilyn Monroe epitomised in her films. Another might be the rediscovery of Mae West who was the object of much criticism by women's associations in America in the 1940s and is now largely accepted as an example of female autonomy.

The lack of historical investigations into women's response to films is not least evidence of the failure to recognise woman as subject. We know that there must have been a response, but we cannot say how it came about, or what form it takes today. In their search for their own identity, women are still far more concerned with the images male society has made of them than with women themselves. Thus, there are many excellent feminist analyses of images of women which all show that these images are a male invention, the projections of male myths and fears about women, but they hardly touch on the subjective meaning of these images for women themselves. This might be explained by the fear of touching on this theme at all, of losing oneself in false images if there is no analytical distance from them. The result, however, is that we still know very little about how these images actually correspond with the inner lives of women. I mean by that more than merely the normative pressures governing social behaviour – choice of hairstyle, or a husband to be seen off in the morning. It is more a question of whether there might not have been something like a history (sub-history) of women's response to films and to the cinema which was not entirely dictated by the male gaze but which gave minimal scope for female projections.

Laura Mulvey, the British feminist art critic and theorist, has shown in an analysis[7] of the psychoanalytic structures of the narrative Hollywood film that the ideal image of Marlene Dietrich rests on a mechanism which interprets woman as a castrated man and attempts to alleviate this threatening example of unprecedented punishment by a fetishised 'elevation' of the penis above its 'loss'. The stereotype of the vamp is thereby explained by recourse to the classic psychoanalytical assumption of a male castration complex, that man fetishised the image of woman according to his own needs. Mulvey does not go further to tell us what this confirmation of Freud's assumption means for the female spectator. According to Freud, it is not only man who experiences woman as castrated, but woman as well. That would be an explanation of why women, or at least the so-called 'phallic women', like these fetishised stars as much

as men do. However, one would be well advised to see Freud's thesis about women regarding themselves as castrated in its historical context. Nowhere does Freud write that this is a natural, necessary mechanism of female socialisation rooted in anthropology. On the contrary, for Freud it obviously applies only to a few women, and even then only for as long as society is primarily phallocentric. The phallus, therefore, said to be replaced by the fetishisation of film stars, is only given power when it combines with social power as is the case in most patriarchal societies. Studies into the cognitive development of children have shown how strong the social components are in forming gender identity.[8] Ulrike Prokop, too, in a reconstruction of this psychoanalytical assumption, argues that the castration complex contains a large historical-empirical element:

> Both sexes unite under a false symbol, a symbol which in the unconscious is that of freedom, power and status. The real relationships are destroyed as man fetishises this symbol in order to overcome his fear of woman. At the same time he despises woman and possesses proof of his superiority and wholeness, whereas woman cannot overcome her self-denigration which remains repressed. Both sexes interact on the basis of the mutual confirmation of this mistaken identification. But this basis of their agreement leads to subjective suffering. This mistaken identification is classified as normal in so far as the ability to love and work is not impaired by it. It is a part of institutionalised alienation.[9]

The oppression of woman does not begin with the false images of her. It is a cardinal weakness of many analyses that they mistake the effects for the cause, and then of course cannot explain why women like watching obviously phallocentric films. Not until it has been shown which needs these Hollywood films have created and which they seem to have satisfied will we have adequately explained why women, too, have crushes on female film stars. The impact of male stars like Rudolph Valentino, James Dean, etc. has also by no means been properly explained. Martha Wolfenstein and Nathan Leites[10] have investigated the American film's syndrome of the 'good little bad girl' in their famous study, and have discovered that images of women are culture-specific by making an international comparison of images of women in films. If the results of these investigations are

correct – and there can be little doubt about that – then they can tell us more about the needs of a female audience. The division into good–evil, mother–whore, marriage–sex, fidelity–infidelity, which form the subject-matter of a whole set of films which Wolfenstein and Leites consider, do in fact correspond to the psychological divisions in woman between the evil, phallic woman, and the submissive, weak, but virtuous woman who is usually represented by sister, mother, wife or daughter. The desire to overcome and subsume these artificial alternatives in a new identity is beginning to gain momentum, a longing which existed before the women's movement tried to articulate it or grasp it conceptually with the object of breaking the false hold of the 'mutual confirmation of this false objectification' (Prokop). This division is the theme of many films in which the fragmented parts begin to play a role (although harmonised in the plot by apparent solutions). The vamp who sleeps with anyone, the ice-cold criminal type of easy virtue – these satisfy women's erotic needs for unrestrained sexuality unbounded by dependence and norms. A keen film-goer once expressed this division in herself and in the film-images like this: 'I so much wanted to live as freely as the sex goddess Pola Negri but I probably came closer to the virtuous Paula Wessely.'[11]

The ideal image of the vamp which represents the fetishised woman had many more connotations for men than simply that of substitute phallus. It is true, though, that for this purpose the very tight, sequinned dress is ideal, for it encloses the female body in a glistening skin; the head was often covered by a tight pointed hat; and in the 1950s the breasts were artificially shaped, quite often in the form of the tip of an erect penis.

That the vamp *was* more than a phallic substitute though is shown for example by Bette Davis in *In Our Time, Mr Skeffington* (USA, 1944, directed by V. Sherman). The theme of this film is the stereotype of female narcissism, a stereotype which is embodied by the vamp in the eyes of the male spectator or phallic woman just as well as the function described above. In this film, Bette Davis plays a young, very beautiful woman who marries a very rich older man. Mrs Skeffington leads an extravagant life which she enjoys largely in the company of younger admirers. When, however, it comes to quarrels with her husband she sinks to the level of a woman spoilt by her beauty who organises her daily life and her identity around the exhibition and acknowledgement of her body. The autonomy which

she thereby wins is that of total frigidity, and absolute power over men of whom she is erotically independent, whom she in fact gathers around her merely to reflect her own good looks. The narcissistic behaviour of this woman is 'of course' punished by a severe illness and the end shows her (now old) forced to return, full of self-reproach, to her blind husband. In spite of its affirmative ending and its mediocrity, this by no means atypical film shows how stereotypes of feminine character, which most certainly also contain the promise of gratification to women, can be found in the genre of the melodrama (or, in this case, a film tending to the 'problem film' by virtue of its references to anti-semitism and the persecution of the Jews in Nazi Germany) which is a genre particularly popular amongst women. In this film, woman's narcissism is merely pressed into the scheme of the 'good little bad girl' and affirmatively denounced as for her husband alone. He is to be the sole beneficiary of female beauty which is shown to be the result of the concentration of all her instincts on exhibitionism and the erotic elements in her own body.

These components in the female erotic are, however, radicalised by Marlene Dietrich. When in *The Blue Angel* (Germany, 1930, directed by Josef von Sternberg) she sings of how men gather round her like moths around a light, when she entices among others the unerotic professor who, by giving up his social position, can offer her the highest narcissistic satisfaction because he is prepared to pay the highest price to love her, then it is very probable that she represents the autonomy and restrained power which is the dream of many women who are themselves oppressed in marriage.

Paul G. Cressey,[12] in an early essay on film reception, defined the possibilities of projection, introjection and substitution as modes of identification. It may be assumed that these modes find counterparts in the structures of preference in the female audience. Introjection, the most powerful form of identification, has become increasingly difficult for women. This means that women no longer go to the cinema in such large numbers because the insipid films now on offer allow only the weaker forms of identification – projection and substitution. It is precisely those film genres which made introjection most easy which have disappeared from the range of films on offer today. Interest in going to the cinema drops altogether if identification has to take place by means of projection and substitution. This is because television, too, can offer these forms of identification while also preventing rather than promoting total introjection,

because its aesthetic and social characteristics mean that many diversions become part and parcel of television viewing.

Cressey's concepts can be reconstructed in psychoanalytical terms along the lines of the model developed by Günther Salje.[13] Salje works from the assumption that the special effect of visual media is based on a kind of translation process in which pre-linguistic, that is, pre-symbolic scenes (in conjunction with the 'primal scene'), are reactivated within the unconscious. According to this, clichés are the representations of early childhood interactions and experiences which are not raised to the level of symbolic representation by means of the linguistic, interpretational discourse which takes place in the therapeutic transferral process. It is because of this that the visual image has scope for influencing the subject in such a regressive and almost direct way. The stronger the potential for the transfer becomes the more complete the identification which takes place. Although Salje gives the mode of transferral a central significance in film and television appreciation it is important to bear in mind that the intensity of the transferral is also dependent on the stimuli of the film material. It seems that the films on offer have become increasingly inappropriate for introjection. A decrease in the number of images of women in films with which women can identify is matched by a decrease in female cinema attendance. It is precisely the needs of the female audience for narcissistic and voyeuristic elements which have been increasingly neglected. The stereotype of the vamp, the autonomous and narcissistic woman – a European import as Wolfenstein and Leites have shown – has given way to that vague image of woman which only distinguishes between comrade and sex partner, a polarisation which in fact only roughly corresponds to what makes up the ambivalences and fragmentation of roles in the female condition. It has become more and more difficult for women to experience a transferral in the cinema. Television's blank stereotypes which are open to any kind of projection are better suited to this. Women's absence from the cinema is itself part of their identity crisis. The images of women which men's films propagate only perpetuate the repressive demystification of woman whose 'enigma' – her bisexuality – is hawked as a superficial stimulus in soft-focus porn. The exaggerated elevation to the grandiose, which Morgenthaler[14] sees as a perverse trait, has in the form of the authentic aura of female narcissism entirely disappeared from the cinema.

7
Jutta Brückner
Women Behind the Camera

Women are waking up to the fact that as film-makers they continue to work within a society which creates and controls consciousness through the media. In this media world women, who have always been exploited (even in many sociological studies) because they are thought of exclusively in terms of deficits, are somehow supposed to become active subjects overnight. Behind the camera, trapped in a production process which has its origins in male ways of thinking and feeling about separation and composition, they are expected to function as creators and express what society has up until now not allowed them to develop – a 'feminist aesthetic'. This is true of both the public sphere of the historical past and the private sphere of the family. The leap from being a loved and manipulated object to being an autonomous, self-determining subject is a little too radical and sudden for there to be no friction between financial backer and director, film crew and director, film and the public. But above all, women are causing friction within themselves. And it is still an enormous temptation to assume a role familiar since our nursery days, that of Daddy's spoilt little darling who can't distinguish caprice from autonomy.

I want here to talk exclusively about the women who resist that temptation. The difficulties they face are tremendous. And even if one assumes that the hour of women has come because, amongst other things, the brokenness of women is more powerful than the wholeness of men, at the same time we are forced to recognise that this society remains well organised enough to drain and break us. And the instinct which defends itself against radical feminism is still alive and kicking. This is relevant because women could not or would not keep feminist films to themselves. These films are not

geared to any special audience; they are not minority films as well-meaning people today still sometimes think. Like every movement which considers itself avant-garde, women film-makers try to reinterpret history, and art history as well, right down to the basics of the western belief in 'ratio', in the *'cogito ergo sum'*. The aims of women film-makers are all-encompassing. This makes them demanding but also essential for survival. Thanks to their 'deficits' women have not forgotten that there is a life which is more than the sum of functions, roles and emotions. Capitalism, the deadly enemy of both art and woman (Ernst Bloch), quite rightly senses the full-frontal attack. Women have for centuries been allowed to practise the fine arts as amateurs while their husbands devoted themselves to the more serious task of creating a society in which women's art was denied any revelatory function and only given the status of decoration. This is not only a patriarchal whim but contains a logical correlation which could itself now turn against patriarchy, namely that women are becoming active at precisely that moment when they have at their disposal an art form which can virtually pinpoint what they have lost most, that is, the pre-linguistic, intimated reality of sensuousness – and not only the sensuousness of the eye. Exposed to our collective conformity and at the price of collective repression, the cinema offers us a place to focus our own desires for particular images, to explore our own experience of linguistic and visual absence, for we have always been made into images instead of acquiring our own. We do not yet have this place, but we would like to have it.

From this negative catalogue it does not sound as if feminist films are going to give us the pleasure we should have if the cinema is to survive as culture. Instead, there is something horrifying about it. But demonstrating those deficits is what is needed today in order to allow a new realism to develop, a realism which does not exclude wish-production. If something does not exist in society then art should not represent it as though it does. Up until now women have refused to be part of that bad German tradition in which art has become a substitute for social movements.

Women's films search for clues and traces of the past. The consolidation of identity is their theme and is also contained in the process of making them; they are accounts of the hope for a self-aware life in which thought is bound to feeling. A feminist aesthetic is the expression of the difficulty of combining seeing with feeling at a

time when sight, the most abstract of all the senses, has taken false objectification to extremes. But it is also the expression of a process, the goal of which is the force which first sets it in motion – a feminist aesthetic. This aesthetic, which is so much in demand, cannot suddenly emerge simply because women are now standing behind the camera. A defeated sensuousness reacts in a defeated way to a defeating reality. The films bear witness to what is to be tolerated only under breakdown and protest. They are not portrayals of feminist insights however important these may be as supports; they are rather the meeting-place of a self-awareness located in the head, the stomach and the knee, gained through visual experience. Perhaps there will be moments in this process when it becomes clear what could be, if

When women do produce radical films, many people feel frustrated, including the many yearning intellectual men who love the cinema. They are frightened off because women film-makers insist on openly revealing what in the darkness of the cinema is only unconsciously sought by all who are not satisfied with functional reality. Feminist films are not suitable for film cults or film buffs; they do not conjure up the atmosphere of the cinema. They are signposts along the path of the gradual liberation of individual and collective creativity.

The difficulties will not diminish if we seem to become more familiar with the production apparatus and techniques. Women, who still have only a fragile self-confidence because only this is acceptable to modern society, must get themselves organised first before they organise anything else. They must organise not their daily routines but themselves; sort out the relation of their stomach ulcers to their calculating heads; the 'neurotic' need for sleep to the demands of a packed day of filming. They have to come to terms with their personal need to excavate their buried creativity, and the pressures to make the film profitable – or at least break even – and get it on the market immediately. We are developing strategies of social resistance, but social resistance is exactly what prevents the special insights we should be communicating from developing at all.

The path leads simultaneously inwards and outwards, the gaze reaches both forwards and backwards, the search for traces stretches into the past and into the future. The present becomes a moment on the journey to what is not yet no longer real. Gabi Teichert* delves

* Gabi Teichert is the main figure in Alexander Kluge's film *Die Patriotin*.

deep down into German history; we, too, delve deep down into ourselves and find German history even in the way we delve.

The result is often a deathly silence which can only be compared with the uncanny stillness at the centre of a real – not only a cinematic–hurricane. Or there is that slowly welling rage which uses existing aesthetic forms only with reluctance. But this is important to us, for it shows that the principle of capitalist rationalisation to which we must at least partially submit film-making has not yet taken possession of us from the inside. The leap from deficits to a confident creativity has something suicidal about it. Only women can tell us what kind of strength is needed to survive the schizophrenic strategies which society imposes on them as artists. It is a question of surviving, trapped between pragmatism and utopia. The tale of Münchhausen who pulled himself out of the bog by his own pigtail is for women a political fable in which the outside is inside, the inside outside.

Women's cinema lives in and by contradictions. It exists as a utopia of endlessly ever-coming-closer and is constantly threatened by social processes which seek to destroy it, not only through active hostility but also through passive refusal. It is not a question of the truth and nothing but the truth, but rather of the lesser untruth. Undeveloped modes whose final shape we can only guess at are no alternative to what already exists; in so far as they relate not to the actual but to the possible, they are a deficit, and any steps we take towards changing the present situation are no more than self-sufficient strategies if they only lead up the rungs of the ladder.

For example, the crucial demand of the Association of Women Film-Makers for 50 per cent of all subsidies poses the danger that we shall suddenly find ourselves without a foundation, that is, we shall be back to square one just because we have climbed the ladder rung by rung. But then again, we wouldn't have needed to begin filming if this danger did not exist in the first place.

That women who for so long have been 'behind' and 'underneath' now want to be 'in front' and 'above' is understandable. Our autonomy must already be very secure if, when offered a plate of sweets, we can still not only remind ourselves that sweets make us sick but also make it clear to our host that we have a right to a proper meal. Great strength is needed to reveal publicly truths which are opposed to the interests of the state-licensed TV channels, the moral sense of Conservative TV and radio listeners' associations, and the

conventions of sanctioned art whose crisis is self-evident. But to be honest with oneself is usually the hardest of all.

This has not become any easier even with a new theoretical consciousness and a few changes which have undermined some bastions of society. The courage it demands really hits home when it creates the autonomous female, for at the same time it destroys the lovable one. The dialectic of this process – to destroy in order to create – not only refers to a culture in which women could not, should not and do not want to have it easy, but also to women themselves. No one is certain what form the synthesis will take.

One of its possible components would be if we allowed ourselves to lose our justified fear of words like happiness and beauty – and not only our fear of the words, but also of what they stand for.

8
Christiane Erlemann
What is Feminist Architecture?

What is feminist architecture? This question is asked at every architectural workshop. It's a topic which arouses strong emotions and is passionately and controversially discussed. Yet before a complete rift forms it usually occurs to one of the participants (and after all, women must stick together!) that the present group cannot answer this question, that in fact the question has been wrongly put. And so everyone heaves a sigh of relief and turns to the problem of residents' participation.

My concern in this article is to revive this faltering discussion. I want to draw attention to dubious developments, consider rarely acknowledged events, come to new conclusions from well-known facts.

There is no end to the search for a form of expression for women who are both feminists and architects. The first few conferences from 1977 on for women engineers and architects were dominated by laments about the near impossibility of such an enterprise. Feelings of professional discontent, of not being able to find a niche in traditional planning practice, depressing experiences with various employers were aired and exchanged. In this way the first step was taken: a recognition of common experiences and conditions. However, it did not go beyond merely taking stock of the situation. Future perspectives were hardly in sight.

Since then the efforts (some receiving considerable publicity, others going largely unnoticed) of women architects and town-planners to clear the path for a more meaningful way of practising their profession outside the traditional career channels (and aren't they closed to us anyway?) have increased.

Unsuspected possibilities opened up from all directions and

continue constantly to appear, in both the theoretical and the practical fields. But with this multiplicity came the dead ends.

It is now time to take stock again. To do this we need the courage to express our opinions, to see trends which are hard to understand as political portents. My attempt at such an analysis should not give rise to new labels but to a better understanding.

Planning at Grassroots Level – An Opening for Women?

Right from the outset the slogan 'planning at the grassroots' caught on with town and country planners who, by the nature of their profession, are dealing with areas in which both women and men live, and for which there is no hope of finding a female financial backer. This grassroots approach to local planning was first practised by enlightened male architects, planners and social workers at the end of the 1960s and then adopted by women in the hope of coming nearer to a feminist approach to town planning.

Their approach can be called democratic in the best sense, that is, it reduces the say the experts have, and no decisions are made without consulting the people who live in the area concerned. The women architects' work collective in Darmstadt wrote in the report of the Second Women Engineers' Conference: 'It is not our concern to establish what feminist architecture will look like because it is not feminist to prescribe what others' goals should be and certainly not at the theoretical level.'[1]

How then was this intention to plan with the residents concerned actually put into practice?

It was extremely rare to find a development area which offered both a planning problem and also a women's group which was able and willing to cooperate. In the desire to do especially well areas were chosen (if possible) where the negative effects of male capitalist town planning were obvious, which usually meant modern housing estates where the planners themselves would on no account have liked to live.[2]

If however, in spite of these unfavourable conditions, the women living in these areas were defined as 'a specially badly hit group' (again out of the best of feminist motives) and were talked with and considered individually, then their hardships were soon reduced to things like: a lack of shopping facilities, restricted mobility because of being tied to small children, a lack of playgrounds and youth

centres. These are primarily factors which when improved reinforce women's sole responsibility for child-care, their isolation in the home and their role as housewife. Any improvement would therefore be deeply anti-feminist!

In their personal lives these women planners and planning students are very sensitive to women's oppression. They live, for example, in communes and make sure that the men do their share of the housework. But as soon as they go 'out into the field' as professionals then all these considerations are forgotten! Why don't they talk to the women who live on the housing estates about women's oppression? Why don't they make loss of identity, fear of one's husband, isolation, etc. themes for discussion if they are so obvious?

The underlying attitude is one of not taking women seriously. Every woman is gladly accepted if she is an informative 'accessory' to a study or research project, the 'typical representative of the social structure of the area studied'. But the acceptance ends when it becomes clear that the most pressing problems of the 'resident' have nothing to do with her physical environment, and that in fact any possible solution lies in the same direction as those the planner has found in her own life! Suddenly all the fine talk of women working in solidarity with women goes up in smoke. The planner is now no more than the representative of her profession and only responsible for solutions within a very restricted field and who is only prepared to communicate with other women within the matrix of their established roles.

She has fallen into the trap. For just as she uses and exploits other women, so she herself is used and exploited in others' interests. This is an age-old mechanism. We all know it, we all want to abolish it by (amongst other things) not going into those 'traditional women's jobs'. But before we can bat an eyelid our femininity has once again been made a function of the *status quo* behind our backs, even in the profession of 'town planning'.

Margit Hoffman and Irmgard Kienzler[3] sum it up thus:

Processes of urban structural change which are based on changes in the economic sphere have the deterioration of essential aspects of the life of the population as a side-effect.... Public planning can and must try to ameliorate the impact of the developments following economic laws (exchange value rationality) on the

population in order to compensate for hardships. . . . Traditional women's jobs do just that. They serve those areas which cannot be covered by the cost-benefit logic. . . . Women are not unwillingly accepted when it is a question of caring for those disadvantaged by planners, a question of the execution of social planning and social work in the housing estates.[4]

What we took on, in the hope that by consulting those concerned better planning could be achieved, in fact really means (under the existing power structure) that the resistance of the affected to decisive changes in their lives is undermined. Eva Schindele[5] resignedly describes the function she was allotted as a representative of a community building firm when on house visits: 'Urban rehabilitation comes to the door in the shape of a friendly young woman.'[6]

Women's Architecture

There are enticing perspectives and prospects for women construction engineers. Everything is possible in theory:

– one could set up an office staffed exclusively by women;
– a female developer could commission a building in which only women would live;
– and this building could be designed in freely flowing creativity according to formal principles completely freed from patriarchal tradition.

All three approaches have been tried in the last few years. If they were all realised simultaneously they would enable feminist architects to have an ideal professional praxis. However, this is unfortunately only a dream. It can only be partially realised. Here and there a little bit of freedom can be won. Maintaining a balance between political integrity, stress-free working conditions and financial solvency is a task which presents itself daily.

However, the intention will be subverted if one approach is singled out and realised; that is, if the women concerned are satisfied with successes on one score and do not try to realise the other approaches.

That can, for example, happen if women place the main emphasis on setting up offices without a male boss. It's easy to open an office,

especially if the first contract is already in the bag. But how does it go on from there? After all, the whole team must be financially secure. And it is tempting to use tried-and-tested recipes for success, that is, to conform to the style and tempo of financially well-off clients. Yet this allows no time for detailed discussions as well as no freedom to turn down contracts.

A women's architectural office which is not too radical stands a good chance of finding a niche in the market, for the feminine, 'gentle' mode of dealing with existing buildings is quite popular. The new generation of women architects is gingerly inaugurating changes with the express aim of making towns more 'human', of course, in cooperation with the population (see above). By doing this women have an advantage over their male colleagues which they badly need in order to survive in the face of the notorious pressure to be twice as good and to work twice as hard as men.

What about the second point about designing a building in which only women would live? Who would commission such a building? Women who consciously decide to live without men also give up the privileges to which men previously gave them access. Only extremely rarely do they own land or have the financial means to employ an architect for a conversion job. The only houses for women's exclusive use whose design and conversion have given feminist architects paid employment are the refuges for battered women – a miserable realisation of the utopia.

Finally, the point about the new architectural forms. Ecology houses in the shape of flowers or leaves, caves and nests, sun hills, houses designed to fit the natural landscape, circular compounds, functionally interwoven towns, gentle extensions to blocks of flats, uterus-shaped underground communal rooms – all these and much more can be found in the designs of women students, unemployed women architects, artists and housewives. Theoretical work has been done on these designs; they have been compared to designs by men, 'feminine' and 'masculine' principles have been discovered, and there has already been a call to see each as complementary halves of a whole.

Where does all this get us? The usefulness of these attempts must be assessed according to who makes them. A liberation of creativity on the theme architecture/spaces/women's spaces has a wide-ranging impact. Professional space-makers can only do feminist work and set about work in a feminist way if they have the support of

a lot of other women, who, even though non-professionals, still have a sense for space, a feeling for the physical. And that, unfortunately, has been more or less driven out of most of us to the extent that we cannot even decide and say whether we feel good or not in a particular space.

The reawakening of a sensitivity for space in many more women is therefore necessary. It has been going on for years now and in a variety of ways: evening classes in craftwork, weekend workshops for body and space awareness, the drawing together of ideas about dream rooms, houses and cities, exhibitions of designs, drawings, models, photo documentaries . . .

For the women concerned, activities like these can have a therapeutic effect which spills over into other areas. Many women have made important progress in this way in their personal development and have got the stimulus to 'get moving'.

But creative design has a different significance for the professional space-maker; it is just one phase in many of the planning and construction process. How many of the most beautiful designs are turning yellow in portfolios and how many women architects are unemployed and destitute! The creative design is not the cause of feminist architects' work difficulties.

Say, what do you think about the shapes?

The discussion about whether there is a typically feminine language of shapes which is clearly distinct from the typically masculine has crystallised around the 'curved/angular' polarity. Cillie Rentmeister, the art historian and archaeologist, has written a well-researched article on this question with the title 'The squaring of the circle – the male takeover of power in architectural shapes'.[7] According to this article there can no longer be any doubt that the victory of patriarchy over the originally matriarchal peoples of the Mediterranean and the Near East can be seen from the dominance of Greek monumental architecture over round, oval and egg-shaped buildings. The author comments on the value of her research thus:

> I think it is interesting and important to research into the 'microphysics of the patriarchal takeover of power' using evidence from archaeology and art history as well as from other areas, to see and experience how male power has taken root in all complicated

discourses – whether in women's bodies or in buildings – and thus to see how everything has come to be what it is. This is a precondition for changing the *status quo*.[8]

There is no talk of recommending a reintroduction of curved shapes in order to bring us closer to our lost power. Cillie Rentmeister rightly issues a warning against the simplistic transferral of historical knowledge to the present situation: 'Just so that there are no misunderstandings: in this essay I most certainly did not want to support archaeological arguments for the "eternal feminine" or those for "feminine universals" in architecture.'[9]

Nevertheless, women's spatial utopias nowadays lean heavily towards curved forms, and if we want to assume that there is more to them than an outline sketch then they must be rooted in a critique of the dominant shapes, a critique which finds symbolic expression in the circular form.

We have nothing against Greek temples. When the criticism of the dominant mode of construction latches on to its 'angularity' then it is turning against the 'rabbit hutches', the 'concrete shoeboxes' as the basic element of construction production.

Here is a detailed critique of the box-construction method and what it implies:

– no limit to how many floors can be piled on top of one another (and therefore a tendency to extremes);
– the building of mass accommodation for nuclear families and people living alone;
– the obstruction of women's emancipation by the ground plan consolidating traditional roles;
– universalisation/standardisation/monopolisation;
– the encouragement of inhabitants' passivity through the inflexibility of the building;
– the neglect of organic building materials;
– concrete construction as a means of industrialising (and patriarchalising) regions which were formerly unindustrialised;
– international and regional levelling of the landscape, the ousting of local popular shapes;
– the deskilling of the workforce; the supplanting of skills and crafts which are specific to one locality.

Every one of these points contains a whole complex of problems,

each of which in itself is a topic for debate. What is new about the criticism made by women is that it does not let itself be compartmentalised. All aspects of the capitalist–patriarchal mode of mass construction are equally bad, and their improvement equally necessary. Why not then begin with the lowest common denominator? One cannot deny it: with a curved basic shape the method of construction criticised above would simply not be realisable.

The Courage to Have an Opinion

A large number of criteria which an architecture would have to fulfil if it were to be favourable to women can be derived from the points of criticism made above. But another starting point is needed for the defining criteria of a feminist architecture.

This critique of the dominant mode of building is not new of course. There have been alternatives to each of the individual points in the past and there still are. Just consider ecological building, cooperative building, socialist architecture, the Bauhaus movement, 'humane' housing[10] etc. If these alternatives are really emancipatory then they are also (within their limited range of impact) favourable to women. But to be feminist means explicitly to take up the cause of women, and that is something new. It is so new that the realisation of this partisanship in itself causes so many difficulties that all other aspects have for the moment to be pushed to one side.

To plan and execute a concept exclusively with women, to live only with women – that is the first precondition and at the same time the greatest obstacle. It is often a luxury or at least a question of secondary importance as to *how* women will use the space they make for themselves; it is first and foremost necessary *that* women get their own space at all.

Therefore, whoever wants to know how feminist architecture could look will have to go where women have created a space for themselves: in towns and in the country; through renting, buying, squatting; with a great variety of purposes: a women's centre, a women's café, a women's bookshop, a women's disco, a women's gallery, a women's pub, a women's craft workshop, a women's arts centre, a women's commune, a women's college, a women's holiday centre, a women's land-holding . . . Or go to where women have temporarily made a space for themselves and their activities: a women's music festival, a women's holiday camp, a women's

summer university, professional women's congresses . . .

If feminist building is to continue within this framework then it is valid to develop criteria (a) for the planning and building phase; and (b) for the design and use of the building.

Criteria referring to both points were developed long ago and even if they were not formulated with feminist construction in mind they are at least applicable to it without more ado. Right from the beginning there was (and is) the unanimous decision within the women's movement to promote communication which is free from domination. Existing differences should be smoothed over, specialised knowledge and skills made accessible to everyone and the general broadening of women's competence in respect to men should be supported. This means for (a):

– the exchange of know-how between those involved,
– the rotation of duties,
– equal pay for head and hand work,
– the non-participation of men in the decision process.

For the purposes of assessment it is not so important that a group fulfils these demands at one go but rather that these questions are discussed and that the group tries to find a way forward. But the group must give itself the chance to do that and not let itself be overwhelmed by the present conditions. For, as Christa Reinig quite rightly commented: 'Our chance lies in not conquering more space than we can defend.'[11]

The same is true of point (b). Here, too, the women's movement has developed demands based on a critique of the nuclear family and the life of the housewife. Questions about the design of space are largely answered by the demands of the ecological mode of construction. We can thus insist on:

– autonomy in the production of energy,
– no building for men or nuclear families,
– housework to be done with the minimum of energy by all occupants,
– in the case of continuous usage, at least one room for each occupant.

A Concluding Word

It wasn't my intention to bewilder by my seemingly fantastic

demands. Of course, every woman who takes her own feminist claims seriously is essentially alone. But my considerations were intended to contribute to a clarification about the female allies every woman must seek for herself. It is not enough just to get together with women who are suffering under their living conditions but who are not prepared to question the way they live with men. Nor is it enough just to get together with women colleagues who have jumped on the bandwaggon and are furthering their careers as architects backed by an exclusively female-staffed office.

A much better way of coming to a decision is to get out of the rat race of professional qualifications and to stop climbing the career ladder – even after having gained much hard-won professional experience. Whoever wants to get on must also have the courage to get out! Our allies are those women who have the same utopias although it would be too narrow to call these 'housing utopias'. It is more a question of recognising that *under* all the beautiful relationship structures which we so desperately would like to have there lies something else – the so-called 'infrastructure'. Without this, the basis of our changed relationships can be destroyed overnight. To have a common utopia means sharing the conviction that no one will hand us these mutual goals and understanding on a plate. We must make them for ourselves. Even if it means getting our hands dirty in the process.

9
Eva Rieger
'Dolce semplice'? On the Changing Role of Women in Music

In the music world women still play only a humble supporting role. Their part in producing music is small compared to men's and the history of music has no record of any female genius. Why is this so? Two things first spring to mind when looking for answers to this question. The first is that women have contributed in different ways from men to the various branches of music, and the second is that their contribution has varied over time. From the middle ages on, women were barred from 'high' music (in contrast to popular music in which they have always played a part) because this was church music and women were excluded from church office and the performance of liturgical rites. This situation changed in the seventeenth century, when women first stepped onto the opera and concert stage as singers, largely as a result of the great popularity of Italian opera whose audience demanded the charms of the female voice instead of the 'castrati' who had previously sung the female roles. In the eighteenth century, as a result of French cultural influence, the piano-playing lady became socially acceptable, and the simultaneous expansion of music publishing promoted the circulation of easy, often trivial, piano pieces which were eagerly bought by these women. It was by no means unusual for this music to be composed by men expressly for women. However, almost all instruments other than the piano were taboo. Up until the beginning of our own century women were not allowed to play in orchestras. The sole exception were women harpists and that only because the harp was considerd to be a 'feminine' instrument. Even today there is a German orchestra – significantly that with the greatest international reputation, the Berlin Philharmonic – which still has no female members apart from a second desk harpist and whose

principal conductor refuses to engage women.[1]

Women, then, were only allowed to enter the public musical world when they could not be replaced by men. They have gradually become tolerated – even if always with misgivings – in the reproductive sphere, although a few instruments such as the brass and percussion have largely remained the prerogative of men. However, in the productive sphere – that of composition – women have never been encouraged; on the contrary, music academies were closed to them for centuries, their compositions were ignored, ridiculed or, even worse, given 'feminine' attributes such as 'insipid', 'pretty', 'lacking in scope' etc.

A comparison with other art forms shows that this disregard for female creativity was not unique. Women have always only been allowed a first foothold in those areas where creativity was considered to be of secondary importance. For example, it was through needlework and the applied arts that women were first able to enter the fine arts. Sculpture, on the other hand, was taboo, so that even at the beginning of this century women sculptors were excluded from the academies of fine art. As for music, women were accepted in the reproductive sphere as singers and instrumentalists and also as teachers, but composition remained out of bounds to them.

There was no lack of attempts to explain the absence of woman's contribution to artistic production by referring to her 'natural' creative deficit. Yet the many forgotten and disregarded works by women still hidden in the archives of music libraries prove this argument to be false. The difficulties of tracing these works are increased by the fact that many of the obviously unjustly neglected women composers published under male pseudonyms.

In the discussion about female creativity it is surprising that such a rigid division is made between apparently uncreative performance and creative composition. In reality this division is a blurred one. Singing and playing an instrument both demand creativity, for the personal interpretation of the performing artist is important to the impact of a piece. Women singers have moved their listeners to tears and earned passionate applause. Can such reactions really be achieved by mere imitation? 'Everything I create comes from deep inside me,'[2] the famous singer Lilli Lehmann confessed in her memoirs. However, once one admits that only a creative personality can be a good singer, then the distinction between composition as creative and artistic performance as uncreative collapses.

With the emergence of the first women's movement in the middle of the nineteenth century the discussion about feminine creativity broadened. The small number of actively creative women was seen to be due less to a 'natural' deficit than to patriarchal culture's bid for exclusivity. How far, then, is our music, which has always claimed to have universal human appeal, dominated by male interests? Can one really seriously assert that music has a gender-specific content?

1. The Masculine World of Music

Musicology has the reputation of being an extremely conservative discipline – even more so than theology. There are obvious connections between its patriarchal structure and the politically stabilising function that 'high' music had for centuries from the middle ages onwards. Music, more than the other arts, has formed an alliance with the interests of the state and has been a disciplinary force. In the middle ages music theorists at the universities asserted their dogmas, and apart from in the nunneries music was taught and performed by men alone. Women were allowed to perform and compose only within the convents and were excluded from the hierarchy of church music. Women's lack of opportunity to apply their art is probably one of the causes of their intellectual impoverishment.

For centuries music was used to praise God; gradually it was subverted to the praise of the secular ruler and individual heroes, and then finally the bourgeois gentleman. Of course, music was also used to represent and praise the many images of woman, but she was always the creation of the male imagination, either as idealised mistress or as a representative of the underworld, of the unconscious, the arcane and the evil. Male phantasies, longings and fears were projected onto her but the realities of women's everyday existence were ignored. It would have been difficult to idealise them in art.

The increasingly strong secularisation which followed the French Revolution initiated a change in the aristocratic and ecclesiastical function of music. The decline of feudalism and the rise of absolutism meant that the bourgeoisie exerted more and more aesthetic influence. The oratorios of Josef Haydn (1732–1809), who translated the desires and dreams of this new audience into music, were greeted with storms of enthusiasm.

The Creation which musicologists have called 'the best expression

of the sense of national community of the period 1800–1820[3], a work which symbolises ideas 'which have been taken from the ideology of a bourgeoisie which felt itself to be free and enlightened',[4] documents the male bourgeois takeover of social power. This work of art celebrates 'the bourgeois way of life in particular' and so becomes 'thoroughly worldly in orientation'[5]. By merging secular and religious elements this music contributed to the popular acceptance of bourgeois norms (one of which was the subordination of women) as given by God. The earthly father, just like the Father in Heaven, is destined to rule. Adam is to lead Eve, she is to follow him, and with the words, 'Your will is my law, that is God's decree', she submits to this power relationship. This also finds musical expression: while Adam conveys action by means of dotted rhythms and rising thirds, Eve is made to signify weakness and passivity by means of suspended notes and seconds.

It is significant that the concert halls built in those decades are architecturally similar to places of religious worship. They often had a temple façade, thereby giving physical expression to the merging of the religious and the secular, the transference of divine power to human – that is, male – power.

The speculative philosophy of German Idealism attributed transcendence and the power of revelation to the musical work and preached the doctrine of eternal beauty. This ahistoric aesthetic which was similar to the cult of genius in the 'Sturm und Drang' had deleterious consequences for women. The composer was worshipped as a 'divine genius'; it was inspiration which was glorified while achievement through personal striving was not highly valued. As a result, the work of art was seen to be a timeless document of divine perfection. The concept of the 'autonomous work of art' and of 'absolute music' was at the centre of bourgeois music culture. 'Absolute music' meant on the one hand the reflection of the absolute, of the metaphysical, in the work of art, and on the other hand, the passing out of the sphere of feeling into that of 'pure thought'. The composer, however, who was able to communicate the metaphysical through his music and who was venerated as one of creation's exceptions, as the human incarnation of the 'absolute', could only be male. The bourgeoisie celebrated its own – male – achievement in his genius. The theory of 'pure thought' propagated by German Idealism also corresponded to the masculine world view, while to be caught in the material, in the sensuous, was long

A. Kolb, *Beethoven*, etching.

Franz Stassen, *Beethoven's Moonlight Sonata*

considered to be a feminine characteristic. This is obvious in Robert Schumann's (1810–1856) masculine élitist claim, referring to a piece composed by a contemporary, Carl Reissiger, that, 'It is a quartet to be heard by candlelight and in the company of pretty women . . . but Beethoven's music must be heard behind closed doors and eagerly imbibed to the last drop.'[6] [. . .]

It was no coincidence that Beethoven decisively furthered the development of the sonata form. This most common formal corset of classical music (to be found in overtures, symphonies, chamber music, etc.) contains gender-role stereotypes in its thematic arrangement. The leading music dictionary in German says of the sonata form, 'Two basic human principles are expressed in each of these two main themes; the thrusting, active masculine principle (first theme) and the passive, feminine principle (second theme.)'[7] The second theme is described as the 'secondary theme' and as 'less complete'. That the musical development of the contrasting themes resembles the polarity of the sexes should not be dismissed out of hand, for although the two mingle in the exposition, the 'masculine' primary theme almost always triumphs in the finale. 'The art of woman accompanies the art of man. It is the second voice in the orchestra, it takes up the themes of the first voice, adapts them, gives them new, individual overtones; but it is given resonance and life by the art of man.'[8] This remark, which was taken seriously at the turn of the century, shows that music criticism did not attempt to analyse, but merely unreflectingly transferred associations connected with the supposedly natural passivity and subordination of woman to music.

The parallels between music and the relation between the sexes which frequently crop up in music literature on the level of verbal associations could be listed in greater detail.[9] One does not have to look far. The music critics themselves gave the contents of a piece of music a sexual setting, for example: 'The recitative is the brother, the aria the sister. He begins, she continues . . .'[10], or attributed certain emotions when listening to music to one sex or the other; 'Whoever likes to immerse himself in the symbolism [of the language of music] may recognise a largely feminine mode of feeling in the adagios and scherzos of our sonatas and symphonies and may also feel himself moved by its mild presence in the so-called second leading themes in the allegros.'[11] Many musical modes were interpreted in terms of gender roles. The 'masculine' principle is expressed by large intervals,

rising arpeggios, volume, sfortzandos, octave runs, fugues, full orchestral scoring and the proliferation of wind and brass instruments. The 'feminine' principle is expressed by lyrical melodies, legato phrases, the use of the flute and the harp, chamber music and delicate instrumentation, muted playing, melodic passages gently rising or falling in seconds, regular rhythms.

A musical example might clarify this representation of women. In Franz Liszt's *Faust Symphony*, Faust is musically represented by the first theme and Gretchen by the second. Faust's theme ascends, has a marked rhythm and is passionate. Gretchen, on the other hand, is given a theme descending in small intervals with the marking *dolce semplice*. The instrumentation of the Gretchen theme is that of an ornamental chamber music piece giving the impression of transparency and the absence of passion. The last male chorus in the finale which crowns the symphony by setting the quote from Goethe 'The eternal feminine draws us ever onward' corresponds to how woman is treated: she can be safely glorified only after having been allotted the musically subordinate place in the second movement.

The assumptions of a masculine music culture also explain why pieces written by women have not been given due attention. Well-known women musicians are omitted by the music dictionary already mentioned.[12] And when women *are* mentioned, then they are usually only singers or the mothers or wives of composers who are valued more for their nurture of composers as mothers and lovers than for their own creativity. It is striking that many composers' funeral monuments are decorated with female figures, although woman is always kept at the appropriate distance and serves only as an inspiring muse or as an aesthetic accessory.

2. The Piano-playing 'Young Ladies of Good Family'

School music lessons, which favoured boys from the middle ages right up to the twentieth century, were primarily singing lessons. After the Lutheran Reformation, boys' school choirs were used in church services and also for secular celebrations. The large choirs which for centuries dominated German musical life as well as church music developed out of these small boys' choirs. Women were not allowed to sing in the choirs and therefore had no comparable training.

Music in schools lost its significance as the supreme religious and

secular power of the church declined around the middle of the seventeenth century. Music gave way to the natural sciences in the school curriculum; there was hardly any systematic introduction to singing at sight even at boys' schools. But musical life was still firmly in men's hands for the profession of the freelance musician began to develop. The churches appointed organists and choirmasters who could also compose.

The eighteenth century saw a change in the situation of the daughters of the wealthy bourgeoisie thanks to the influence of French culture. The emergence of a commodity economy was accompanied by an increased demand for aesthetic pleasure as compensation for the struggle for existence, and above all by an increased demand for material manifestations of the newly acquired self-confidence. Women's role was to provide drawing-room entertainment by playing the piano and singing.

A strange ambivalence can be seen in the manuals dealing with the musical education of young ladies. Woman's destiny as housewife and mother forbade on the one hand any intensive study of the arts and sciences. On the other hand, it was important to a man's prestige that his wife could entertain his guests with music, and of course a musical education for his daughter served as a good investment for an advantageous marriage.

Towards the end of the eighteenth century the educationalist Johann Daniel Hensel drew up a list of 'essential, less essential and inessential arts and sciences' for women. Knitting, sewing, cooking, baking, washing, etc. are absolutely necessary; music, which is subdivided into playing an instrument and singing, is 'one of the less essential but still very useful' skills. Music theory and composition are considered to be completely unnecessary.[13] Another educationalist agreed that the arts should form the centre of women's education but regretted 'certain features of degeneration in women's education' in that women were being trained to become virtuosi and artists. Instead, their aesthetic sense and taste should merely be aroused and refined.[14] Yet another educational theorist warned women on no account to 'use music to flaunt themselves and show off' and above all not when their housewifely duties had been left unfulfilled.[15]

The gist of all this is clear. The aim is to draw a distinct boundary between dilettantism and virtuosity. To go beyond singing by ear and indulge in a deeper and more serious pursuit of the art of music is

not appropriately feminine behaviour. [. . .]

Many schools for the daughters of the wealthy bourgeoisie were founded from around 1850. Music formed an unfortunate alliance in the curricula of these girls' boarding schools and ladies' colleges with other genteel subjects such as literature, French and drawing. The first women's movement objected to this combination of subjects saying it led to a one-sided and superficial education. 'This arty education . . . produces branches without sap or strength,'[16] asserted one of the first woman critics, Luise Büchner. She pointed out that as a consequence of this curriculum at the girls' schools, the pupils at the ladies' colleges also tended to study arts subjects instead of the sciences and that this merely promoted sexual inequality instead of undermining it. Luise Otto Peters also pointed out the inhumanity of this 'ladies' education', manifested in its uselessness: 'When a wife has to stay at home and wait until midnight or even later for her husband, what else can she do other than play a little music, read a little or embroider a little – and all this without any point or usefulness other than to kill time?'[17] The struggle of the first women's movement against the 'finishing school' education at girls' schools and ladies' colleges was not a fight against the individual subjects but against a sexist education which denied women any deeper study of the sciences and the arts. A curriculum similar to that of boys' schools was finally introduced into girls' schools less as a consequence of the efforts of the feminists than as a result of the changed economic conditions around 1900 and a growing need for trained female employees. [. . .]

In the nineteenth century private music lessons, too, only gave girls a smattering of knowledge. The private and state music academies which sprang up at the beginning of the nineteenth century fall into two categories. Into the first come those which were founded to fill an economic and cultural need for musicians, above all for orchestral musicians. Pupils in these establishments received a thorough professional training. Male pupils were in the majority but girls were allowed to study singing and piano. The other category was made up of schools which gave a more specialised and limited education. In these, girls made up the majority of pupils. So, for example, in Leipzig as early as 1812 there were two singing academies at which 'young ladies of good family' were educated.[18] The parents were promised a quickly achieved proficiency for a small fee and the girls could phantasise about a prima donna career.

As the training was usually short, it was, however, only sufficient for the domestic drawing-room at best.

The musical education on offer in the nineteenth century was very lacking in uniformity. At the beginning of the twentieth century there were no state examination regulations for music teachers. This enabled women, above all, who were denied an education in other professions, to enter this unprotected field in large numbers. Thus a professional proletariat scraping a living together developed: 'One could sing a long sad song about the misery of the music teacher whose fee varies fron a hot dinner to a few copper coins.'[19] Yet in spite of this misery women still flocked into the profession. In Berlin at the turn of the century there were 244 private women music teachers as well as 504 male teachers.[20]

Contemporaneous with this development was the gradual under-mining of the 'amateur'. When the bourgeoisie were first in the ascendant, when men also played music in the home and were called 'amateurs', the designation had completely positive overtones. It only acquired a derogatory implication when it became increasingly applied to women. By the nineteenth century composers wrote pieces for amateurs and dedicated them expressly to women. Czerny's 'Collection of Popular National Melodies' op.575 was intended for 'tender ladies' fingers'; Weber dedicated his six écossais to 'the fair sex', Daniel Steibelt entitled his op. 35 'Amusements for Ladies', Johann Vanhals' easier pieces were recommended for women as 'light musical fare' and Mendelssohn refused, in spite of many requests, to write a second volume of 'Songs without Words' as they were, in his opinion, suitable only for women and would therefore be accorded a low rank in his *oeuvre*.[21] [. . .]

There were a few protesting female voices. Some of the most important criticism was formulated by the singer, composer and writer Nina d'Aubigny in her pamphlet which appeared at the beginning of the nineteenth century.* It is a plea for women to be given an intensive vocal training, a first attempt to point out the value of a proper musical education for them. Although she agreed with her contemporaries that it was woman's destiny to be housewife and mother she also strongly condemned the meagre educational opportunities for women and dismissed the argument that any

* *Letters to Natalie concerning singing as a means of promoting domestic hapiness and social entertainment* (1803)

training for women was superfluous because of woman's 'natural destiny'. This epistolary plea was widely read (even Beethoven had a copy), probably because of the growing need felt by members of the bourgeoisie to educate their daughters.

The piano teacher Fanny Schindelmeisser was one of the founders of a girls' music school (boys were later also admitted). She thoroughly drilled the pupils and promised maximum achievement within a short space of time. But she was a social outsider in two ways – as a member of an insecure profession and as a single woman – and was not taken seriously. Her application to patent her piano-teaching method was refused by the Prussian Ministry of Education; other music teachers published articles about her method without her knowledge, and as a last straw her method was adopted by another teacher who made considerable changes, and although he used her name did so without her consent. It is highly likely that she paid the publication costs of her pamphlet in order to be able to defend herself publicly.

3. Private and Professional Life

The conflict between kitchen and career has had more fateful consequences for women employed in music than in other artistic spheres. A woman painter could be married without any detriment to her reputation. For singers, however, it was different: many opera house directors made celibacy a condition of employment. Marriage could be interpreted as a breach of contract and grounds for dismissal.[22] State institutions also made difficulties for women artists. When the husband of the pianist and composer Ingeborg Bronsart (1840–1913) became a theatre director she had to give up playing in public because the wives of Prussian officers and civil servants were not allowed to perform in public.[23] Marriage was tantamount to professional renunciation for the famous singer Gertrud Mara, née Schmehling (1749–1833). She commented on her several proposals of marriage, 'if I accepted them, then my artistic career came to a close; I therefore refused them and made the laurel wreath my goal. If I had not succeeded I would have had to comfort myself with the bridal wreath.'[24] A full century later nothing has changed. Lilli Lehmann writes of her sister, the singer Marie Lehmann, that she 'suddenly gave up all plans of marriage; love of her art had returned to her.'[25]

Chopin monument in Paris by Fromont-Meurice

A writer at the turn of the century who had thoroughly studied the fates of women singers wrote: 'One has to admit that there is a barely bridgeable chasm between Polyhymnia and Hymen and that these two deities have sworn death and destruction. Fame and love do not easily mingle.' He closes with the sigh, 'Blessed are those who have room in their heart for art but also for the domestic and serene happiness of matrimony! Blessed are those who as prima donnas do not cease to praise noble morality and virtue!'[26] The cause of the conflict is seen to be only in the women themselves. It is their fault if their hearts do not have room for 'the serene happiness'. In fact, however, the traditional female role was not compatible with the professional singer's daily life. A soloist had to be personally and artistically independent and always demand the most of herself. In her private life, however, she was expected to accept the socially imposed role of servile and subordinate wife. One can only guess at how many women experienced intense personal conflict within marriage. Biographies only incidentally mention these psychological pressures because of the taboo on discussing intimate family relationships. 'On her marriage there was a short interruption in her triumphant career but the irrepressible vigour of her inner nature caused her to return to the world of art.'[27] 'It was as Fidelio that Amalie Weiss took her leave of the stage in 1863 in order to give Josef Joachim her hand. She made her exit with a heavy heart.'[28] Family problems also often forced women artists to fulfil the unavoidable feminine duties: 'Angela Orgeni's sparkling career was often interrupted by long and severe illnesses in her family circle. These forced her to leave the stage much too early for all those who knew her magnificent talent.'[29] For most women artists there was only an either–or and no hope of combining career and family life.

Women singers have for centuries had the reputation of being 'of easy virtue'. However, the many tales with this theme are more the product of wishful thinking than of reality. Women singers could permit themselves more freedom than most women because they lived outside bourgeois norms, but they were often dependent on the men who determined their careers. Although they sometimes received quite large fees, the real beneficiaries of their artistic productive capacity were the impressarios, the opera house directors, the financial backers and the patrons. Many men arranged a concert in return for sexual favours and there is evidence that even newspaper critics expected sexual benefits in return for favourable

reviews.[30] This negative image caused emotional stress for many women. In 1886 the operetta singer Eugénie Erdösy committed suicide because her fiancé had doubted her virginity. She demanded in her will that she be posthumously examined by a doctor and her virginity certified – which was duly done.[31] [. . .]

The world famous singer Wilhemine Schröder-Devrient experienced similar conflicts. Her upbringing by her mother, the great tragic artist Sophie Schröder, meant that as a child she had already escaped the limitations of girls' socialisation. Her autonomy as an artist conflicted with her private life because she could not free herself from bourgeois expectations. As she said, 'I had to free myself in order not to be destroyed both as a woman and as an artist', expressing the fateful separation of roles which finally broke her.[32] [. . .]

Alma Mahler-Werfel, on the other hand, who later led a life free from bourgeois constraints, submitted to the prohibition on composition issued by her husband, the composer Gustav Mahler, without protest. The songs she wrote in her youth show that a remarkable talent was suppressed and thereby destroyed – as happened to many women. Her inability to compose again after an enforced interruption of many years reveals that an artistic gift must be allowed to develop smoothly and be constantly exercised. Gustav Mahler's behaviour is evidence of a masculine self-assertion and an egotism which could not permit the independent development of his own wife.

Clara Schumann was able to continue her career after her marriage in spite of all opposition, supported by an ambitious father. The distinction she imposed between piano playing and composing is, however, revealing. Although her father allowed her to be educated in both piano and composition she associated her feminine identity with virtuosity alone. Her husband, Robert Schumann, would have preferred it if she had renounced giving concerts as well.[33] For her, however, making music was part of her self, 'the air I breathe'.[34] It is certain that she was influenced by the current idea of her time that composition was for men only. And she capitulated in the face of the many obstacles which even her husband noticed. 'Clara,' he writes in their second year of marriage, 'has written a number of small pieces which are more imaginative and tender than ever before. But children, a husband who is always dreaming, and composing do not go together. She lacks constant practice and this often saddens me,

for many a deep thought is lost because she cannot develop it.'[35] Clara Schumann's diaries and letters often contain complaints about the lack of time to compose as well as comments on the pleasurable experience of independent creation. Although she considered virtuosity to be her right, she always saw composing as a pleasant side interest. Her comments about her own compositions and those of other women show that she had internalised the generally accepted devaluation of women's creativity.

4. Self-suggested Inferiority

It is not surprising that women were made to feel most insecure as composers. Quite apart from the institutional prohibitions noted by Elisabeth Kuyper and Sabine Lepsius, women's education in the nineteenth century was such that the stress placed on achievement and competition which male adults had to accept did not come into question for women. Women made music in order to sparkle in the drawing-room, not in order to earn money. This explains the modesty of many female composers. When publishers expressed interest in Sophie Menter's (1846–1918) compositions she asserted that she 'did not want to make any money out of her paltry talent'.[36] Fanny Hensel, née Mendelssohn, also hesitated for a long time before deciding to publish. This reluctance was not the result of innate feminine modesty as is often supposed; it had to be inculcated, often with difficulty. An ideal example of such conditioning is Abraham Mendelssohn's letter to his daughter, Fanny. When she was fifteen she had expressed the wish to study composition in greater depth, just like her brother. Her father, however, made it quite clear that this was impossible. While music is for Felíx the 'groundbass' of his being and he therefore may develop 'ambition and eagerness', music is for her to be an 'ornament'. She should remain 'good-natured and reasonable'. And wagging an admonishing finger her father closes, 'Behave and think in this way, for only this is feminine, and only the feminine is fitting for women.'[37] The polarity of 'groundbass' and 'ornament' encapsulates the attitude of the time which degrades women's creativity to a mere triviality.

It seems as though ideological barriers are harder to break down than institutional ones. The invisible can often do more damage than the visible, particularly as it is easier to act against obvious limitations. Only so, for example, can one explain why women

students still tend to avoid composition and conducting although the music academies have been open to them for decades. The derivation of woman's artistic competence from her 'natural' qualities was one of the most striking characteristics of patriarchal ideology. Woman's lack of creativity, her passivity and bidability were regarded as part of her essence, and any transgression was therefore a violation of her femininity. (Women artists were in fact called 'anaemic, perverse beings', 'viragos with the instincts of prostitutes'.)[38] It is hardly surprising that women learnt to believe all this themselves. Philippine Schick's refusal to allow her name to be printed is an illustration of this as are Clara Schumann's derogatory remarks about 'ladies' work'. The situation of Cosima Wagner, Franz Liszt's daughter and wife of Richard Wagner, was made worse by an authoritative father and a despotic husband. Her father forbade her right from the beginning to appear in public as a pianist. During her marriage to the conductor Hans von Bülow she started to write, went to lectures on the history of music and took Italian and composition lessons. Bülow, who was otherwise not particularly well disposed towards women, considered her to be a genius and wrote of his feelings of his own artistic inferiority in his letters to Liszt. However, in her second marriage, Cosima devoted herself to Wagner with almost masochistic self-negation. She gave up all her activities, hardly played the piano and lived only through and for Wagner, for whom such a wife appeared ideal. The wishes she expresses during her marriage to von Bülow ('the only chance I see for myself is to become a great artist')[39] at first change into doubting self-reflection (she feels herself, for example, to be 'an amphibian being, half creative, half passive, a hybrid role to which we women are damned')[40] and then disappear as the process of self-negation gains force during her marriage to Wagner. The conviction of being damned to her life remained with her to her death. She found satisfaction in totally subordinating herself to another person because she was denied self-fulfilment.

5. Feminine Creativity – Feminine Aesthetic

The few women who in the course of the nineteenth century managed to write influential books on music were hardly enthusiastic supporters of the women's movement. Lina Ramann, music teacher and biographer of Liszt, and Elise Polko who wrote rather less

ambitious works avoided socially critical questions, as did Marie Lipsius who used the pseudonym La Mara at her father's request and published numerous books on music history. She also dedicated a volume of her popular *Musical Portraits* to musical women. But she did not consider the difficulties women composers had to contend with. In contrast to this, women in the early women's movement agreed that culture as a whole was one-sidedly masculine. However, most of the comments along these lines deal with the arts in general and very few with music in particular.

A first glance at the present situation might give one the impression that much has improved, not least as a result of the activities of the modern women's movement. In the USA one can buy records of past and present music written by women. A publishing house in Munich gives preference to works composed by women. There has been a women's music newsletter in Germany for two years now and there are two associations which promote the performance of works by women.[41] But all of this would merely be an attractive widening of the repertoire if one were to remain content with only publicising women's works. It is not enough to show an astonished world how good the many women were whose works have been confined to the archives. Instead, it is necessary to draw attention to the works that were never written, to the many works which were never put down on paper and never could be. A competition between the sexes today would still be a non-starter for women. It is necessary to reveal why women play a smaller part in the creative process and to provide the conditions for women's independent artistic development. [. . .]

10
Renate Möhrmann
Occupation: Woman Artist
On the Changing Relations Between Being a Woman and Artistic Production

To conclude, then, there is no occupation which belongs either to woman or to man, as such. Natural gifts are found here and there in both creatures alike; and every occupation is open to both, so far as their natures are concerned.

But if the only difference appears to be that the male begets and the female brings forth, we shall conclude that no difference between man and woman has yet been produced that is relevant to our purpose. We shall continue to think it proper for our Guardians and their wives to share in the same pursuits.

We come round, then, to our former position, that there is nothing contrary to nature in giving our Guardians' wives the same training in mind and body. The practice we proposed to establish was not impossible or visionary, since it was in accordance with nature. Rather, the contrary practice which now prevails turns out to be unnatural. (Plato, *Republic*, Book V, trans. F.M. Cornford (Oxford, 1966).)

'Women's creativity? There's a question for you! Overwhelming! Just trying to formulate it runs the risk of creating such chaos and confusion that it would be better to sweep it under the carpet and let it lie there forever.' In spite of the risk, let's attempt to approach the topic and instead of creating chaos and confusion try to find some order.

Occupation: woman artist. In fact, the topic itself although so vast does have some ready-made frontiers. We are talking not about women artists in the very general sense of the word nor about those who are only part-time artists; we are talking about those who are

artists by profession. This already limits our discussion to a certain extent.

Some people (and particularly women in the modern women's movement) hold the view that to try to define the contribution of women to artistic production by using traditional criteria is mistaken. The prevailing definition of art is inadequate as it is the product of a consensus of patriarchal definitions of art, of a male cartel of art criticism. The women's movement has argued that an artist should also be defined as someone who decorates a house, a flat or a room, who lays the breakfast table pleasingly or who transforms a garden into a symphony of colour. Although this attitude is certainly on the right track, this is not the line of argument we are concerned with here. We are looking at professional artists, that is, with activities which have a place in the administrative framework under the heading 'occupation: woman artist'.

If we take a look at today's cultural landscape we can see a wide variety of professional women artists. Amongst writers there are Ilse Aichinger, Ingeborg Bachmann, Gisela Elsner, Sarah Kirsch, Angelika Mechtel, Christa Reinig, Karin Struck and Gabriele Wohmann, to mention just a few. As representatives of the new media the film-makers Margarethe von Trotta, Ulrike Ottinger, Helma Sanders-Brahms, Marianne Lüdcke and Helke Sander spring to mind, while Ulrike Rosenbach, Rebecca Horn and Valie Export are notable video artists, and Pina Bausch's name stands at the top of the list of German choreographers, followed closely by her promising and dynamic colleague from Bremen, Reinhild Hoffmann. In spring 1980 in Milan there was an exhibition in the Palazzo Reale with the title 'The Avant-garde's Other Half'. It introduced visitors to about a hundred women artists working in the twentieth century. The alternative and underground movements also include women's names: in Berlin in 1981, at the First International Women's Rock Festival, women appeared as band leaders and not only in the traditional role of vocalist.

So, 'occupation: woman artist' can be seen everywhere, an everyday phenomenon. Well, that's the picture at first sight. However, on closer inspection the cracks in the apparently smooth surface of the picture can be seen. In 1969, Dr Wolfgang Stresemann, director of the Berlin Philharmonic and son of the former German Foreign Minister, wrote in answer to applications from women musicians to his orchestra: 'Following an old tradition, the Berlin Philharmonic does

not accept any women musicians.' Dr Stresemann, at any rate, prefers to follow old traditions rather than the law.

Nowadays such a blatant exclusion of women is less common. However, this does not mean that it does not exist. The means to exclusion have merely become more subtle and it has become harder to recognise them. The film-maker Helke Sander reports that she was asked very nicely during her entrance exam for the Berlin Film Academy whether she thought a woman could stand the training and it was suggested to her that she should use her female gift for reproduction and become an actress instead. [. . .] I've given this example because it casts a few critical shadows on the seemingly so unproblematic picture of the professional woman artist. But it's not my intention to draw up a comprehensive list of deficits and discrimination and join in the old wailing lament. It's far more important to get some kind of order into this amorphous and wide-ranging theme of 'occupation: woman artist'. History can help us here. There is a long tradition to the latent discrimination, to the whispered doubts about those women who are not content to confine their creativity to eccentric knitting patterns and fancy icing on the Christmas cake, but who practise as professional artists.

Rather than recite the litany of lament it is far more interesting and revealing to find out how women fought against the 'black list' and how they did in fact gradually establish themselves in the institutionalised arts. I'm going to use three examples. These have not been chosen arbitrarily and each one is of exemplary value. These are the examples of the actress, the writer and the film-maker.

The profession of actress is the oldest artistic profession in which women have participated, even managing to climb the career ladder, not merely as helpers and assistants of male organisers and masters, but in their own right by virtue of their own achievements. Nowadays, there are no more critical objections to women acting, no more arguments that women are incapable of acting. Even parents who have more secure and reliable professional prospects in mind for their daughters than acting do not question women's competence in this sphere. Acting – a profession for women? Such a question would be an anachronism today.

When we look at the history of western theatre we see a very different picture though. Our two and a half thousand year-long tradition here is marked by a two thousand year-long absence of women. The Greek tragedies do have female roles, but women were

not allowed to play them. The great tragic heroines, Clytemnestra, Iphigenie or Antigone, were played by men – that is, by the so-called 'girl actors' who had a special preference for such eccentric female roles. The Christian mystery plays were also men-only affairs. Mary, the angels, and the repentant Mary Magdalene were all played by men – in fact, usually by venerable clerics who in this way became travelling artists and learnt to master the female roles. In Shakespeare's company there were no women either.

The decisive change came from Italy, in the Commedia dell'Arte, the first professional groups which had come together in North Italy during the late Renaissance in the second half of the sixteenth century. Women were not merely occasional or incidental members but had equal status with the men largely because the institution of 'girl actors' was incompatible with their repertoire.

What is interesting here is to investigate the reasons and motives which led to the sudden acceptance of women as actresses after a two thousand year-long exclusion. Put in a nutshell: what made it possible for women to become actresses, to practise their first professional artistic occupation? It is telling that scholars have displayed almost no interest in this question. The Commedia dell'Arte's break with age-long tradition with respect to women seems never to have been the subject of serious debate.

It is important to remember that the Commedia dell'Arte is realistic theatre. Its characters are not kings and queens, not representatives of the aristocratic Mount Olympus. They are everyday people: business people, doctors, lawyers, comics, young couples and servants. Its subject matter is no longer the exceptional introverted individual, no longer Greek mythology. It is the life of its time; the sources of conflict are taken from the observed and experienced present. Theatre is no longer the stylisation of an heroic past but the quite humble and humdrum present. Within this framework men playing the female roles would be out of keeping, contradicting the whole realism of the theatre. In a word, it can be said that women's first artistic profession came from the need to depict everyday reality.

As soon as art – theatre – began to treat the everyday, to shape the everyday, then the cooperation of women became an absolute necessity. Woman knew the daily routine. She could contribute her own experience, something which she could never do in, for example, the scholarly theatre of the humanists, the *Commedia*

erudita, which was usually in Latin.

Thus it was from Italy that the actress conquered the stage which was supposed to represent the world. France and Spain followed suit; England hesitated; while the triumph of women on the stage came to Germany last of all. It was not until the end of the seventeenth century that women there could step onto the stage with a proper contract behind them. But once set in motion, their conquest was unstoppable. Audiences were no longer content with the traditional 'girl actors' after they had seen women acting.

Their appreciation was not universal though. Theorists in particular dubbed the entry of women into the temple of the theatrical muse 'harmful'. This is Eduard Devrient, one of the most influential commentators of the nineteenth century: 'The intro-duction of women into the theatre corrupted the taste and judgement of the male audience forever by introducing sex interest.' This comment is worth discussing in more detail because it links up with the present.

Summarised, it says nothing more nor less than: 'Woman brought sin to the theatre as she did to the world.' That is, the antediluvian picture of woman as the incarnation of sexual danger – as represented in the twentieth century by Otto Weininger's *Sex and Character* – has been resurrected. Even if this can be dismissed as the eccentric male fantasy of a nineteenth-century gentleman, the second implication concerning women contained in this comment is very much more problematic. Devrient is asserting that: 'The introduction of women onto the stage diverted the male audience sexually and diminished their artistic judgement.' The contradiction here is obvious. It could equally well be asserted that attractive male actors sexually divert the female audience and reduce their aesthetic judgement. Devrient is apparently oblivious to the fact that he has manoeuvred himself into a contradiction. But this contradiction is revealing for it highlights a phenomenon which has only recently become the subject of debate thanks to the emergence of the modern women's movement. I mean here the social non-recognition or incorrect recognition of female sexuality. The dualistic stereotyping of women into virgin or whore which is implied here projects images of women which have nothing to do with reality.

Let's consider an incident which occurred in the international theatre world recently which shows how topical such attitudes are and brings me to the current relevance of this theme. The place is

London, the National Theatre. Peter Hall is directing Aeschylus's *Orestes* in a traditional production, that is, without female performers. All the female roles are played by masked men. One could call this an experiment. Theatre in its present crisis is clutching at any means of raising its appeal and innovatory interest. And when did one last see men only playing tragedy? All this is understandable. What is astounding here is the theoretical justi-fication, the serious commentary and criticism on the production. 'The loss turns out to be a gain,' writes the serious Mr Bohrer in the serious paper the *Frankfurter Allgemeine* referring to the absence of actresses, and continues reassuringly: 'We no longer run the danger of becoming the voyeurs of breath-taking female perversions and audacity.... By looking at the purely tragic masks we get an idea of the horror which Aeschylus is concerned with and which he finally explains. There is no false realism.' These words involuntarily remind us of our friend from the nineteenth century, Eduard Devrient. As thinking beings we need to ask ourselves how it is that only the *male* mask can communicate this purity and is protection against voyeurism for men alone.

Let me make my position clear. I am not really objecting to the attempt to reconstruct ancient Greek theatre with all that that implies, including men-only theatre; my objections are directed against the argument used to justify this, which clearly shows that the times when the presence of women was thought to debase aesthetic pleasure are still with us. As mentioned above, the theatre was the first institution to accept women as professional performers. It took another three hundred years before this followed in the other arts.

That the theatre was able to take the lead undoubtedly had a lot to do with its lack of social prestige. Actors were itinerants. They usually did not even possess citizens' rights and were debarred from Christian burial. There was no scholarly consortium which initiated a theoretical discussion on the suitability or unsuitability of female participation in the theatre. The need for realistic acting in a specific cultural and historical situation simply made the participation of female performers necessary. Opposition to actresses came from the church, city fathers and moral theologians, but never from the theatre itself. It was very different in the other artistic areas where women were later to be professionally active. There it took much longer: another three hundred years before the professional woman

writer could establish herself.

Which brings us to the second example of 'occupation: woman artist'. Here, too, it's worth emphasising there have doubtless been isolated individual women writers for as long as there has been literature. Just think of Sappho, or of the dramatist Roswitha von Gandersheim who, interred in her convent, became nothing less than the first woman dramatist of the Christian world. It is symptomatic that such a woman who stood at the beginnings of European drama is not part of our common cultural consciousness.

But as I said, there are many isolated examples of women's literary achievements. However, it was not until the nineteenth century that the professional woman writer appeared on the scene – to be precise, it was not until the decade before the 1848 Revolution. Only then did women begin to feature as best-seller authors, with print-runs of four thousand – in those days a huge number – and support their families from their writing income.

The hostile reaction of their male colleagues shows that it was not just a question of isolated women writers as had been the case in the preceding centuries. 'I do not,' complained the leading literary light of those days, Gottfried Gervinus, 'dispute that the exceptional woman can have a man's talents, but I do dispute that women in general are so endowed. It is a great pity that the exceptional should now become the rule, so much so, that a very rich Amazonian group has been established whose works could fill a whole library. They now even have their own newsletter.' But he's quite moderate in comparison with Johannes Scherr, thought to be an extremely progressive writer. 'You may be certain,' he writes with regard to the 'lack of taste and the shamelessness' of the modern mother, 'that the contingent of women who flaunt themselves in public consists either of ugly and hysterical old maids – who may be excused on physiological grounds – or of slovenly housewives and irresponsible mothers whose housekeeping books – if they have them at all – are in disorder, whose parlours, kitchens, pantries and linen cupboards are a disgrace, whose dressmakers' bills are too large and unpaid, and whose children are physically and morally unwashed.'

For the male cartel, the crux of the matter was whether woman by nature was suited to writing – a question which had never been posed with regard to women and acting. Hereditary explanations were given in order to try to explain how women writers, whose literary quality could not be doubted, achieved their success: for example,

Luise von François' gifts were largely attributed to the 'Prussian soldiering blood' flowing in her veins. The extent to which the women writers themselves internalised this male view is shown by an autobiographical poem Annette von Droste-Hülshoff wrote in which she addresses herself as 'Mr'. Further evidence of this are the male pseudonyms which many female writers felt the need to hide behind.

And it wasn't just women writers who used this ploy. The International Association for Women and Music has shown that a large number of compositions with a male signature in fact conceal the work of women. It has recently been established that Felix Mendelssohn, for example, made his career claiming some of the compositions of his sister, Fanny, as his own. One should bear this in mind when pointing out how inadequate that so frequently posed' question is of why there has been no female Goethe or Schiller. We now know that so-called artistic genius is much less the result of the legendary kiss of the muse than a careful artistic training. The fact that until the end of the last century the education of middle-class girls was over at the age of fifteen shows the disadvantageous position which faced the other half of humanity.

But what is the situation today? Does our present condition allow us to dismiss the past as 'old hat'? According to a recent report, twenty-one authors out of every hundred authors are women. But only 11 percent of members of the international writers' association PEN are female. Writing women don't appear in the proportion twenty-one to a hundred as should be the case according to the percentage. . . . This holds true of conferences, anthologies, writers' associations and all other kinds of literary groups. And it's a tacit rule in publishing houses to promote one – or at the most two – new women writers a year. A third is simply out of the question.

The writing woman stands on the frontier of the male catalogue. The critics, too, treat female authors differently from men. The criticism of their private lives, their clothes and make-up are invariably part of textual criticism. Sometimes I get the impression that the writer is more important than her book. It is also far more common to look for autobiographical elements in women's books than in men's, to hunt out the 'confessional' element and so give the work the smack of sensationalism. [. . .]

As my last example of the theme 'occupation: woman artist' I shall take a look at what women film-makers have been up to. Women

have had a particularly hard time here. It's generally believed that women can be active in the film service industry – as cutters, script girls, costume designers and occasionally as directors' assistants, and of course as actors. But they are not supposed to stand behind the camera and have full responsibility. That is management. That is men's work. And the prejudices against women are correspondingly strong. Of course, there have been exceptional women in this field too, right from the beginning. These were the so-called 'white negroes', as the director Helma Sanders-Brahms once labelled herself. Take, for example, the first woman director, Alice Guy, a French woman who started as the secretary of Léon Gaumont in 1897 and directed about twenty films from 1902 to 1920; or Leni Riefenstahl, who made a considerable contribution to film-making while commissioned by the Nazis. But women like these – as had been the case for writing women in the century before – were the exceptions.

The writing woman was, however, able to win a place for herself in the cultural world in spite of all the male reservations. This was very different for the female film-maker. The reservations concerning women are especially great in an area of production like that of the film which is dominated and defined by men. And there's another overriding handicap: filming means travelling; it cannot be organised from a desk at home; it demands a high degree of mobility. Male film-makers can usually rely on a loving, caring wife to support them. Female film-makers do not have such 'wives' at their disposal. 'You've got a choice – work or family' is what the philistines have told them. But it is precisely this choice that today's women artists are not prepared to make any more. Times have changed since the early twentieth century when the price a woman had to pay for work was usually giving up having a family. The woman artist today considers this renunciation – this order imposed from above – intolerable.

I'll say a few words here about the modern women's movement as its impact on women film-makers' sense of identity cannot be exaggerated. Whereas the women's movement in the nineteenth century campaigned for women's liberation so that a woman could become 'a better companion to her husband' and 'a more responsible mother to her son', the modern movement is concerned with women in their own right.

The movement has as its starting point that women's needs and interests are not sufficiently recognised in present society. It exposes the fact that girls' role-specific socialisation means an additional

restriction and deformation which limits all women irrespective of class, as its roots lie not in capitalism (as the Left has often claimed) but in patriarchy. Another theme which has been given much attention, and which had been neglected by the nineteenth-century movement, has also been brought back into the public debate, that is, the theme of the female body, female sexuality. What's more it's a theme not dealt with in the traditional medium of literature but in film. A film collective formed very quickly within the autonomous women's movement, whose aim was to draw attention to sex discrimination against women by making its own films and videos. The women film-makers' group in Berlin was the first to make a film on female sexuality, and so bring it out into the open.

Its films are concerned with the anti-abortionist Paragraph 218 of the Federal German civil code which prohibits abortion on demand, with the financial difficulties which women who gave birth to unwanted children have to face, with legal and illegal contraception: an example is Helke Sander's *Free the Pill* (1973). All these films can be classified as documentaries, and most were critically partisan. Young women primarily wanted to draw attention to themselves, to make the private public, and to show how the public was linked to the private, for after all, their concerns had still been treated as of lesser importance even by their progressive male colleagues.

That had already led to the first feminist protest. Women students had begun distancing themselves from their comrades in the Federation of Socialist German Students when they realised that the male Left exerted the same dominance in their political organisations as did men in society as a whole. The women were granted power in the kitchen, the men were granted the right to talk. You have to remember this if you are to understand the aggressiveness of those angry young women.

Film became the primary medium in which women articulated their discontent. That this was often shrill and without the usual aesthetic 'packaging' is understandable when one remembers the anger which consumed these women as they distanced themselves from the men. Here the connection between the women's movement and the film-makers stands out. The concerns of the women's movement were the subject-matter of the women's first films. However, that does not mean that every woman director emerged from the movement: Erike Runge and Helma Sanders-Brahms can be cited as counter-examples. Yet it should be acknowledged that the

film-makers' self-confidence as a professional body received decisive stimuli from the women's movement and that the discussion about film as a medium acquired a new impetus. Even if a director says that she has not been directly influenced by feminism she does in fact continually come into contact with the earlier work of her sisters in the movement.

A further milestone on the path to widening the professional opportunities for women film-makers was the founding of the periodical *frauen und film (Women and Film)* by Helke Sander in the summer of 1974. The aim of this sole feminist film magazine is to 'investigate how patriarchal culture influences the film medium, to recognise and define the premises of a female culture, and to respond to and develop further the questions it raises.' That means confronting the existing possibilities open to film, the politics of film, the film industry and film criticism, investigating women's ways of seeing and the images of femininity which are communicated via film. The magazine created a forum for public discussion of the professional problems facing women film-makers.

The founding of women's film and TV colleges was another step towards overcoming and breaking down the barriers. It allowed access to institutionalised directing. Women no longer had to seek out an established director and to show him their work, but now had the opportunity to learn the profession officially. This was an achievement which cannot be overestimated considering how strong the prejudices against women were – male directors only chose men to be camera, production and direction assistants. Cultural history has shown clearly enough that without access to institutionalised training, qualified female professional activity in any field will remain the exception, and this was the reason why girls' neglected education was always the main concern of the first women's movement and why it pleaded for the improvement of education.

When one puts all this together the picture is not so bleak after all. Over the last fifteen years women film-makers in the Federal Republic of Germany have made a considerable impact starting from nothing. In order to see how much has changed both quantitatively and qualitatively one only needs to call to mind that twenty years ago when the Oberhausen manifesto on the revival of the German cinema was signed on 28 February 1962 not a single woman director was amongst the signatories. At the 28th Berlin Festival in 1978

Hans Blumenberg declared: 'Women, women's films, women's fantasies – even after the first five days one can see a new trend. There are more films by women and about women than ever before.' And Karena Niehoff remarked at the 32nd Film Festival: 'There are fifty-seven films being shown and many women's films are amongst them. These are not so sour and aggressive as before. Women now have more self-confidence and a wider-ranging curiosity – even about men – and less bitterness.' I don't want to give the impression that everything's rosy now. Yet it should be clear that a lot has changed – in spite of the continuing difficulties – and that these changes are thanks to women's own efforts.

11
Gisela Breitling
Speech, Silence and the Discourse of Art.
On Conventions of Speech and Feminine Consciousness

I

At the beginning of the 1970s with the emergence of the modern women's movement women began to take a new interest in images, in women's art. At the same time female artists began to try to put the new feminist consciousness into a visual form. The result was an art which explicitly claimed to be feminist and which was characterised by stylistic features which have been almost exclusively associated with women over the last ten years. For example, painting – with the exception of the 'new fauves' – remained more or less taboo. Programmatic feminist art preferred using other techniques: ready-mades, performances, photo-collages and pointedly 'anti-classical' materials. [. . .]

This narrow selection of certain 'permissible' techniques and materials attracted my attention, for it gave the impression that there was a secret feminist International at work, a Central Committee for Culture which from time to time issued guidelines as to the direction feminist cultural politics was to take. I found that my 'discoveries' continually repeated themselves whether I was searching for women's art in Rome, Munich, Paris or Berlin until they were soon no longer 'discoveries'.

What was the origin of this consensus? Who formulated the feminist aesthetic programme, and what did it consist of? Apparently painting was only permitted if it referred to past art; painting, it seemed, was 'masculine'. And as I asked myself what were the questions art had posed and searched for the answers that women artists had given to women's concerns, I slowly became aware that it

was more a problem of language, of speech and silence, of an artistic discourse which was trying to break a commandment of silence which was thousands of years old. This problem of language conceals the tragedy of women's lack of tradition and its silenced history. The preference for 'anti-classical' techniques turns this denied tradition into an artistic counter-programme, turns it inside out and into opposition to the current accepted cultural consensus. [...] Why can't women now that they are – at least on paper – allowed to enter the academies and art business be damned whether the art they create is later thought to be 'feminine'? Why is it so important for art to be 'feminine'? And anyway what counts as 'feminine', what does it include and why?

But first of all one must ask what it actually means when women begin to search for 'the hidden woman', begin to discover that the feminine has been excluded from the spectrum of 'human' self-representation and communication, and find merely fantasies and representations of the feminine, men's brainchildren, instead of truth or reality.

II

'Humanity can face the truth,' said Ingeborg Bachmann. It is an affront to demand that women face the truth about their speech and silence because an acute consciousness of their oppression is daily accompanied by new painful experiences. Women who have run away from the paternal home of patriarchal ideology are made to feel the 'frosts of freedom'. The truth about their silenced silence, their suppressed discourse, is an unreasonable demand on women. And the truth which men have spread through time and space will become an unreasonable demand on men and a half-truth so long as humanity means only half of humanity.

Women's speechlessness has its roots not only in the fact that they were for so long subjected to silence, that what they *did* manage to say was not and still is not listened to. It is also rooted in the fact that language itself only permits the female as a special category, that it ignores it or subsumes it under the masculine which is, however, presented as sexually neutral. Language does not only represent a permanently used instrument of immediate communication. It is also the medium which contains our subjectivity, our identity: our discourse shapes our history. History, in turn, only tells us what the

instrument language is capable of telling. Language is a system analogous to consciousness at any one given time, to its norms and values, for it is reproduced by consciousness and permanently redefined by it. [. . .]

Language expresses what is commonly human in masculine grammatical forms. And, in fact, this 'common humanity' does reflect solely that which grammar signifies, that is, it refers exclusively to the masculine and neglects feminine aspects. In analogy to language, history, too, makes women invisible. However, 'historiographical methods which consider only half of humanity and moreover perceive this half not to be men but to be sexually neutral beings construct not only an incomplete universality but also a false one.'[1] It would, however, be incorrect to assume that 'history has realised that it has so far been largely the history of men even if it has not called itself such,' concludes the historian Gisela Bock.[2]

The masculine, which because it is defined as the 'commonly human' functions as a linguistic form (and therefore points towards a signified), does not only exclude women as a category in the writing of history. As the 'universal' it also, in a paradoxical way, makes this exclusion effective as well as invisible. It is impossible for women within this structure to make statements which transcend gender. Female discourse cannot reach out beyond its genderised character (limitations), feminine discourse never includes masculine discourse. [. . .]

When women set out in search of a new feminine self they are confronted with difficulties which are literally indescribable, for the medium 'through' which we want to expose the fact that men have stamped the neutral concept of humanity with their own mark is itself a product of this process. This reduces our avenues of expression and confuses our thought.

III

Language twists our own meanings often enough. When I say I'm a painter [*Malerin*]* that is not the same as when a man says he is a

* Breitling's example becomes clear when it is realised that in German many nouns designating occupations have gender endings; thus the word for a female painter is *Malerin* and for a male painter, *Maler*. The root is almost always the masculine form. These German nouns thus immediately indicate gender unlike their English counterparts which usually require qualification.

painter [*Maler*]. If a man wants to convey the same meaning as me then he would have to say that he was a painting man. When I say I'm a painter [*Malerin*] then the significance of my statement lies primarily in that I'm describing not what I do but in that I do it *as a woman*. With the sentence, 'I'm a painter [*Malerin*]', I differentiate myself and am differentiated from men who are painters. My vocabulary confines me to the company of women who are painters and thus my painting, too, is primarily considered within this special limited context. Language confines women to segregated spaces, denies them any claim to universality which would put them in a relation to all human beings. This is only possible for a female subject who denies her femininity and selects a formulation which pretends to transcend gender but can in fact only be construed as masculine; for example, when the feminine subject is submerged by a 'masculine name/noun'. If I wanted to say more exactly what I mean when I talk about my work – painting – then I would have to use the following convoluted formulation: 'I am a woman painter and a painter'. I want to put my painting in a relationship to all painting and that is not just out of personal ambition. It is impossible for someone who is in the art world to have any idea of what being a painter means if she/he does not consider all art which is accessible to her/him or which interests her/him and include it in her/his process of learning, in her/his range of experience which, after all, has the conquest of the whole world as its final goal.

It would be absurd to think that women should only refer to female predecessors and models, should only develop artistic themes and techniques within a history of women's art because they are 'different' and because the 'universal' art up until now is in reality men's art. Quite apart from the fact that this would mean an extreme limitation for women artists and would therefore reduce the impact of their art, and quite apart from the fact that in our culture female predecessors are few and far between, such a limited female openness to the world is to be rejected for other reasons.

Art, even one person's art, is never merely an individual achievement, for it originates and develops in a complex social framework. One individual's artistic product is embedded in a fabric woven out of others' contributions, whether these are encouragement, material or intellectual support, or the art which emerges at any one particular time and the tradition behind it. It is true that the cultural climate up until now has been predominantly made by men but it

has always benefited from female collaboration (which was hidden under a male signature and has therefore remained invisible). The contribution made by women has not always been a material one; they did not always only create the necessary domestic comfort of a well-run household, for example. There was also an intellectual component. But woman's confinement to erotic and/or domestic service devalued her intellectual work, particularly if she worked alongside a man within a sexual relationship. Irrespective of what a woman artist (or gifted woman) developed by way of an intellectual contribution in such a relationship, be it as a model, muse, inspirer, pupil or mistress, the 'muse' could always become a whore just as the sexually (ab)used model could become the stylised 'muse' with the result that the one was equated with the other and correspondingly devalued. [. . .]

Feminine creativity and feminine cultural achievement lie buried under such misleading classifications and definitions. However, that is no justification for the claim that only men can publicly represent art as it has been handed down to us. That would merely continue female dispossession on another level. The male sex therefore has no more right to call on our cultural tradition than the female sex does. However, there is a tendency in art history to question the female right. Women are more often compared with women than with men – and men never refer to women as precedents. Thus all too often like is not compared with like. For example, Modersohn-Becker with Kollwitz instead of with Cézanne or Jawlenski; Kollwitz with Modersohn-Becker instead of with Klinger or later with Barlach.

Women artists are uprooted from their historical context and banished to a special area – the feminine – so that their work, their achievements and their ideas usually become incomprehensible. The ghetto of the feminine presents us with a mixed bag of works, the creators of which usually have nothing more in common with each other than their sex. Another reason why this segregation is wrong is that in a patriarchal society it is usually only isolated individual women rather than groups of women who can manage to free themselves from the limitations of their gender role. These women were therefore compelled to create within a male environ-ment and to have relationships with men who have been their models, their contemporaries and their intellectual companions. (When such relationships are described it is usually along the lines of muse, model, 'mistress of artistic genius', etc. which confines

Gisela Breitling, *Woman reading newspaper*, 1981, gouache.

Gisela Breitling, *Woman facing right, smoking*, 1981, gouache.

women to the traditional female radius of action and therefore also excludes them from the context of historical developments.)

When the Mexican muralists' pictures were exhibited at the Nationalgalerie in Berlin, Frida Kahlo's work was left out although the exhibition would have been the fitting place for it. Instead, it was in another show alongside photographs by Tina Modotti – two women who artistically have almost nothing in common with each other. You won't find Paula Modersohn-Becker's pictures in the Worpswede room of the Kunsthalle in Bremen – they hang in a special room. However, when displayed in the context of her male contemporaries, as in the Staedelsche Kunstinstitut in Frankfurt, her qualities become apparent – only then does her power, her expansiveness, her sensibility for colour become apparent – or in the Nationalgalerie in Berlin where two of her pictures hang side by side with Schmidt-Rotluff and Otto Müller. The company of her male contemporaries highlights how no one so far has adequately allotted her her rightful place. Her paintings belong to the rare jewels of German turn-of-the-century art, to the few miracles, to the few acts of daring which are so seldom seen in art and elsewhere. She needs to be placed in the context from which she comes, on which she calls, which she defies and which she transcends, for otherwise her achievement and the goals of her art remain hidden. [. . .] We cannot do women's creativity justice so long as we consider it in an exclusively female context. (The same is true of men's creativity.)

IV

Feminist linguists have recently taken it upon themselves to investigate not only the suppression of feminine discourse but also the suppression of the feminine in every kind of discourse. Feminists know all too well that women have to work out from the context whether they are included when the words 'all' and 'every' are used; this is often impossible. It also makes whatever applies to women the exception, the deviation from the norm. That which is seen to be feminine, the special case, the marginal, is reduced in the end to sexual functions – menstruation, the ability to give birth, the uterus – which in turn defy the rules and become diseased because, as they do not concern the male biology, are not contained in the definitions of him.

Recognising the feminine as deviance leads to the notion that it

cannot and should not realise itself in what is universal, that it is not in the position and does not have the right to represent what transcends the gender-specific . Women's claim to make a statement which is binding for all appears to trespass into a territory for which she is not equipped, for if what we find describes only males then the feminine (not-masculine) must be the absolutely opposite, the 'quite other'. Attempts to come closer to (male) positions which claim universality and neutrality are therefore suspected of false identification. The 'quite other' of the feminine appears as a negation, as an antithesis to the 'normal'. [. . .]

However, as soon as we talk in terms of 'woman in academia', 'woman in art', or woman in this or that field and do not at the same time refer to 'man in art', 'man in academia', we assume that 'woman' thinks, acts and speaks with one accord. Questions about 'woman' originate in diffuse expectations and in their turn arouse expectations, for example, that 'the second sex' now has to construct a completely new and different discourse, take on a completely new form compared with that of the traditional image of humanity on the one hand and the traditional image of woman on the other.

That 'label of quality', the feminine, can be denied a feminine discourse if the discourse does not live up to these expectations. It must prepare itself for the reproach that its thought is male-centred and that it has accepted the masculine interpretation of culture, as though woman only has the right to work in an area until then reserved for men if whatever she wants to do or does in fact achieve is unusual (that is, opposed to the universal) and undoubtedly feminine. No review of women's exhibitions in the last few years has neglected to raise the question of whether and in what way the art on show documented femininity. This question implies the following attitude: if it does, in fact, emerge that women's representations do not differ so greatly from men's then it is quite superfluous for women to be artistically (intellectually, etc.) active, and it is sufficient for men to remain the sole occupants of these areas of human activity.

V

Do masculine precepts in language influence our perception? The very close connection between sight and knowledge immediately becomes apparent when we realise that fields of vision and perceptual

capacity are limited if certain things are not talked about, are not allowed to be talked about. Speech taboos become prohibitions on perception. And conversely, whatever is linguistically expressed acquires a new impact, a special quality, a kind of super-reality. Thus phenomena which are invisible or in reality non-existent have an impact, can be perceived and be perceived as natural, can determine our lives, if they are named or used in turns of speech. (Prejudices against women, for example.) Visual phenomena become visible for us because of the 'pre-consciousness' with which we approach a work of art – or anything visible at all. We would be 'blind' were it not for our linguistically-shaped consciousness. [. . .]

Attempts to interpret pictures which are so far removed from our cultural assumptions that the key to their language has been lost merely reflect our own ideologies. This comes out most clearly in descriptions of prehistoric art (Ice Age cave paintings). Here, today's man–woman relationship is crudely applied to the distant past and it is taken for granted that all art, even the earliest, is made by men. [. . .]

When J.M. Io Duca asks in his preface to George Bataille's *Les Larmes d'Eros (The Tears of Eros)*, 'what is the origin of the arbitrariness of human endeavour, of the colossal wastage – 200 million eggs to create one mortal being? [Correction: nature always needs only one fertilised egg for this purpose, G.B.], of the preference for renewal born out of destruction? What is the origin of his [George Bataille's] insight . . . *that homo sapiens has become conscious of himself because of his exposed genitals?*'[3] he neglects the fact that consciousness of one's own sexuality is only possible on the basis of the *recognition of the existence of another sex.* (Quite apart from that, this remark conveys the wrong and presumptuous assertion that only the male sex has attained self-awareness and has therefore been capable of culture from the beginning of human history.) Awareness of one's sex is, however, intrinsic to the development of human – and that means female also – self-awareness. In so far as we know anything about the development of a sense of identity we know that it is very closely linked to the sense of being female or male. Recent research leads to the conclusion that a child between one and a half and three years old already feels herself/himself to be a 'sexual person' and not a member of the species 'human being'. [. . .] We learn to associate our sense of being with our sexual existence so early that we cannot see ourselves merely as a 'person'.[4] The recognition of one's sex, and therefore of the male–female dualism

which is the first significant cognitive step a human being makes, is the basic pattern according to which all creatures and natural phenomena are classified, the first ordering principle, the first process of abstraction when observing the world, the first distinct experience of oneself. The dualist mode of thought which develops out of this has shown itself to be in working-order right up to the present day.

Recognising that the existence of two sexes is fundamental to our thought does not only answer the question of why there is no human society which does not describe in detail the difference between man and woman, and why activities, abilities and spheres of life are everywhere strictly defined. It also explains why today's women in their attempts to free themselves, in their search for expression, for language and images, so strongly emphasise that their utterances and self-presentations should be seen as feminine. This search sends women off in many different directions. Their questions exclude them from the 'normal' (masculine) context of understanding. There, 'outside', femininity is merely the residuum, it is what cannot be assimilated into the (false) universality of the masculine. According to the masculine standard the feminine is subjective, subversive, trapped in the body.

VI

What concept of femininity has now been accepted in women's search for identity? What classifications does the search recognise? Does it allow the masculine standard to remain valid? What is the nature of the feminine which finds expression in women's art and their use of language? [. . .]

The female origin of techniques which are 'anti-classical' is always emphasised. These techniques, as I said before, include ready-mades, action art, performances, video and a mixture of techniques which use diverse and often apparently 'valueless' materials. All techniques and forms of expression which depend on the artist as an individual are given preference to the 'traditional' techniques like painting or sculpture. In the two-volume work *Frauen in der Kunst* (*Women in Art*)[5] there is only one example of contemporary women's painting (Maria Lassnig) in the section of illustrations; sculpture in its traditional sense is entirely missing. Instead, photo-collages and mixed-material collages, ready-mades, and photos of performances

are amply represented. This corresponds to a 'quasi-official' feminist consciousness. Similar ideas about feminist ways of shaping and bringing things together can be found in other publications published by the women's movement, for example in *Courage, Emma, Kassandra* and other smaller feminist magazines. The exhibition 'Typisch Frau' (Just like a Woman) in Bonn and the Lucy Lippard book on art also emphasise performance, action art, and ready-mades; the exhibition 'Frauen International' (Women International)[6] showed the same tendency as early as 1977. Women's contemporary art is to a large extent characterised by anti-classical techniques.

> It is no coincidence that it is feminist artists in particular who see women as fragmented and broken dolls, as kitchen madonnas and keepers of the refuse. It is no coincidence that they work with limp unsightly materials which look as though they came from the special-offer counter in order to produce kitchen environments behind which the 'shadow of the great housewife' becomes visible. These are images of women reduced to the functions of domestic production and consumption within the fetid atmosphere of the family.[7]

The impact of these images is ambivalent – possibly also the process of their creation. On the one hand, the functionalisation of the feminine is deemed worthy of representation, hidden aspects of female life are brought out into daylight. Women's work is no longer the meditative idyll of the seamstresses and potato peelers of a Ter Borch, Chardin or Menzel nor are they the socially critical, accusing figures of misery of the Belgian realists or of the late Kollwitz. The derisory masquerade of such images denies aesthetic pleasure as well as an emotional identification in the sense of feeling involved. On the other hand, they do not transcend the residues of femininity. Femininity has not changed its location, it is merely described 'differently'. Damaged femininity – or 'femininity as damaged existence' – does not contradict patriarchal consensus. The impact of such images and montages cannot be grasped if they are seen to be merely – as is intended – criticism of what already exists, as a rejection of the traditional role. I think women artists underestimate the force of the impact of those realistic images which do not allow any identification in male and female viewers. The sphere of the feminine even when distorted by caricature remains allocated to

woman as her area of competence and she remains dependent on it even if, or precisely because, it is represented as a wretched sphere which drives women mad.

The fine arts – or the contemporary arts at least – do not possess any rigidly defined system of rules and therefore no provable 'right' or 'wrong' as grammar does. Yet the endeavours of the female (feminist) consciousness today are also reflected in a different way of handling language. This use of language perhaps clarifies the path women have taken in their search for new self-images. They are becoming increasingly aware of the androcentric tendency in language and are therefore trying to check universal, supposedly neutral formulations and reveal their inherent masculinity. (The attempt to replace the little word *man* by *frau* is the most obvious example of this.*) However, language use also shows an 'anti-classical' tendency. Competence and expert knowledge have all too often been rejected as 'masculine and achievement-orientated'. Carelessness or inelegance could therefore be regarded as 'open', 'non-structured', 'subjective and spontaneous' stylistic means; efficient professionality and intellectual edge – aspects of articulation and self-representation which have anyway hardly ever been permitted to women – have also had to suffer the feminists' reproach of 'unfemininity'.

Marlis Gerhard, in her search for new self-representations by women in literature, notes the lack of 'the utopian vision which conjures up distant women who neither allow themselves to be functionalised nor have succumbed to the "enchantment" of commodities'[8], explicitly referring to the fine arts. The perspectives which such a long-distance vision could open up, 'liberated images', are, however, absent in the official descriptions of what characterises 'feminine forms of expression'. But after all, the male-oriented bias of the culture business is no secret to feminists and they are therefore justified in mistrusting a public which has from time immemorial assigned certain characteristics to 'women's art', specified it as feminine, and excluded it from 'general' development trends. In addition, the forms of expression and trends which we can see today have been pre-selected and we are only allowed access to them via the channels permitted to art by the media and the art market. For

* In German, the word for the impersonal 'you' is *man*, which also means (English) 'man', (in German *Mann*). Many German feminists replace this with the word for 'woman' (*Frau*) which is by analogy written *frau*.

these reasons the women's art which is made public nowadays should rather be seen as a selection of work which is considered by the male-dominated art business to be 'feminine' and so excluded from 'real' art. Women, even as artists, find themselves in a 'double-bind': publicity, which is vital to art if it is to act as a 'discourse', is only permitted to women under restricting conditions because it contradicts the traditional image of woman.

As a figure of identification, the publicly recognised and autonomous woman really means the actual liberation from the constraints of the 'so far invisible sex'. But we have to ask whether the public sphere doesn't have the tendency to favour those women's art projects which can be located beyond the masculine norms. Yet if women's art remains excluded by the public sphere and the commodity market, then it is impossible for other women to identify with even 'liberated images'; and the 'utopian long-distance vision', however little it may 'functionalise' women, remains ineffective because it is concealed. The desire to succeed asserted by women artists in the public sphere is a signal for the undoubtedly necessary end to women's imposed modesty. Yet women should not under-estimate the obstacles they have to overcome before they are allowed to enter the market.

One might think that the feminist description of feminine forms of expression would contradict the customary 'official' interpre-tations of 'women's art'. Surprisingly, the opposite is the case: changing object arrangements, collages of temporary materials, forms of expression involving the body like performances, video and action are not only described as genuinely feminine by the art market, the magazines and the papers' arts pages which set the standards, but are confirmed by feminist interpretations as well. It is even more surprising that the 'female counter-culture' has apparently not yet questioned this consensus; indeed, it doesn't seem to have noticed it. The culture business remains exempt from the suspicion of adopting 'token women' – in contrast to other public spheres. [. . .] 'Feminist counter-culture' has not merely adopted a given image of femininity and accepted that a considerably limited area has been put aside for women's discourse, it is rather that it has fashioned this image itself and has therefore potentially even aggravated the polarisation of the sexes.

The criteria which determine whether a work of art is feminine – in the feminist sense of the word – describe quite closely the opposite

of what language allocates to the 'sexually neutral masculine': the 'feminine' is subjective, subversive (anti-classical), physical, irrational or 'deranged', agitated, fleeting – that is, it is a process, not directed towards permanence, opposed to the norm ... Such criteria overlook women's capacity for abstraction. On the contrary, they promote the exclusion of women's creativity from the areas of art which *do* transcend gender. And in so doing they conform to an art market which has always labelled women's desire to impose form as irrelevant to general trends, as marginal, subjective and narcissistic, and as far as possible denied women's other artistic endeavours. Such attitudes do not transcend patriarchal dualistic thinking; rather they articulate resistance merely as the negation of the dominant norm which is thereby not only recognised (revealed) to be masculine but also recognised (accepted) as such. This norm represents not only an 'incomplete' but also a 'false universality'. Femininity is not merely 'difference', although up until now it has been defined only as those leftovers of human existence which cannot be assimilated into the male consciousness of self. The solution of the problem then is not to discard the notion of a sphere which transcends gender just because it has so far merely endowed the masculine with a 'false universality'.

A transcendence of the limitations imposed on the feminine must at first look like a step into the territory of the masculine according to current language usage. The insights of women who have uncovered its false universality offer a starting point for the first draft of a new and true universality in which the feminine will find its rightful place and the masculine its actual dimensions (for in future it can no longer be 'the measure of all things'). [. . .]

About the Artists

From the beginning of this project I wanted to include illustrations of works by women artists, though not with the intention of illustrating the theoretical discussion, and so being caught in a close, one-to-one relationship. Nor can the selection be said to be representative of women's art generally. Rather they should have a presence of their own and, if anything, express the variety of women's art. I went to many exhibitions, and picked out the women artists I was interested in – deliberately including a few less well known ones. I then contacted them, told them about the contents of this book, and invited them to choose their own contribution. Thus the pictures which illustrate this book do so in a different sense from the usual one.

The artists' responses ranged from anxiety about being ascribed to 'women only' art, to willing cooperation. I found, too, almost as many different statements as there were artists. I was told about discouragement, restrictions on the market and long non-productive periods; but also of the creative impact it made consciously to paint as *women*, in full awareness of the tensions which go with this.

It is unlikely that many readers will know the artists presented here and the wider context of their production. As it was possible to include only one picture per artist, I will make a few comments on the general tendencies to be found in their work. Although many of the artists chose a picture with a thematic allusion to 'woman', it is quite obvious that what is presented is neither mere representation nor does it presume to be a programmatic continuation of the sociological and political debate of the 'woman question' by artistic means. One of the decidedly new turns has been that women are striving to be both subject and object of artistic expression. This is an

historically important step, and has provided the ground for further development.

Gretel Haas-Gerber's critical realism has always focused on women. She was born at the turn of the century and her early work – including portraits of peasant women – was banned under the Nazi regime. She resumed painting again in her late sixties. I think she can teach us a lot by the trenchant approach of her themes and by her courage to go on even though there is little demand for realism in the art world today.

Anna Blume describes the motives underlying her drawings of damaged and disabled women thus: 'to record brute facts with an eye which can feel and sympathise', and 'to depict women in their present state of emotional and physical deformation with solidarity'.[1] The merging of the analytical with empathetic identification is a quality which distinguishes her work from the caricatures of similar women by male artists.

Ithes Holz's cheerful contribution to a competition of art by women to be hung in a women's hospital is an example of how an artist who usually handles other registers can also employ a realistic style instrumentally, and adapt it to a specific situation.

A painter like *Rune Mields* presents a sharp contrast to this. With single-minded precision and intellectual curiosity she explores the web of signifiers of all sorts of sign systems and structures – mathematical, geometrical, mythological – translates them into visual images, and thus marks her own courageous position between what appears to be order and chaos. When I walk along the street where she has her studio and see her tools, the ruler, protractors and compasses, I am convinced that one of the current feminist beliefs about women's art, namely that it is straightforwardly subjective and personal, is a strange orthodoxy.

Maria Vedder is another woman who employs sign systems in her search for communication and artistic self-expression, but in confrontation with a world which reflects these efforts as absurd.

The term 'scriptural painting' which is often applied to *Annalies Klophaus*'s work is not very meaningful because she aims neither at the purely visual and ornamental character of writing nor at the systematic value of a linguistic code, but works towards the dissolution of static positions by bringing them into play.

Eva Maria Schön sets herself the task of following traces left by anonymous forces.

There are many different modes of expression here, like everywhere else in women's art. *Gisela Breitling* explicitly deals with problems which might arise from this departure from 'classical' techniques in her article (see Chapter 11). Her own work is full of intertextual allusions to her male predecessors. *Sarah Schumann*'s collages have accompanied numerous feminist projects in Germany: visions of feminine subjectivity in which inside and outside, cultural debris and images of desire merge; *Carola Andries*'s delicate brush stroke seeks to reconcile oriental and occidental traditions; *Ulla Horky-Heuel* frequently combines shell-like material together with photography and her own body; *Michaela Melian* paints on carpets, camp-beds (e.g. a 'Triptych on Camp-beds') and bedspreads; *MaKo*'s portraits of women artists include reflections on their own specific style of expression; and *Ulrike Rosenbach*, who has become well known for her performances and her 'School of Creative Feminism', contributes one of her early photocollages.

Desire has been seen as one of the moving forces in the paintings of *Elvira Bach*, who has become famous for her dazzling and ambivalent images of women who appear as erotic contemporary figures but also contain mythical qualities. A similarly bold visual language can be traced in *Christa Näher*'s and *Annette Pfau*'s explosive paintings which struggle against the limitations imposed by the canvas. *Marianne Eigenheer*'s intense preoccupation with unconscious material emerges in fairytale-like, often erotic, figurative forms which are presented with an ironic lightness. *Angela Räderscheidt*'s contribution is part of a huge object arrangement in which she explores sexuality, using gestures from classical painting and sculpture and adding mythological symbolic objects. The sensuous bodily detail in *Barbara Hammann's* videos serves to decompose the socially coded female body by jarring fragmentation.

The *Malgruppe WeibsBilder* are a group of women who paint in a collective process which brings together different styles, formal associations and feelings. They protest against 'the myth that real painters can only paint in isolation from others to make "real" art, "authentic" art'[2]. In their name, their theoretical writing and, of course their painting, we find a great deal of provocation and wit, which does not exclude self-irony.

<div align="right">Gisela Ecker</div>

[1] *Typisch Frau*, catalogue of an exhibition of women's art (Bonn, 1981).
[2] See a fictitious interview by the group in *Informationen aus dem Landesverband BBK* (1984).

Notes on the Contributors

Silvia Bovenschen lives in Frankfurt–am–Main and teaches at the German Department of Frankfurt University. She has published *Die imaginierte Weiblichkeit (The Fantasised Feminine*, 1979), an investigation into representations of femininity, as well as being co-author of a book on witches, and contributor to a collection of essays on Herbert Marcuse.

Elisabeth Lenk is Professor of French Literature at Hannover University. She has introduced various French writers, such as Fourier, Aragon, Bataille and Lautréamont, to a German public, and has published a monograph on André Breton as well as numerous essays in journals and newspapers. In her latest book, *Die unbewußte Gesellschaft (The Unconscious Society*, 1983) she criticises the 'sadistic nature of objective structures of thinking', and outlines a history of the imaginary based on an analysis of dream structures.

Sigrid Weigel was born in 1950 and teaches German at Hamburg University. She has published works on women's journals and journalism as well as on the revolutionary pamphlet literature of Berlin in 1848. Her most recent book deals with prison literature 1750–1933. She is also one of the organisers of the series of conferences 'Women in Literary Criticism', of which two have already been held.

Heide Göttner-Abendroth was born in 1941 and lives in Munich where she obtained her doctorate in 1973 on the Logic of Intepretation. She teaches Philosophy and Aesthetics there, and has been active in women's studies for some years. Her publications include

two studies of matriarchal mythology and an investigation into logical structures in literary theory as well as various articles. She also writes and publishes poetry.

Christa Wolf was born in 1929. After studying in Jena and Leipzig she entered the publishing world as editor and critic. She has been a freelance writer since 1959 and lives in East Berlin. Several of her books have been translated into English, including *The Quest for Christa T., A Model Childhood, Cassandra* and *The Reader and the Writer: Essays, Sketches, Memories.*

Gertrud Koch was born in 1949 and studied German, Philosophy and Sociology combined with teacher training in Frankfurt where she now lives. She writes film reviews for various papers and journals and is involved in several research projects as well as teaching courses on film theory at universities and colleges of higher education.

Jutta Brückner was born in Düsseldorf in 1941, and studied Political Science and Philosophy in Berlin, Paris and Munich. She has published various articles, including one on pornography in film and one on *Carmen*. Since 1973 she has written scripts for Bavarian television and radio. Several of her films have been shown in Britain including *Hungerjahre* ('Years of Famine') and *Fangschuss* ('The Final Shot') in collaboration with Volker Schlöndorff and Margarete von Trotta. She lives in Berlin.

Christiane Erlemann was born in 1953. She is a freelance architect and town-planner and works with women engineers and scientists within the women's movement. She lives in West Berlin where she teaches a course at the University on identity conflicts of women in science. She has published numerous articles on various subjects including feminism and ecology, women and technology and women and transport. Since 1977 she has been active at the national conferences for women in science and technology.

Eva Rieger was born in 1940 on the Isle of Man and grew up in a Protestant pastor's household. In 1953 she moved from London to Berlin where she later worked in a music archive. After training to become a music teacher she took up a post at the Academy of Arts in Berlin and simultaneously studied music. She has been at the Music

Department of Göttingen University since 1978 and active in the women's movement since 1973. Her publications include a study of music teaching in East Germany and two investigations into women and music.

Renate Möhrmann was born in Hamburg. In spite of an early marriage, and bringing up her two children, with a good deal of effort she went on to study German, French and Philosophy at Hamburg and Lyons, and in 1968 moved to New York where she became involved in media studies and obtained her doctorate. After returning to Germany in 1973 she became a lecturer at Duisburg University and has been Professor of Theatre, Film and Television Studies at Cologne University since 1977. Amongst other topics she has published on German women writers of the mid-nineteenth century and on women and film.

Gisela Breitling was born in 1939. After attending textile engineering college she studied at the Academy of Fine Arts in Berlin where she won the first prize. She then went on to study copper engraving in Paris and in 1977-78 continued her studies in Rome. She now works as a freelance artist and writer in Berlin. She has had many retrospective shows in Germany and been represented in numerous joint exhibitions. In 1980 she published *Die Spuren des Schiffs in den Wellen (The Traces of the Ship in the Waves)*, an autobiographical account of a search for the traces women have left in art; she is also the author of several essays on women and art.

Notes

Introduction

1. Adrienne Rich, *On Lies, Secrets, and Silence* (London, 1980), p. 78.

2. Helke Sander, introduction to Gislind Nabakowski, Helke Sander, and Peter Gorsen, *Frauen in der Kunst* (Frankfurt, 1980), p. 12.

3. Rachel Blau du Plessis, 'For the Etruscans: Sexual Difference and Artistic Production – The Debate Over a Female Aesthetics' in Hester Eisenstein and Alice Jardine (eds.), *The Future of Difference* (Boston, 1980), p. 151.

4. See, for example, Fredric Jameson, *The Political Unconscious* (London, 1981).

5. Juliet Mitchell, 'Femininity, Narrative and Psychoanalysis', in *Women: The Longest Revolution* (London, 1984), p. 290.

Chapter 1: Is there a Feminine Aesthetic?

1. *Frauen in der Goethezeit* (Stuttgart, 1960 ff.).

2. Shulamith Firestone, *The Dialectic of Sex* (New York, 1970), p. 161.

3. George Sand, *Meine Lebensbeichte* (Berlin-Leipzig, n.d.). p. 98.

4. Karl Scheffler, *Die Frau und die Kunst* (Berlin, 1908), p. 29.

5. Franziska zu Reventlow, 'Viragines oder Hetären?' *Züricher Diskussionen* (1899).

6. Valie Export, in *Feminismus: Kunst & Kreativität*, ed. Valie Export (Vienna, 1975).

7. Theodor Gottlieb von Hippel, 'Ueber die bürgerliche Verbesserung der Weiber', *Sämtliche Werke*, 6 (Berlin, 1828).

8. Chantal Akerman, interview with Claudia Aleman, in *frauen und film*, 7 (March 1976).

9. Firestone, *op. cit.* p. 159.

10. Lucy Lippard, 'Warum separierte Frauenkunst?' in *Feminismus: Kunst & Kreativität*.

11. Frieda Grafe, 'Ein anderer Eindruck vom Begriff meines Körpers', in *Filmkritik* (March 1976).

12. Simone de Beauvoir, *The Second Sex*, (Paris, 1946; London, 1949), p. xviii.

13. de Beauvoir, interview with Alice Schwarzer, in *Der Spiegel* (April 1976).

14. Herbert Marcuse, 'Marxismus und Feminismus', in *Zeitmessungen* (Frankfurt am Main, 1975), p. 13.

15. Akerman in *frauen und film*.

16. Meret Oppenheim in *Feminismus: Kunst & Kreativität*.

17. Mario Praz, *Liebe, Tod und Teufel: Die schwarze Romantik*, v. 1–3 (Munich, 1970).

18. Sigmund Freud, 'Die Weiblichkeit', in *Vorlesungen zur Einführung in die Psychoanalyse*, Studienausgabe, v.1, p. 545.

19. Dorothy Richardson, *Dawn's Left Hand* (London, 1931), p. 204f.

20. Virgina Woolf, 'Women Novelists', in *Contemporary Writers* (London, 1965), p. 26.

21. Woolf, 'Women and Fiction', in *Collected Essays*, vol. II (New York, 1967), p. 146.

22. Sylvia Plath, *The Bell Jar* (London, 1963), p. 88.

23. Lippard, in *Feminismus: Kunst & Kreativität*.

24. Woolf, 'Romance and the Heart', in *Contemporary Writers*, p. 124f.

25. Richardson, *Dawn's Left Hand*, p. 202f.

Chapter 3: Double Focus: On the History of Women's Writing

For reasons of space this article had to be considerably abridged. In the original Sigrid Weigel discusses the work of Caroline Schlegel-Schelling, Sophie Mereaux, Rahel Varnhagen, Bettina von Brentano, Fanny Lewald, Louise Aston, Inge Buhmann, Christa Wolf, Maria Erlenberger, Caroline Muhr and Ingeborg Bachmann to illustrate the strategies which women writers employ in their fiction.

1. Licia in conversation about feminism, in Rossana Rossanda, *Einmischung*, (Frankfurt am Main, 1980), p. 226.

2. Simone de Beauvoir, *The Second Sex* (Harmondsworth, 1979).

3. Hans Meyer, *Outsiders. A Study in Life and Letters* (Cambridge, Mass., 1982).

4. Elaine Showalter, *A Literature of Their Own. British Women Novelists from Brontë to Lessing* (Princeton, 1977).

5. Ernst Behler, *Friedrich Schlegel in Selbstzeugnissen und Bilddokumenten* (Reinbek b. Hamburg, 1966), p. 84.

6. Rahel Varnhagen, *Buch des Andenkens an ihre Freunde*, ed. Hans Landsberg (Berlin, 1912), emphasis added.

7. Rahel Varnhagen, *Buch des Andenkens an ihre Freunde*, 3 vols. (Berlin, 1934), vol. 2, p. 564, emphasis added.

8. This is the sub-title of Ulrike Prokop's *Weiblicher Lebenszusammenhang* (Frankfurt am Main, 1976).

9. Christa Wolf, *Nachdenken über Christa T.* (Halle/Saale, 1968). Editor's note.

10. Here, Weigel refers to Fanny Lewald, a mid-nineteenth century German writer. Editor's note.

11. Lidia, in Rossanda, *op. cit.*, p. 220.

12. Claudine Herrmann, *Sprachdiebinnen* (Munich, 1977), p. 30, emphasis added.

13. Luce Irigaray, 'Romantische Liebe' in *Sex und Lust*, ed. Arno Widmann, *Aesthetik und Kommunikation*, vol. 7 (Berlin, 1981), p. 52.

14. Herrmann, *op. cit.*, p. 65.

15. Elisabeth Lenk, *Die sich selbst verdoppelnde Frau.* (Translation in Chapter 2 above.)

16. ibid.

17. ibid.

18. Varnhagen, *op.cit.*, p. 83.

19. 'Kein weibliches Schreiben? Fragen an Julia Kristeva' in *Freibeuter*, vol. 2 (1979), pp. 81–2.

20. Luce Irigaray, *Das Geschlecht das nicht eins ist* (Berlin, 1979), p. 162.

21. ibid., p. 165.

22. ibid., p. 81.

23. Hélène Cixous, 'Wenn ich nicht schreibe, ist es, als wäre ich tot', in Hélène Cixous, *Die Unendliche Zirkulation des Begehrens* (Berlin, 1977).

24. Cixous, 'Geschlecht oder Kopf', ibid., p. 34.

25. J.J. Rousseau, *Emile; or a Treatise on Education*, trans. Barbara Foley, (London, 1955).

26. Irigaray, *Das Geschlecht, op. cit.*, p. 25.

Chapter 6: Why Women Go to Men's Films

1. See Schneider and Laermann, 'Augen-Blicke', in *Kursbuch 49*, (Berlin, 1977), pp. 36–58.

2. ibid., p. 54.

3. See individual remarks made in interviews in the study by Ernest Dichter International Ltd, 'Freizeitsbedürfnisse und Präferenzstrukturen des Filmpublikums in der Bundesrepublik', in Prokop (ed.), *Materialien zur Theorie des Films* (Munich, 1971), pp. 339–83. Also Dieter Prokop, *Soziologie des Films* (Neuwied, 1970).

4. Hegel, *The Phenomenology of Mind*, trans. J.B. Baillie (London, 1931), p. 496. 'Since the community gets itself subsistence only by breaking in upon family happiness and dissolving individual self-consciousness into the universal, it creates its enemy for itself within its own gates, creates it in what it suppresses, and what is at the same time essential to it – womankind in general.'

5. Sigmund Freud, *New Introductory Lectures on Psychoanalysis*, trans.

James Strachey (London, 1964), p. 131.

6. Jean Mitry, *Esthétique et psychologie du cinéma* (Paris, 1963).

7. Laura Mulvey, 'Visual pleasure and narrative cinema', in *Screen*, 16 (1975), pp. 6-18.

8. See Lawrence Kohlberg, *Zur kognitiven Entwicklung des Kindes*, particularly 'Analyse der Geschlechtsrollen - Konzepte und Attituden bei Kindern unter dem Aspekt der kognitiven Entwicklung', (Frankfurt am Main, 1974), pp. 334-471. Kohlberg works on the assumption that it is not only the perception of specific body metaphors which contributes to gender identity but also the quite obvious social allocation of roles. Thus 'penis envy' would be the result of a genital body metaphor and also of social allocations of power.

9. Ulrike Prokop, *Weiblicher Lebenszusammenhang. Von der Beschränktheit der Strategien und der Unangemessenheit der Wünsche* (Frankfurt am Main, 1977), p. 142.

10. Martha Wolfenstein and Nathan Leites, *Movies. A Psychological Study* (Glencoe, 1950).

11. Gisela von Wysocki, 'Gespräch mit meiner Mutter', in *frauen und film*, 17 (1978).

12. Paul G. Cressey, 'Der soziale und psychische Hintergrund der Filmerfahrung', in Prokop (ed.), *op. cit.*, pp. 382-8. 'Whereas *projection* implies an unjustified limitation of the scope of the self, *introjection* implies an inclusion of a part of the environment into the idea of the self. *Substitution* on the other hand means a partial sublimation of people and values in the self's own social world by the figures and objects on the screen while the spectator continues to experience the action on the screen in the imagination but at the same time maintaining a consciousness of still being self', p. 384ff.

13. Günther Salje, 'Psychoanalytische Aspekte der Film- und Fernsehanalyse', in Leithäuser, *Entwurf zu einer Empirie des Alltagsbewußtseins* (Frankfurt am Main, 1977), pp. 261-87. 'This mode can be called a *typical* climate of transferral because it is contained in a typical way in almost all film and television material. It is only the intensity which seems to vary independently of the variations in material', p. 279.

14. Fritz Morgenthaler, 'Verkehrsformen der Perversion und die Perversion der Verkehrsformen. Ein Blick über den Zaun der Psychoanalyse', in *Kursbuch 49* (Berlin, 1977), pp. 135-51. 'It is a question of access to the grandiose. In all people a feeling of self bears with it the traces of childhood omnipotence. Perversion represents a quantitative escalation of grandiosity and also gives it sexual overtones. Someone who is perverse has a much more direct relationship to sensuality. However, this leads to a qualitatively different way of dealing with sensuality, a way which no longer conforms to reality', p. 136.

Chapter 8: What Is Feminist Architecture?

1. Second Conference of Women from the Natural Sciences and Technology, (Hamburg, January 1979), report p. 30.

2. Is this choice still haunted by remains of the old theory of progressive deterioration?

3. Margit Hoffman and Irmgard Kienzler, 'Frauen in der Planung: The Witches are Back!' in *Bauwelt* 31/32 (Berlin, 1979), p. 1319.

4. *ibid.*

5. Eva Schindele, *Mieter Stören* (Rotbuch, Berlin, 1980).

6. *ibid.*

7. Cillie Rentmeister, 'Die Quadratur des Kreises – Die Machtergreifung der Männer über die Bauformen', in *Bauwelt* 31/32 (Berlin, 1979), p. 1292ff.

8. *ibid.*, p. 1296.

9. *ibid.*

10. 'Humanes Wohnen e. V.', a Hamburg pressure group.

11. Christa Reinig. *Der Wolf und die Witwen* (Frauenoffensive, Munich, 1981).

Chapter 9: Dolce semplice? On the Changing Role of Women in Music

1. In answer to the question why there are no women musicians in the Berlin Philharmonic, Herbert von Karajan said at a press conference in Peking that 'a woman's place is in the kitchen and not in the symphony orchestra', (*Die Welt*, 7 November 1979).

2. Lilli Lehmann, *Mein Weg* (Leipzig, 1913), vol. 1, p. 171.

3. Schering, cited in Eberhard Preusser, *Die bürgerliche Musikkultur* (Hamburg, 1935), p. 23.

4. ibid., p. 75.

5. ibid., p. 78.

6. Cited by Carl Dahlhaus, *Die Idee der absoluten Musik* (Kassel and Basel, 1978), p. 20.

7. 'Form', in *Musik in Geschichte und Gegenwart*, (Kassel, 1956), vol. 4, col. 549.

8. Hans Hildebrandt, *Die Frau als Künstlerin* (Berlin, 1928), p. 108.

9. Cf. Eva Rieger, *Frau, Musik und Männerherrschaft* (Berlin, 1981).

10. Oskar Bie, *Die Oper* (Berlin, 1913), p. 22.

11. Otto Gumprecht, *Neue musikalische Charakterbilder* (Leipzig, 1876), p. 45.

12. For example, composers such as Luise Le Beau and Elisabeth Kuyper who achieved considerable fame during their lifetime and were highly productive.

13. Johann D. Hensel, *System der weiblichen Erziehung* (Halle, 1787).

14. Friedrich I. Niethammer, *Der Streit des Philanthropismus und*

Humanismus in der Theorie des Erziehungs-Unterrichts unserer Zeit (Weinheim, 1968), p. 351. First published 1808.

15. Johann Heinrich Campe, *Vätherlicher Rath für meine Tochter* (Braunschweig, 1789), p. 120.

16. Luise Büchner, *Die Frau, Hinterlassene Aufsätze, Abhandlungen und Berichte zur Frauenfrage* (Halle, 1878), p. 46.

17. Cited in Jürgen Zinnecker, *Sozialgeschichte der Mädchenbildung* (Weinheim, 1973), p. 103.

18. Cited in Georg Sowa, *Anfänge institutioneller Musikerziehung in Deutschland. Studien zur Musikgeschichte des 19. Jahrhunderts*, vol. 33 (Regensburg, 1973), p. 185.

19. Karl Krebs, *Frauen in der Musik* (Berlin, 1895), p. 202. The first examination for music teachers in Prussia took place in 1906.

20. Sowa, *op. cit*, p. 247.

21. Cf. Hans-Christoph Worbs, 'Le tribut à la mode. Die Anfänge der Salonmusik', in *Neue Zeitschrift für Musik*, 3 (1971), p. 128.

22. Adolph Kohut, *Die grössten und berühmtesten Soubretten des neunzehnten Jahrhunderts* (Düsseldorf, n.d.) p. 49.

23. La Mara, *Musikalische Charakterköpfe*, vol. 5, *Die Frauen im Tonleben der Gegenwart* (Leipzig, n.d. [1902]), p. 49.

24. O. v. Riesemann, 'Eine Selbstbiographie der Sängerin Gertrud E. Mara', in *Allgemeine Musikalische Zeitung* (Leipzig, 1875), no. 32.

25. Lehmann, *op. cit.*, vol. 1, p. 247.

26. Adolph Kohut, *Die Gesangsköniginnen in den letzten drei Jahrhunderten*, (Berlin, n.d. [1906]), vol. 2, p. 215.

27. Anna Morsch, *Deutschlands Tonkünstlerinnen* (Berlin, 1894), p. 92. (about Antonia Mielke).

28. Morsch, *op. cit.*, p. 105.

29. ibid, p. 101.

30. A. Kohut, *Die grössten . . .* , *op. cit*, p. 55.

31. ibid., p. 6.

32. The *Erotische Memoiren* published in 1979 by Prinz in their *Playboy* series are a complete fiction. It is significant that this is covered up. Schröder-Devrient is portrayed as an insatiable *femme fatale*, a role which is all too often applied to female singers.

33. Cf. Berthold Litzmann, Clara Schumann, *Ein Künstlerleben* (Leipzig, 1918), vol. 2, p. 6.

34. ibid., vol. 3, p. 223.

35. ibid., vol. 3, p. 21.

36. Robert Münster, *Komponistinnen aus drei Jahrhunderten* (exhibition catalogue).

37. Sebastian Hensel, *Die Familie Mendelssohn. Nach Briefen und Tagebüchern* (Berlin, 1879), vol. 1, p. 89.

38. Karl Scheffler, *Die Frau und die Kunst* (Berlin, n.d. [1908]), p. 101.

39. Cited in Alice Sokoloff, *Cosima Wagner* (Munich, 1973), p. 110.

40. Cited in Moulin-Eckhart, Richard Graf du, *Cosima Wagner. Ein Lebens und Charakterbild* (Berlin, 1928), vol. 1, p. 200.

41. The association 'Frau und Musik' which is based in Cologne welcomes male members and aims for greater participation by women in culture as it already exists, whereas 'Musikfrauen', based in Berlin, questions Establishment culture and demands radical social changes in women's interests.

Chapter 11: Speech, Silence and the Discourse of Art

1. Gisela Bock, in Karin Hausen (ed.), *Frauen suchen ihre Geschichte* (Munich, 1963), p. 25.

2. ibid., p. 25f.

3 J.M. Io Duca, in George Bataille, *Les Larmes d'Eros* (Paris, 1981), emphasis added.

4. Jean Baker Miller, *Towards a New Psychology of Women* (Harmondsworth, 1978).

5. G. Nabakowski, P. Gorsen *et al.*, *Frauen in der Kunst* (Frankfurt, 1980).

6. 'Frauen International' (1977), in Berlin; 'Typisch Frau' (1981) in Bonn. Editor's note.

7. Marlis Gerhard, *Kein bürgerlicher Stern, nichts, nichts konnte mich je beschwichtigen. Essay zur Kränkung der Frau* (Neuwied and Darmstadt, 1982), p. 129.

8. ibid.